LIGHTNING GODS AND
FEATHERED SERPENTS

The Linda Schele Series in
Maya and Pre-Columbian Studies

This series was made possible through the generosity of William C. Nowlin, Jr., and Bettye H. Nowlin, the National Endowment for the Humanities, and various individual donors.

REX KOONTZ

LIGHTNING GODS AND
FEATHERED SERPENTS
THE PUBLIC SCULPTURE OF EL TAJÍN

University of Texas Press ⌁ *Austin*

Requests for permission to reproduce material from this
work should be sent to:
 Permissions
 University of Texas Press
 P.O. Box 7819
 Austin, TX 78713-7819
 www.utexas.edu/utpress/about/bpermission.html

♾ The paper used in this book meets the minimum
requirements of ANSI/NISO Z39.48-1992 (R1997)
(Permanence of Paper).

LIBRARY OF CONGRESS CATALOGING-IN-PUBLICATION DATA

Koontz, Rex.
Lightning gods and feathered serpents : the public sculpture
of El Tajín / Rex Koontz.
 p. cm. — (The Linda Schele series in Maya and
pre-Columbian studies)
Includes bibliographical references and index.
ISBN 978-0-292-71899-9 (cloth : alk. paper)
 1. Tajín Site (Mexico). 2. Totonac sculpture—Mexico—
Veracruz-Llave (State). 3. Totonac art—Mexico—
Veracruz-Llave (State). 4. Totonac architecture—
Mexico—Veracruz-Llave (State). 5. Veracruz-Llave
(Mexico : State)—Antiquities. I. Title. II. Series
F1219.1.T2K66 2009
972′.62—dc22

 2008042078

CONTENTS

ACKNOWLEDGMENTS

A book that brings together art historical and archaeological data incurs many debts. To Sara Ladrón de Guevara, whose careful reconstructions of Tajín sculpture will be fundamental to all later studies, I owe the data on which important elements of Chapter 4 are based. Her colleague Yamile Lira López also contributed key data and interpretations to that section. Arturo Pascual Soto's insistence on the *longue durée* of Tajín history, especially that period before the apogee, became very important for my seriation of the narrative sculpture in Chapter 3. Patricia Sarro continues to be a source of insight into all things Tajín.

The larger questions raised by this study owe their genesis to the remarkable synthetic works of William Ringle and the team of Alfredo López Austin and Leonardo López Luján. While these works differ in important details, they both draw our attention to the overarching political and social context in the rather tumultuous period of Mesoamerican history following the decline of Teotihuacan. Scholars involved in the groundbreaking 1989 volume on this period (*Mesoamerica After the Decline of Teotihuacan,* Dumbarton Oaks) have shared their thoughts on the subject over many years. Original volume contributors Jeffrey Kowalski, Virginia Miller, and Andrea Stone have been especially generous.

John Pohl has been an insightful critic throughout the project. Karl Taube opened several fecund avenues of research with his knowledge of comparative Mesoamerican iconographies; Javier Urcid provided valuable guidance to Oaxacan material. Julia Guernsey and Matthew Looper offered insight into Izapan and Classic Maya patterns at an important point in this work.

The University of Texas Press has supported the project from its inception. Special thanks are due to Theresa May and Megan Giller for their careful, patient, and invaluable work on the manuscript.

Significant parts of this book were drafted during a stay at Dumbarton Oaks during the summer of 2002. Research for the book was also supported by a National Endowment for the Humanities Summer Stipend Grant in 2003.

Finally, those who have lived through every step of the research and writing process with me have my most heartfelt thanks. To Daniela, Julian, and Lee, I dedicate this volume.

LIGHTNING GODS AND
FEATHERED SERPENTS

APPROACHING EL TAJÍN

El Tajín was an ancient capital of an extensive lowland Mesoamerican realm in the latter half of the first millennium AD. The site is perhaps best known for its elegant niched architecture, which is found in profusion in the pyramids and other structures that formed the city's monumental core. First among these other structures were masonry ballcourts for the playing of the Mesoamerican rubber ballgame, and scholars have long examined the rich iconography of these courts for clues to the meaning and function of this ritualized sport.[1] Despite interest in fundamental aspects of the city, El Tajín's place in Mesoamerican history has not been well defined.

The site's singularity has hindered attempts to place it more firmly in the context of Mesoamerican history. El Tajín was the largest city in the region during its zenith (Wilkerson 1999:113–116), as well as the only center with such a wealth of sculpture and fine architecture. Unlike the numerous large cities that formed the contemporary Maya area to the south, El Tajín was a city apart, with ties to more southerly areas of the Gulf lowlands but no peers in the region (Kampen 1972; Pascual Soto 1990; compare Proskouriakoff 1954:84–87). Smaller sites throughout the area imitated Tajín architectural style on a reduced scale (Palacios 1926; Jiménez Lara 1991; Pascual Soto 1998:25–28), but none of these had even a significant fraction of the public art produced at the capital. Important recent studies (Ringle 2004; López Austin and López Luján 2000; Smith and Berdan 2003) have begun to shed light on the interregional webs of art, commerce, and politics that operated during the period, but these studies have yet to be incorporated systematically into studies of the site itself. Finally, with some key exceptions (e.g., Taube 1988), studies of Tajín imagery outside the ball-

courts have been less successful than the studies of ballcourt imagery cited above. The task of this volume is to bring together iconographical studies that point to El Tajín's place in a larger Mesoamerican world, although this can be done only when the public imagery as a whole comes into better focus, both inside and outside the ballcourt. It is a double movement, then—internally, to a more nuanced reading of the major public imagery as a coherent set of statements, and externally, to a better understanding of the public imagery of other elites with which El Tajín was interacting—that gives this volume its particular logic.

The ancient city of El Tajín sits in the rolling hills of the north-central Gulf lowlands, only 40 miles from the Gulf of Mexico to the east and a slightly greater distance from the foothills of the Sierra Madre to the west (Fig. 1.1). The site lies within the boundaries of Mesoamerica, that area of complex pre-Columbian civilizations that extends from the southern half of Mexico through Guatemala and Belize to the western portions of Honduras and El Salvador. Among the elements that characterize this culture area are pyramids and monumental sculpture at the center of cities. El Tajín contains just such a complex monumental core area, with large amounts of impressive cut stone architecture together with the complex sculpture and painting that are indicative of a Mesoamerican city.

Eleven ballcourts have been found in the core, with six others in the near vicinity. Many if not all of these were in use during Tajín's apogee (ca. AD 650–1000). By this time Mesoamericans had been playing some form of the ballgame for at least two millennia (Hill and Clark 2001; Ortíz C. et al. 1997), so ballplaying is not what sets El Tajín apart. The concentration of courts in a single urban center is unusual, however, and places the site alongside a handful of other Mesoamerican cities. Given the amount of energy devoted to the construction and decoration of masonry courts, there is little doubt that the ballgame and surrounding rites were central to the city's elite.

Several Tajín ballcourts are decorated, and the central court contains one of the richest collections of ballcourt sculpture in all of Mesoamerica. The iconography of these central court panels has been crucial to scholars studying the ballgame in this region and throughout Mesoamerica, providing fundamental information on the major objects associated with the game (Ekholm 1949) as well as sacrificial rites surrounding the game (Tozzer 1957; Knauth 1961). While isolated details from these panels have served well as comparative material for larger Mesoamerican iconographical patterns, any reading of the ensemble of panels as a coherent narrative series is still in dispute, a problem that will be taken up fully in Chapter 3.

Beginning by the seventh century and continuing until the eleventh, El Tajín served as a major Mesoamerican capital in an area that had previously been marginal to the region's urban tradition (Brüggemann 1993; Wilkerson 2001a; Daneels 2002:659). During this same period, previously peripheral areas all over western Mesoamerica became major centers of commerce and political power. This newfound power was announced in the form of monumental architecture and art. In this the public sculpture of El Tajín is typical, and must be seen in the larger context of changes to the Mesoamerican political and social landscape occurring during this period.[2]

The period of El Tajín's apogee accords with the decline of Teotihuacan, the chief urban center of the first half of the first millennium AD. The waning of Teotihuacan's power initiated waves of political, social, and economic realignment throughout Mesoamerica in the period AD 650–900/1000, called here the Epiclassic (Pasztory 1978:15–21; Millon 1988; Diehl and Berlo 1989; Coggins 2002:43–45; Braswell 2003).[3] Many scholars have pointed to El Tajín's importance during the Epiclassic period (Jiménez Moreno 1959; Webb 1978; Diehl and Berlo 1989; Smith and Berdan 2003), when it was one of several regional centers that experienced a surge of activity as Teotihuacan power waned. The reconstitution of a Mesoamerican world after the decline of Teotihuacan remains one of the chief questions of Mesoamerican history, but El Tajín's key role in that process is not in doubt.

Recent scholarship on the Mesoamerican Epiclassic has stressed the construction of elite networks that replaced the old Teotihuacan order (Ringle et al. 1998; Ringle 2004; López Austin

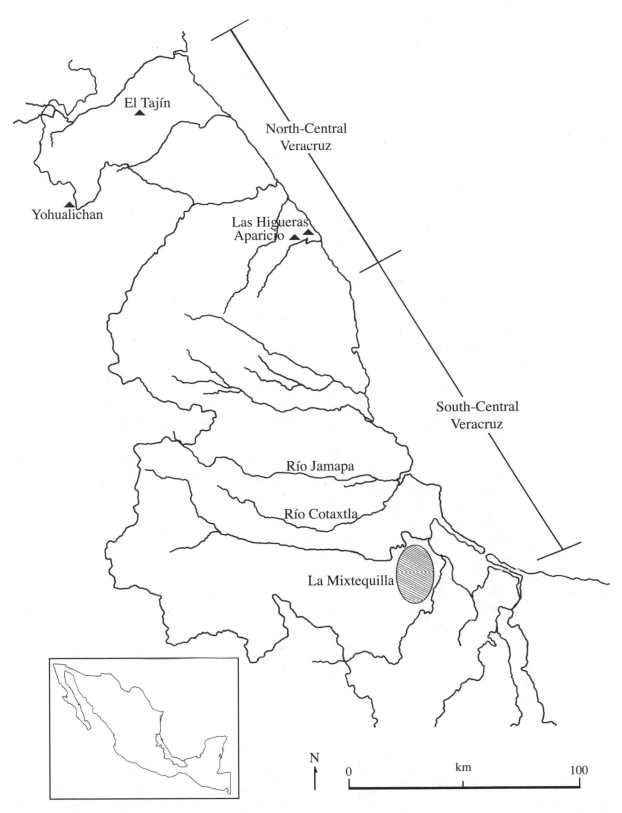

El Tajín

Yohualichan

North-Central
Veracruz

Las Higueras
Aparicio

South-Central
Veracruz

Río Jamapa

Río Cotaxtla

La Mixtequilla

N

0 km 100

FIGURE 1.1. Map of the Gulf Coast with El Tajín, showing the location of El Tajín and other major Classic Veracruz sites. Inset on lower left shows Mesoamerica with state of Veracruz outlined. Drawing by the author.

and López Luján 1999, 2000; Smith and Berdan 2003:25). The nature of these networks is still a matter of debate, but it is clear that one crucial aspect involved the presentation of complex public statements in the urban center proclaiming these new elites and the systems that legitimated them (Nagao 1989). It is of great interest that a significant part of the symbolism was shared among many of these elites, while at the same time a certain regional identity was imposed on the art and architecture. This is true of El Tajín, as it is of several other capitals across Mesoamerica at the time (Diehl and Berlo 1989; Ringle 2004).

The decoration of these city centers has been likened to political billboards, but this is a static characterization of what was a dynamic area, with numerous rites enlivening these spaces and interacting with the permanent carved messages on the buildings (Fox 1996; Kowalski 1999:11). These sculpted stories are concerned above all in presenting various rituals enacted in the same spaces. El Tajín is particularly rich in narrative sculpture that speaks directly to the presentation of these rites. In this respect the city's public sculpture is similar to the contemporary public art and writing of the Maya (Schele and Miller 1986; Reents-Budet 1989; Stuart 1998). That said, the presentation of ritual on El Tajín's public monuments should not be conceived as simply reflecting ritual practice. Recent scholarship on Mesoamerican ritual imagery reminds us that many choices were made as to which rituals were to be depicted and how (Quiñones Keber 2002; Herring 2005:42–45), decisions that should be kept in mind as we examine El Tajín's imagery of ritual throughout this book (see especially Chapter 5).

If we are to see El Tajín in the context of the Epiclassic period in Mesoamerica, then it may be helpful to explore how we came to think of the Epiclassic as a period and what are perceived as its major characteristics. Many Mesoamerican scholars, and virtually all those working in the Maya area, use the terms "Late Classic" and "Terminal Classic" to refer to the period under discussion. This works well in the Maya area, where there is a much stronger continuity between the first and second half of the millennium, with only the "Terminal Classic" (ca. AD 800–1000) seen as the sort of disruptive period normally associated

with the Epiclassic to the west. Radical changes in settlement, trade, and style patterns happened earlier in western Mesoamerica, however, with major shifts beginning by the sixth to seventh centuries AD. The rise of El Tajín as a key center was one of these shifts, and the Epiclassic may be best characterized as the period in which these transformations came into being and matured throughout much of western Mesoamerica.

Initially the Epiclassic was seen as a transitional period between the peaceful, theocratic Classic (to ca. AD 650) and the more militaristic Postclassic (after ca. AD 900; Jiménez Moreno 1959). Later scholarship, however, has shown conclusively that the Classic period was not without militarism and conflict, suggesting that if the Epiclassic was transitional, the transition was not between periods of peace and conflict.[4] Thus while it was clear that settlement, stylistic, and other patterns shifted during this period, there was no longer a grand historical narrative to make sense of these changes. More recently, Webb (1978) proposed that trade, not conflict, was at the heart of the Epiclassic transformation: Classic societies traded items central to religious practice in a relatively peaceful setting, whereas Epiclassic capitals such as El Tajín were involved in more militaristic trading ventures focusing more on secular or luxury trade items. The emphasis on Epiclassic trade among these emerging capitals, and its relation to militarism and other aspects of the period, continues to be a topic of debate (Ringle et al. 1998; Ringle 2004:213: Sugiura Yamamoto 2001).

Despite the importance of the Epiclassic context for the rise of El Tajín, the city did not exist only in the rather rarefied air of these rising Epiclassic capitals. It was the hub of a region that had long been inhabited but had remained largely peripheral to Mesoamerican history. While we know too little of this regional culture and its workings, strong evidence suggests that El Tajín built directly on the earlier regional culture (Wilkerson 1972; Pascual Soto 1998). In addition, we now have evidence for a regional sculptural tradition that is directly ancestral to the Epiclassic Tajín flowering. The regional context is an important consideration when examining the problem of style in El Tajín and its relation to other Epiclassic centers. Much has been written on the "eclectic" nature of Epiclassic art, with its

ability to borrow both graphic practices and symbolism from throughout Mesoamerica (Kubler 1980; McVicker 1985; Nagao 1989). Although El Tajín may have appropriated a number of symbols circulating during the Epiclassic, the style employed, when viewed from the perspective of the earlier regional tradition, is largely an indigenous development and shows little if any of the conscious stylistic appropriations often cited for other Epiclassic capitals such as Cacaxtla and Xochicalco. This history of regional sculpture is presented in Chapter 3, while below we describe the center of the city as it was during Tajín's Epiclassic apogee.

Introduction to the Urban Core

The center of El Tajín (Fig. 1.2), which contains all the major architectural and sculptural programs, is located among the rolling hills that are typical of this part of the Veracruz lowlands. There is a steady decline in elevation from north to south, going from 200 to 140 m above sea level. The architects of the site artificially modified the upper portions of the monumental center to contain the Mound of the Building Columns and the Tajín Chico areas (García Payón 1954). The rest of the center, referred to as the lower monumental center, sits in the valley floor, which opens only to the south.

A wealth of sculpture adorned the buildings of the monumental center. This book focuses on the meanings of that sculpture and how those meanings would have been experienced by specific audiences. This is not to say that the book is a catalog of the literally hundreds of panels, stelae, and architectural friezes at the site. Two fine, complete catalogs have already been produced (Kampen 1972; Castillo Peña 1995), and there is little reason to go over yet again every sculpture in this fashion. Instead, this book treats at length the three richest, most important sculptural programs adorning what are widely regarded as the most important public spaces in the monumental center: the Pyramid of the Niches/Central Plaza ensemble, the South Ballcourt, and the Mound of the Building Columns complex (Fig. 1.2). In this respect the book is a sustained examination of a restricted set of ancient monuments.

The majority of the book looks at what can be gleaned from the iconography of the sculptural programs in a reading of motifs, relations, and finally narratives.

A pre-Columbian person approaching El Tajín at its pinnacle would have seen a city of 15,000–30,000 people (Brüggemann 1991:104; Brüggemann et al. 1992:62) spread over 1,000 hectares or almost 4 square miles (Ortíz C. and Rodríguez 1999:103). At its center was a monumental ensemble of pyramids, ballcourts, and palaces that covered more than 10 percent of the city (Brüggemann 1991:81; Fig. 1.2) and was delimited by two small streams flowing from north to south, beginning on either side of the upper portion of the center. House mounds dating to Tajín's florescence ring the center, continuing into the hills that encircle the site (Krotser and Krotser 1973:181).

Much of the lower monumental center is organized into plazas formed by pyramids surrounding a central space. Just off these plazas, the builders of El Tajín placed one or more ballcourts. Eleven courts have now been documented for the monumental center, giving El Tajín one of the highest concentrations of ballcourts in Mesoamerica. All of these are found in the lower center; in Tajín Chico, in the upper center, the buildings take on an administrative/ceremonial character (Sarro 2001). Many of these public buildings in both areas were decorated with full-figure sculptures, relief panels, and elaborate mural paintings. The corpus of art at the site is still growing, for the study of El Tajín is ongoing, and we are still discovering major sculptural pieces and even entire mural programs.

Only recently, in the last quarter century, have we been able to piece together a vision of the city. Early European and Mexican explorers did not consider El Tajín a city, but a single, isolated pyramid (Ruíz 1785). The Pyramid of the Niches, as it has come to be called, is indeed one of the most beautiful, elaborate, and important buildings at the site. Its architectural complexity entranced the world for more than a century after its discovery, with several famous European explorers producing renderings of the building (Fig. 1.3). The combination of niches constructed of numerous separate blocks of stone surmounted by an emphatically projecting cor-

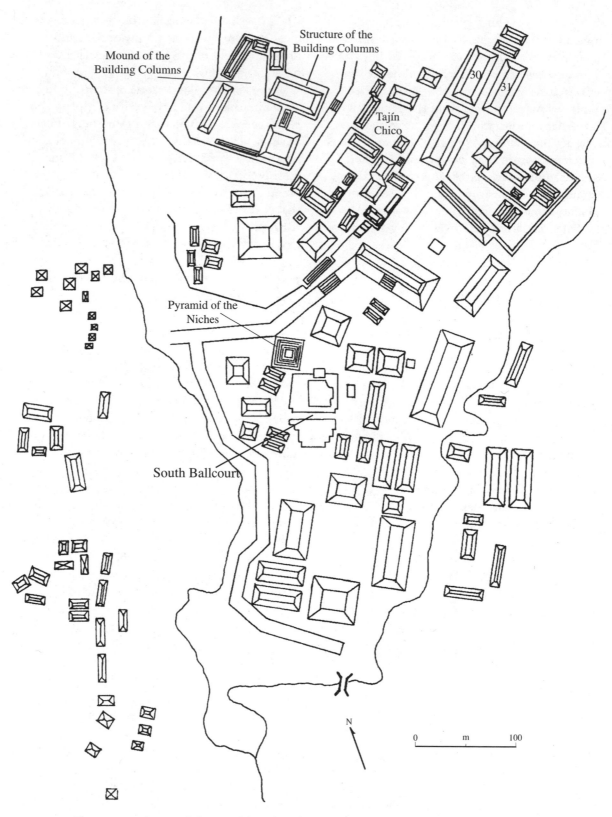

Mound of the
Building Columns

Structure of the
Building Columns

30

31

Tajín
Chico

Pyramid of the
Niches

South Ballcourt

N

0 m 100

FIGURE 1.2. The monumental center of El Tajín and the sculptural programs discussed in the text. Map by the author after a modified version of Ladrón de Guevara 1999:19.

nice (the "flying cornice"), seen to greatest effect in this building, was to become the sine qua non of Tajín architectural style. Throughout the nineteenth century, the Pyramid of the Niches served as the sole major example of that style, while the culture from which the pyramid sprang, like the city that surrounded it, remained almost completely unknown. Given the paucity of archaeological information coming from the region and the lack of any other documentation apart from the growing number of decontextualized portable stone objects, this is hardly surprising. Even when archaeological investigations began in earnest in the first half of the twentieth century, the lack of a regional context for understanding El Tajín continued to be a major problem.

It is now clear that at the time of its apogee El Tajín would have been the largest and most populous urban center in the north-central Gulf lowlands (Wilkerson 1999; Brüggemann

2001a:377). As Tajín's power grew towards the beginning of the Epiclassic, other, smaller centers within 30 km of the site adopted the Tajín practice of building in stone, as well as its architectural style (Jiménez Lara 1991; Wilkerson 2001b:652), as did cities as much as 80 or 100 km to the west, such as Yohualichan on the flanks of the Sierra Madre (Fig. 1.1; Pascual Soto 1998:28–30).[5] Kubler (1973) has posited that the niche and flying cornice, elements diagnostic for Tajín architecture, were marks of Tajín identity wherever they were found.[6]

Throughout this region of Tajín architectural style, the ceramics used during this period are much like those found at El Tajín (García Payón 1971:532; Daneels 2004), suggesting that the architectural style signaled a deeper affiliation. The *palma,* an especially complex, portable carved stone object with decoration strongly reminiscent of Tajín art, also marks this region and joins

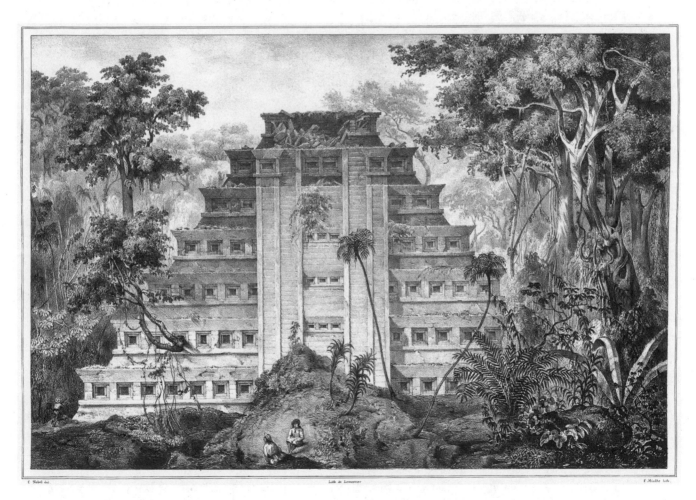

FIGURE 1.3. Pyramid of the Niches, El Tajín. After Carl Nebel 1836: Plate 5.

it to the highland traditions just to the south, around Xalapa, Veracruz. Daneels (2004:421) has defined a ceramic sphere that encompasses this larger region but suggests that these ties were more general than those seen in the heartland of Tajín's architectural style.[7] The art and material culture of these peripheral sites indicate close Tajín ties in some elements (e.g., painting styles and rites depicted), but they also exhibit important differences (different ceramic figurines and a lack of flying cornices in the architecture) that suggest less intimate political and social relationships (Headrick and Koontz 2006:195). This book will examine some of these relations as they reveal themselves in the iconography, but for the moment one can safely envisage the smaller corridor of Tajín-related architecture as the Tajín polity or realm, with the ancient city at its center as the capital (Fig. 1.1).

Although the Tajín realm may be relatively well defined on the basis of architecture and material culture, little is known about the people who inhabited that realm. Ceramics were the principal means used in the past to identify the Tajín people and have also been the chief evidence for dating the site and exploring its relationships with other Mesoamerican centers. All this is quite a bit for the ceramic evidence to bear, as we shall see, and it suggests that a close examination of the ceramics will be repaid with a better understanding of how El Tajín has been constituted as a culture.

Ceramics: The Dating and Ethnicity of Tajín

Wilfredo Du Solier (1939, 1945) published the first systematic studies of Tajín ceramics. His stratigraphy came from several test pits in the west part of the site (Du Solier 1945:148), especially from one midden found in the extreme west of the monumental center, near the arroyo (Du Solier 1939:25). All other observations seem to be based on surface finds and earlier collections. The fact that he was unable to systematically compare his test pit stratigraphy to the fill in buildings, leaving the latter to be dated on style and a priori assumptions about urban development, was a situation that plagued Tajín archaeology until the Proyecto Tajín's systematic study

of the ceramic fill in six of the ballcourts in the late 1980s (Raesfeld 1990, 1992), and one that continues to plague buildings outside the ballcourt study.

Du Solier created type categories for both the sherds (1939:27–29) and the figurine heads (1939:36), which he was able to associate with specific areas of Tajín. These correlations have not been discussed since and may still prove to be interesting. For example, Du Solier associated Polished Black Relief ware with the Mound of the Building Columns, where he found "hundreds" of these relief vessels carved with the "13 Rabbit" glyph, which he interpreted as a date (1945:155–156). He associated "captive taking" vessels with Tajín Chico, as well as a certain type of Fine Orange ware with pre- and post-fire grooving that he found in the top portions of his trenches in the site's western extremities. It is largely on this evidence that Tajín Chico is placed late in the architectural sequence (1939:31).

To date the site, Du Solier created three rough stages of Tajín ceramics and concentrated on the outside relationships of the Polished Black ware to other sites in Mesoamerica. He saw a relationship between what he defined as early Polished Black with Teotihuacan II or early III ware. This connection was one of the main pieces of evidence used to date Tajín as a Classic period site, although as Brüggemann (2004) later pointed out, it ignored the larger context of the Tajín ceramics in favor of a simple correlation. Put another way, Du Solier had no proof that the Tajín ceramics were found in stratigraphic situations comparable to the Teotihuacan pieces. This problem would crop up each time a ceramic relationship with Teotihuacan was attempted. In a later essay, Du Solier (1945:190) posited that there was no direct Teotihuacan influence at Tajín, and that any characteristics of the former site were "passed through the sieve of Huastec culture" before arriving at Tajín.

Paula Krotser (in Krotser and Krotser 1973) extended Du Solier's typology, did more trenching to establish a ceramic sequence, and also performed an intensive surface collection. Again the attempt was made to link Teotihuacan and Tajín through the Polished Black ceramic type, called here Terrazas Lustroso. This study suffered from the same lack of context as Du Solier's (Brügge-

mann 1992a:29, 2004), namely that the Tajín ceramics were not found in contexts that showed other firm Teotihuacan relationships. Not only were they found in different stratigraphic contexts, but at Teotihuacan these ceramics were a luxury ware, whereas at Tajín they were a domestic ware (Yarborough n.d. [1992]:244–245). More generally, Krotser was able to tie the ceramics of Tajín to both the Huastec and Totonac ceramic spheres, and she noted that close relationships existed between Tajín and the nearby lowland site of Las Higueras as well as the highland Puebla site of Xiuhtetelco (see also García Payón 1971:528). The former contains murals in a style that can now be seen as related to Tajín (Sánchez Bonilla 1992; Morante López 2005).

Krotser's ceramic work was done about 2 km south of the central monumental zone, in groups of house mounds that the author designated as somewhere between those of the common farmer and those of the city's highest elite. Through these important early investigations of the periphery of Tajín, done in conjunction with Ramón Krotser, the authors were able to demonstrate that El Tajín was truly urban and not a largely vacant ceremonial center. That said, the work did little to clarify the architectural sequence at the heart of the site.

At approximately the same time that the Krotsers were working south of the center, S. Jeffrey K. Wilkerson was exploring the nearby site of Santa Luisa, where he was able to construct the first complete ceramic sequence for the region and anchor it at least partially to radiocarbon dates (Wilkerson 1972, 1979, 1980, 1987a, 1990, 2001b). This regional chronology, in which the apogee of El Tajín is dated to the La Isla A (600–900) and La Isla B (900–1100) phases, has been critical to all later work in the region. Because Wilkerson could not correlate this information systematically with a large majority of the buildings at Tajín for lack of comparable material in good archaeological context, its usefulness remained marginal to constructing a chronology for the site proper.

Although the large amount of data on ceramics gathered in the 1960s and 1970s could not be applied to a chronology of monumental buildings at the site core, it was often used to defend or demolish hypotheses on the identity of the Tajín people. The great majority of scholarship on the city's inhabitants argued for one of two principal candidates: the Totonac (García Payón 1963) or the Huastec (Du Solier 1945; Wilkerson 1972, 1979). While north-central Veracruz sported a multiethnic population when the Spanish arrived, the Totonac were the dominant group in the area and thus the first candidates for building the much earlier city; however, ceramics associated with the Totonac are distinctive polychromes that do not appear at Tajín until late in the sequence, thus disqualifying the Totonac as we know them archaeologically from founding the city. Despite the ceramic evidence indicating that the Totonac arrived late in the sequence, García Payón (1963) saw the proof of Totonac identity for Tajín in colonial accounts of the historical movements of the Totonacs into this area that claimed a much earlier arrival, in the middle of the Classic period (ca. AD 300–400). This is possible only if one posits the different ceramic assemblage at that time to also be Totonac, which is what García Payón did (1963:245). In short, the Totonac identity hypothesis has a very weak basis in the material evidence, and the colonial records on which it is based provide a shaky foundation (Ramírez Castilla 1995).

Using ceramic evidence instead of colonial records, Wilkerson constructed an important argument for El Tajín as a Huastec site. He noted, as did Du Solier before him, that several very early (ca. 1000–300 BC) ceramic styles and figurine types are shared between the Tajín region and the area immediately to the north (Wilkerson 1979:40–41). This northern Gulf region has long been associated with the Huastec Maya, and it was hypothesized that these northern ties indicated a deep stratum of Huastec culture in the Tajín region. Recent archaeological finds in the Nautla River valley just to the south of Tajín have significantly changed this view of early Tajín affiliations. It is now clear that by ca. 300 BC a culture separate from that to the north had developed in the Tajín region and Nautla Valley (Wilkerson 1994, 2001a). By Tajín's Epiclassic apogee, the Huastec area to the north was a distinct ceramic sphere (Daneels 2004:421). Thus neither the Huastec nor the Totonac have definitive claims to the culture of Tajín.

Although it is difficult to assign a specific lan-

guage or ethnic identity to El Tajín, the archaeological and artistic evidence is more easily related to other regions and spheres. As noted above, regional architectural styles and ceramic assemblages indicate a close-knit north-central Gulf lowland sphere during the period of Tajín's apogee. Fundamental traits of the Tajín art style indicate even wider Gulf relations. The widest sphere that has been clearly related to El Tajín is that of the Classic Veracruz style, which Proskouriakoff (1954) defined through the use two motifs: the scroll and the raised double outline. The sphere's definition in terms of stylistic practices, as opposed to reconstituted ethnicities, means that Classic Veracruz continues to be a productive, although debated, category. Refinements to Proskouriakoff's initial definition of the sphere show that the particular scroll style used at Tajín is indicative of later developments in the style of the northern half of the central Gulf lowlands (Stark 1998). It is especially close to the work seen on *palmas,* an elite sculptural form that is also specifically associated with the northern portion of the Classic Veracruz style sphere.

With a stalemate on the question of ethnicity, and rather impressionistic methods of dating the monumental center, the next phase of research into Tajín ceramics, chronology, and ethnicity began in 1983 with the launching of the Proyecto Tajín. During this massive project, the largest by far to date, little interest was shown in the ethnicity of the city's residents, but the question of dating consumed a significant portion of the project's resources. Several researchers came to the conclusion that any settlement before the Epiclassic period (ca. AD 650–1000) had been rather small, and that the apogee of Tajín may have been as short as three centuries (Brüggemann 1993).

To explore the question of chronology further, Raesfeld (1990, 1992) excavated test pits in six of the ballcourts, obtaining a comparative sample of more than 3,500 sherds. All six ballcourts proved to have the same fill, and surface collections at others suggest that all were constructed in a very short time. Furthermore, ceramic types that had been used to distinguish a Late Classic and an Early Postclassic phase were mixed in all the ballcourts, suggesting that these types may not be chronologically diagnostic, a problem

that Wilkerson had already touched upon in his work at Santa Luisa. At the same time, Brüggemann (1993) telescoped the history of the site to the time span between AD 850 and 1150, finding no basis either in the architecture or the ceramics for any building that García Payón attempted to date as earlier. Lira López, in her published dissertation on Tajín ceramics (1990), notes little chronological development at all in the ceramics, following the results of Brüggemann and Raesfeld. Both Brüggemann and Lira López place what appears to be the compressed apogee period in the ninth to twelfth centuries on the basis of a radiocarbon date.[8]

Despite the problems with chronological control at the beginning and end of the sequence, the important work of the Proyecto Tajín on Tajín chronology focused researchers on the rather short period of Tajín's apogee and the Epiclassic connections during that time. In arguing these points, and especially the initial date of AD 850, the Proyecto workers chose to ignore the earlier regional work of Wilkerson (1972), which showed that apogee-period ceramics found outside the center could be dated to the period between 600–1100, with these dates anchored to a more substantial series of radiocarbon dates than that used by Brüggemann and Lira López in the center.

While the above information is crucial to situating the city of Tajín in space and time, the focus of this book is not the city as a whole, but the three programs of public sculpture erected at its center. Since all three of these programs have been known and studied for some time, any study of the iconography of Tajín comes with a certain set of interests and assumptions. As we will see, these assumptions, and the debates they have generated, often have a direct effect on how scholars view Tajín's place in the greater Mesoamerican world.

The Study of the Imagery

Ellen Spinden (1933) was the first scholar to write at length on the imagery of El Tajín, and to help make sense of its figures and symbols, she turned to current understandings of Aztec imagery. This was a natural strategy. Not only did the Aztecs

leave a voluminous body of art that had already been studied seriously for more than half a century, but they were also the subject of the finest ethnohistorical materials in Mesoamerica in the body of work by Sahagún and others. In addition, the greatest iconographer of the nineteenth century, Eduard Seler, used these Aztec materials almost exclusively to construct the first wide-ranging and coherent view of Mesoamerican iconography. Thus by the late 1920s, when Spinden began her work at Tajín, there was a venerable tradition supporting the use of Aztec analogies in examining other Mesoamerican symbol systems.

Although she analyzed a wealth of Tajín sculpture using Aztec analogies, Spinden did not have access to a single complete sculptural program; however, she did have access to four of the six monumental panels of the South Ballcourt. From these images, Spinden posited that the ballcourt sculptures depicted the initiation rites of a young warrior into a military cult with solar symbolism. Significant to all later scholarship were Spinden's (1933:256) identification of ballcourt sacrifice in the northeast panel (Fig. 3.8) and the association of this iconography with the Great Ballcourt of Chichén Itzá.

José García Payón, who followed Spinden and who for over three decades was the head archaeologist at El Tajín, was especially intrigued by the iconography of the South Ballcourt panels. On one level, García Payón largely accepted Spinden's hypothesis that the panels represent the initiation of a warrior. He introduced another layer of symbolism by identifying the South Ballcourt as a *citlaltlachtli,* or constellation ballcourt, and the actors as sky deities or impersonators. On both interpretive levels, he continued to use Central Mexican analogies initiated by Spinden. When he wrote his first major essay on the subject (García Payón 1959), an important part of the program remained unknown. Soon after that essay was published, García Payón found the two central panels of the South Ballcourt. He interpreted the panels as depicting a pulque rite due to the presence in both scenes of the maguey plant, from which the intoxicating beverage is made (García Payón 1963). He eventually expanded this hypothesis into a large part of his last major publication on the site (García Payón 1973b:31–57).

H. David Tuggle (1968) was the first to publish and interpret as a whole the extensive imagery found in the Mound of the Building Columns program. In this important article he identified the scenes as a series of rituals, most of which involved human sacrifice. He linked several of the key scenes with imagery found in the lower monumental center, thus being the first to note the iconographic coherence of the site as a whole. Following Caso (1953), he showed that the glyphs inserted into the carved scenes named the figures. Tuggle suggested that the most important individual, named "13 Rabbit," was a historical ruler at the site.

Michael Kampen (1972) was the first person to publish a systematic study of the site's iconography as a whole. His book, *The Sculptures of El Tajín, Veracruz, Mexico,* was by far the most important publication on the imagery up to that time. In it he illustrated the entire known corpus of sculpture with careful line drawings that have proved invaluable to all later researchers. His iconographic analyses were placed in a synthetic chapter on the subject and in the descriptions that accompanied the catalog of the sculptures. In both places he dropped the interpretations of Spinden and García Payón, by then embedded in the literature, and instead carefully noted the basic vocabulary and syntax of Tajín iconography. He then linked these patterns to basic themes such as ballcourt sacrifice. Kampen was especially wary of direct analogies with later Aztec imagery given the significant differences in the organization, location, and historical position of the two cultures. He found the wide-ranging comparative method introduced by Spinden to be too impressionistic and too reliant on simple correspondences between Mesoamerican systems. This critique, together with superior documentation of the site's sculptural corpus, made Kampen's book indispensable to Tajín studies.

The work of the Proyecto Tajín has continued Kampen's documentary work and has also proven invaluable for iconographers. The recent catalog of sculpture by Patricia Castillo Peña (1995) and the monograph on works in all media by Sara Ladrón de Guevara (1999) contain extensive collections of new material as well as more-detailed reconstructions of old sculptures and murals that formerly had been known only as disconnected fragments. The latter work also contains a consid-

ered analysis of the global worldview evident in Tajín iconography.

Arturo Pascual Soto (1990) further systematized many of Kampen's observations. Throughout his book on the site's imagery he treats the elements of Tajín iconography as if they were Maya hieroglyphs, and he goes so far as to borrow the notational system that Thompson (1962) used to describe the glyphs. Pascual Soto's main objective was to generate a chronology for the sculptures by noting the historical transformations in particular iconographic elements in order to date the monuments and identify workshops. This goal may be opposed to the narrative reading that drove the earlier analyses. Pascual Soto's close attention to iconographic detail and archaeological context allowed him to establish for the first time several important groups of sculpture, including a much clearer idea of the public sculpture in and around the Central Plaza (Pascual Soto 1990:173).

At the same time, Wilkerson (1980, 1984, 1991) was involved in exploration of the narrative content of the South Ballcourt program, initiated by Spinden and García Payón. Synthesizing the work of the two earlier researchers, he linked Spinden's hypothesis on the meaning of the corner panels as warrior initiation rites with García Payón's interpretation of the pulque ritual of the center panels. In Wilkerson's analysis, the corner panels show the rituals leading to ballcourt sacrifice, which then produces the "response of the gods" in the form of pulque. He also expands on García Payón's astral symbolism, which he links specifically with Venus. Taking up Tuggle's thesis on the position of 13 Rabbit in the Mound of the Building Columns, he argues that one of the more important scenes (Fig. 4.4B) records the affirmation of this ruler's power.

Karl Taube (1986, 1988) has reinterpreted several important Tajín images by placing them in their larger Mesoamerican context. He is the first to apply such a wide-ranging comparative method to the imagery of Tajín since Spinden's initial article. Most importantly, he identifies the central panels of the South Ballcourt as an example of the cosmogonic imagery found throughout Mesoamerica (Taube 1986:56–57), and a main scene in the Mound of the Building Columns as scaffold sacrifice (Taube 1988).

The most sustained attempt to place Tajín iconography in its Epiclassic Mesoamerican context is that of William Ringle (Ringle et al. 1998; Ringle 2004). His focus is not on El Tajín per se, but on the shared Feathered Serpent symbolism used by Epiclassic elite networks throughout Mesoamerica. Ringle is particularly interested in the link between Tajín imagery and that of Chichén Itzá in the Yucatan, a relation first remarked upon in Spinden's original Tajín article.

Although they do not specifically treat Tajín imagery, López Austin and López Luján (2000) provide an important complementary model for shared Epiclassic symbolism, derived from a close reading of later ethnohistoric sources as well as analogies with later political systems. They base their model on an exegesis of the language of Zuyuá, an arcane elite language used in Contact period Yucatan, but which these authors argue has deep and broad roots in Mesoamerica. Especially important for this study is the recognition that elites would associate themselves both with the local patron deity as well as the more universal Feathered Serpent, the latter usually conceived as a combination of a quetzal (*Pharomachrus mocinno*) and a rattlesnake (*Crotalus* or *Sistrurus* sp.).[9] Like the Ringle model noted above, the Zuyuan model places Feathered Serpent imagery at the center of shared Epiclassic symbolism across the region, a theme we will explore as it pertains to Tajín. Both models attempt to explain the shared symbolism and the wide-ranging contacts of Epiclassic elites, two of the most pertinent and heretofore little understood aspects of Epiclassic elite art.

Both Epiclassic models play against a recent tradition of studying Tajín iconography that has steered away from analogies. To place Tajín in a Mesoamerican context, however, requires the judicious and frequent use of analogy. If the imagery of El Tajín is to be brought fully into the Mesoamerican fold, then the use of analogies with other Mesoamerican iconographic systems is the single most important issue in the study of Tajín's imagery. A major problem for any analogical argument is the lack of textual documentation on Tajín thought and religion. The major documents for the study of Tajín culture turn out to be the art and architecture themselves. This is the lot of the prehistorian, to be always searching

for relevant documents but never finding anything so immediate as the art and other aspects of material culture that the people themselves produced. Everything else—including documents produced by later cultures, as is the case with later ethnohistoric writings from the area, as well as the contemporary Maya writing and the iconographic statements of related Epiclassic capitals—is at some remove from the matter at hand. How to connect these documents with the iconography of Tajín has been and continues to be a major problem in Classic Veracruz studies, and one we will explore in its specifics as we examine the imagery.

In sum, the best treatments of Tajín iconography have always involved close, intrinsic readings of the imagery combined with analogies from well-documented Mesoamerican iconographic traditions. In the scholarship on Tajín before 1960, these analogies were drawn almost exclusively from the Late Postclassic Aztec tradition. Later authors have criticized the use of iconographic analogies from a culture that was organized differently, lived in a significantly different ecosystem, and followed the apogee of Tajín culture by 500 years. This revision of the use of analogy in Tajín iconography follows a wider trend in which the appropriateness of the Late Postclassic Aztec analogy was questioned throughout Mesoamerican studies (Kubler 1967). The Late Postclassic analogy had its defenders (Nicholson 1971), but even these admitted that indiscriminate use of Aztec materials seen earlier was no longer tenable. Instead, recent analyses have focused on finding analogies that are more specifically suited to the Tajín context for structural and/or historical reasons. Particularly important to this study are approaches that focus on the Epiclassic context of the imagery.

THE PYRAMID OF THE NICHES

As the earliest explorers did, we begin our investigation of the public sculpture of Tajín with the Pyramid of the Niches, and for good reason: Tajin's most important, widely accessible public space may be found in the adjoining Central Plaza, at the foot of the Pyramid of the Niches (Fig. 2.1). Not only is this space at the heart of the monumental core, but it is also one of the largest public spaces found anywhere at the site. Other large public ensembles of architecture and sculpture had important limitations on any potential audience: although sizable, the South Ballcourt's audience was limited by the form of the playing field and the relatively restricted vista created by the large framing architecture, while the Mound of the Building Columns program was deliberately made difficult to access and, moreover, contains a very small plaza from which to view the program. Other architectural groupings with similar access and on a comparable scale, such as the Arroyo Group near the southern end of the monumental area, do not have large amounts of monumental sculpture. Thus the Pyramid of the Niches/Central Plaza configuration may be characterized as a premier public space due to its ease of access, large size, and complex sculptural program. The presence of the Pyramid of the Niches (Fig. 2.2) is also indicative of the importance of this space: although fairly small by Mesoamerican standards (ca. 18 m high), the amount and quality of the architectural work in this building are unsurpassed at the site or, indeed, in the region. The niches that give the building its name are individual stone slabs that were fitted together and stuccoed to create the niches, and then capped by outsloping profiles called flying cornices. Recall that the combination of niche and flying cornice was so fundamental to monumental architecture at Tajín that wherever else

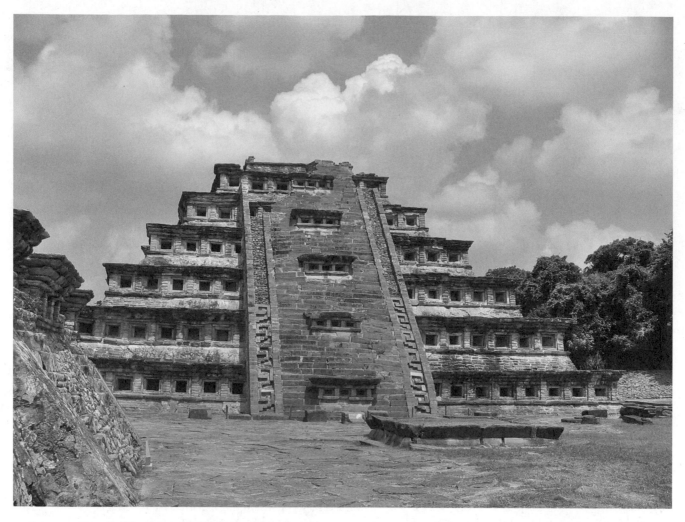

FIGURE 2.1. Pyramid of the Niches, El Tajín. Photograph by the author.

it appeared it would have indicated Tajín identity (Kubler 1973; Sarro 2004:335–336). The same architectural combination seen in smaller sites across the northern portion of the central Gulf lowlands during this period is surely indicative of the larger Tajín realm. Of the dozens of buildings in this region that contain this diagnostic configuration, the Pyramid of the Niches stands as the most detailed, elaborate expression of the architectural style (Reese-Taylor and Koontz 2001:16–17). The combination of a large public area, the most elaborately worked niche/flying cornice architecture, and a large and important sculptural corpus suggests that the Central Plaza space was critical to the definition of the monumental core. This chapter explores the role of the Central Plaza and the Pyramid of the Niches in that definition.

Although the Pyramid of the Niches has been the object of measurement, analysis, and description since the late eighteenth century, we know surprisingly little of its history. Some descriptions have referred to a previous building encased in the current structure, but the deep excavations that might have revealed substructures have either ended in collapsed tunnels soon after they were begun (García Payón 1951) or have yet to be fully published (Ortega 1988), thus leaving open the question of the building's early history. According to the most recent opinions, it may have been a single-phase construction, with the "substructure" glimpsed by García Payón (1951) actually functioning as the retaining walls of the current structure and not as evidence of an earlier plain pyramid (Brüggemann 1995:32).[1]

Attempts to explain the pyramid's function

and symbolism have treated both its architectural form and the iconography of the sculpture of the ruined sanctuary on top of the structure (García Payón 1951). This chapter explores the meaning of the building from a different angle. Because the Central Plaza is clearly the main area from which most people experienced the building, we will begin by examining the sculpture found at the foot of the pyramid, in the Central Plaza. Both the iconography and function of this group of sculptures suggest that rites centered on standards or banners were performed in this space. Similar rites using standards may be found represented in the imagery of other Epiclassic Gulf lowland traditions (see below) as well as elsewhere in Mesoamerica, including elaborately described standard rites at the central pyramid of the Late Postclassic Mexica capital. The Mexica saw the standard rites as re-creating the actions of the patron deity at a central sacred mountain, and thus viewed their central pyramid as a re-creation of that mountain. In conceiving of their central pyramid as a sacred mountain, the Mexica followed deeply rooted Mesoamerican patterns of imbuing central monumental architecture with the aura of sacred, mythologized locations, and below we will examine similar meanings for the Tajín pyramid. The main facade of the Pyramid of the Niches gives out on the clearly delineated space of the Central Plaza (Fig. 2.2). The plaza is defined on the north and south sides by Structures 4 and 2, respectively, and it is closed on the east by a side of Structure 3. While Structure 3 seems to be clear of any associated art, each of the two buildings flanking the Pyramid of the Niches in the Central Plaza (Structures 2 and 4) contained one piece of narrative sculpture.[2] Both of these sculptures depict rites that occur in architectural spaces associated with the Central Plaza and surrounding buildings, suggesting that the iconography of the two sculptures define key rituals enacted in or around the Central Plaza.

Structure 2 Panel: Ballcourt Decapitation

Of the two narrative panels directly associated with the Central Plaza, the panel from Structure 2 is the more straightforward and has gar-

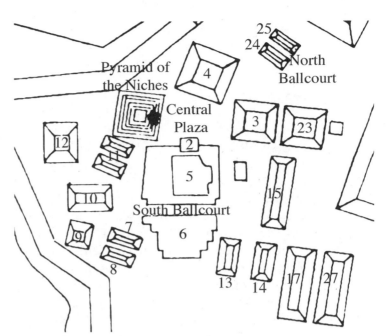

FIGURE 2.2. Plan of the Central Plaza and numbered structures at El Tajín. Drawing by the author after a modified version of Kampen 1972:5.

nered the most attention from iconographers.[3] The Structure 2 Panel is a trapezoidal sculpture with large areas of loss in the upper portion of the composition (Fig. 2.3). The central scene depicts two persons flanking an almost entirely destroyed central figure. The personage on the right wears a yoke and *palma* set around his waist. Both items are intimately associated with the rubber ballgame and surrounding rites

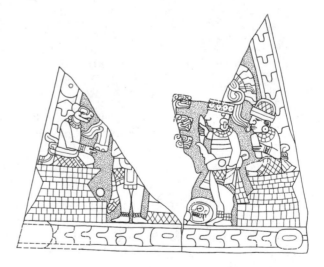

FIGURE 2.3. Structure 2 Panel, El Tajín. After Kampen 1972: Fig. 19a. Reprinted with permission of the University Press of Florida.

throughout the north-central Gulf lowlands. The figure holds a sacrificial knife in his right hand, and a ball with a skull inscribed in its center rests at his feet. The central figure is almost completely effaced, and only the lower portion of the personage on the left remains, revealing the same ballplayer skirt and train seen on the knife-wielding figure. The three central actors are flanked on the left by an anthropomorphic figure with a blunt-nosed zoomorphic head, probably feline, seated on an architectural motif, and on the right by a human seated on a mirror image of the same building type. These buildings form a profile view of a ballcourt, with the bench (near the feet of the players) surmounted by the sloping apron, which in turn is capped by a flying cornice. The two lower elements, the bench and apron, are typical of many Mesoamerican court traditions (Taladoire and Colsenet 1991: Fig. 9.1), but the combination of flying cornice, bench, and apron is more specifically associated with Tajín monumental architecture. The nearby South Ballcourt has just such a capping cornice on a flanking building that surmounts the ballcourt bench, suggesting that the action depicted in the sculpture took place in this area. Although the ballcourt architecture in the image is not depicted to scale, architectural features are often miniaturized in Tajín narratives. Further, similar outsize figures and miniature ballcourt structures appear in a panel from the South Ballcourt (Fig. 3.1), again suggesting that the Structure 2 Panel scene took place in this space, as Kampen (1972:38) and Wilkerson (1984:122–123) have suggested.

The relationship with the South Ballcourt is natural to this side of the Central Plaza. Structure 2 marks the transition from the Central Plaza space to the platform of Structure 5, which in turn becomes the northernmost wall of the South Ballcourt (Fig. 2.2), and in this way the image may be seen to be directly connected to that court.

Although clearly there was a central motif around which the composition turned, that motif is now lost. All that remain are the heads of three serpents facing the knife-wielding figure. These serpents are arranged much like those emerging from the necks of victims of ballcourt decapitation sacrifice in other Classic Veracruz imagery.

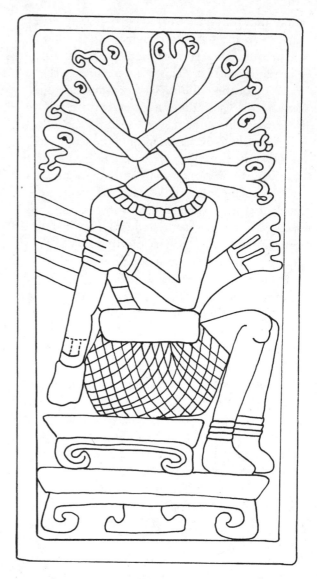

FIGURE 2.4. Serpent-headed figure on panel at Aparicio, Veracruz. Drawing by Daniela Koontz.

For example, a panel from the Aparicio ballcourt (Fig. 2.4) shows a seated figure with yoke, *palma*, and ballgame glove, but in place of the head, serpents intertwine and radiate from the neck, creating the same serpent-head pattern seen in the Tajín panel (García Payón 1949). Given the knife held by the figure to the right and the height and pattern of the serpent heads, the missing central figure in the Tajín panel may have been quite similar to the Aparicio figure (Tozzer 1957; Wilkerson 1991). The site of Aparicio is located farther south in the Gulf lowlands, in an area that produced other examples of this ballcourt decapitation imagery. A mural from the nearby site of

Las Higueras, although not in a ballcourt, shows the same seated, decapitated figure with yoke and *palma* (Sánchez Bonilla 1992:149; Morante López 2005:98). The ends of the serpents emerging from the neck are lost, but the serpent bodies are still evident. The figure is seated on a ball decorated in its center with a skull, a very specific motif shared with the Tajín panel, where it is found at the foot of the missing central figure. These close iconographic resemblances strongly suggest that there was a specific Epiclassic cult of ballcourt decapitation sacrifice throughout the Gulf lowlands, and that this cult was expressed with specific, highly conventionalized imagery (Wilkerson 1991).

Both the Aparicio and Las Higueras examples of ballcourt decapitation imagery occur in related Gulf lowland contexts, but specific elements of this imagery may be found much farther afield. The skull ball, seen in both the Tajín and Las Higueras scenes, is also the central motif of ballcourt decapitation representations at distant Chichén Itzá, where perhaps the closest analog to the incomplete Tajín image may be found. A comparison of the central figures in the Structure 2 Panel at Tajín (Fig. 2.3) with the central figures of the ballcourt bench panels from Chichén Itzá (Fig. 2.5) allows us to complete the Tajín com-

position (Kampen 1972:66; Wilkerson 1984:124, 1991:57; Taube 1994). Elements such as the ball-game gear, the sacrificial knife, and the skull/ball motif are all analogous in the two compositions. The serpent heads that face the knife-wielding ballplayer in the Tajín panel may be compared with those that spring from the body of the decapitated sacrificial victim shown in the Chichén Itzá example, again suggesting that the missing central figure in the Tajín example had serpents emerging from the neck.[4] Thus the missing figure in the Tajín composition may be seen as a victim of ballcourt decapitation sacrifice, and it is equally clear that at some point during the Epiclassic, sites along the Gulf and into Yucatan and Guatemala adopted a particular public imagery that featured images of this decapitation rite associated with the ballgame (Tozzer 1957; Pasztory 1972; Parsons 1969:102; Cohodas 1978; Ringle 2004:187–189). This widespread Epiclassic ballcourt decapitation imagery will be taken up in Chapter 3, where we explore ballcourt imagery of the South Ballcourt, but at this point it is important to note that ballcourt sacrifice is referenced in the Central Plaza via the imagery on this panel.

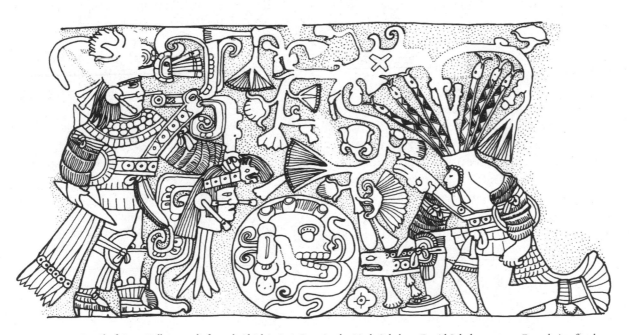

FIGURE 2.5. Detail of Great Ballcourt relief panel, Chichén Itzá. Drawing by Linda Schele, © David Schele, courtesy Foundation for the Advancement of Mesoamerican Studies, Inc., www.famsi.org.

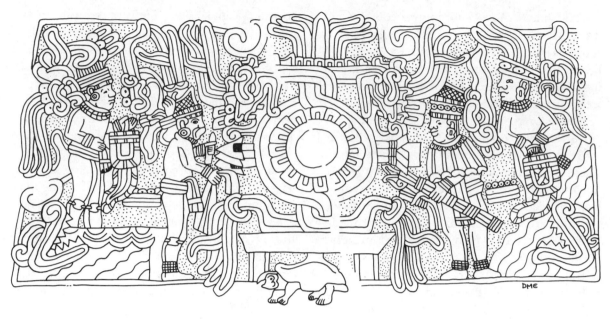

FIGURE 2.6. Upper surface of Structure 4 Panel, El Tajín. Drawing by Daniela Koontz.

Structure 4 Panel: The Raising of the War Standard

The other narrative panel directly connected with the Central Plaza is found on the opposite side of the space, on Structure 4 (Fig. 2.6; García Payón 1973a). The panel measures approximately 1 x 2 m and has a thickness of 20 cm. It is decorated on most but not all of its surfaces, suggesting a specific orientation that we will explore below. An elaborate scene covers one large surface, and scroll carvings line three of the sides. The large surface on the face opposite the figurative image was left blank, as was the side at the top of this drawing. A hole was drilled through the entire thickness of the center of the piece and neatly incorporated into the iconography, shown here in the center of the composition, surrounded by a raised circular rim and petaled motif. Given the placement of the carved faces, the panel must have been set horizontally against a wall, with the figurative scene facing upwards and the scroll carving on three of the sides facing outwards (Fig. 2.7). In this orientation, both the uncarved large surface and the one undecorated edge would have been invisible to the viewer, while all carved surfaces would have been visible.[5] The large, upward-facing surface of the panel contains the major narrative scene (Fig. 2.6). The symmetrical composition consists of

two pairs of figures facing a motif that covers the entire central portion of the image. The central motif is the key to this scene. It consists of a pole that grows from the back of a turtle and pierces an elevated base. Above the base, the feathered tails of intertwined serpents surround the pole and then divide, framing the circular motif in the center of the composition. As noted above, this circular motif consists of a petaled fringe surrounding an actual hole that was carved through the entire width of the stone. The necks of the serpents intertwine above the hole, ending in a feathered serpent head on either side of the composition. An arrangement of feathers surmounts the entire motif.

The same petaled, circular motif that sur-

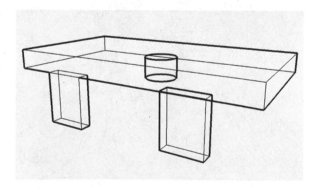

FIGURE 2.7. Possible placement of panel inside Structure 4. Drawing by the author.

rounds the central hole in the panel appears on the backs of warriors, ballplayers, and other celebrants at Tajín (Fig. 2.8). To the later Mexica these back devices were known as *tezcacuitlapilli*, back mirrors that were intimately associated with the warrior groups of the Mexica (Taube 1983:165). Taube (1992b:172–177) has shown the importance and ubiquity of back mirrors in Teotihuacan iconography and ceremonial dress, extending the antiquity of this important ritual item to the period of Tajín's apogee and earlier. In addition to examples from Teotihuacan, the author points out that these mirrors may be found in the iconography and burial furniture of Esperanza phase Kaminaljuyú and the contemporary Lowland Maya.[6] Other forms and uses of mirrors as ritual devices have been identified in earlier Olmec assemblages and iconography (Carlson 1981). Seler (1990–1998:6:89) long ago identified the back mirror as an important Epiclassic/Early Postclassic prestige item at Chichén Itzá. Beginning in the Epiclassic or Early Postclassic, many of these mirrors contained a pyrite surface with a turquoise rim. Earlier mirrors, like those found at Kaminaljuyú and Teotihuacan, were also pyrite or other reflective material, but extant examples from this early period lack the turquoise rim. At times these disks were fitted with an elaborately carved stone backing. Interestingly, the stone backing on several early examples, including one from Esperanza phase Kaminaljuyú, was decorated with Classic Veracruz style scrolls (Proskouriakoff 1954:74), a variant of which was employed later by El Tajín. This early example of a mirror with Classic Veracruz scroll style decoration suggests that the regional artistic heritage continually referenced by El Tajín had already developed the mirror as an important ritual object.

Thus far we may say that the central motif of the Structure 4 Panel consists of an elaborately framed mirror raised on a staff or pole. García Payón (1973a) identified the entire central motif (including the pole support) of the Structure 4 Panel as part of the "ballcourt marker" group, often referred to in the literature by its Late Postclassic Nahuatl name, *tlachtemalacatl*. The latter is not a freestanding monument, but a disk-shaped architectural element tenoned to the wall of the ballcourt. Sahagún (1950–1982, Book 8:29),

FIGURE 2.8. Figures with back mirrors. Detail of central column, Structure of the Building Columns, El Tajín. Drawing by the author.

writing on Late Postclassic Central Mexican practices, states that the device served as a goal in the rubber ballgame. Aveleyra (1963) identified a similar object depicted in use in a Classic period Teotihuacan mural in the Tepantitla apartment compound. Because assumptions concerning the nature and function of the Teotihuacan ballcourt marker have played such a crucial role in the interpretation of the Tajín panel, it is helpful to examine the evidence for the original readings. The Teotihuacan mural shows several players hitting a ball with a stick while other stick-wielders sing, speak, and gesticulate (Fig. 2.9a). Near these stick-wielding figures is an object consisting of a pole surmounted by a disk. This object is shown rising out of a platform, and the whole effect is not unlike the depiction on the Tajín panel, as García Payón recognized. Aveleyra further identified a stone effigy of this object in the La Ventilla compound at Teotihuacan (Fig. 2.9b), and two other complete stone effigies were later identified, one from an approximately contemporary context at the Maya site of Tikal (Fialko 1988).[7] The third object was found midway between these two sites, at the south Gulf lowland site of Piedra Labrada (Ortíz 1990:313). It is clear from the archaeological contexts, together with the representations, that the objects at Teotihuacan and Tikal constitute a meaningful object class, and by extension, the little-known Gulf lowland example at Piedra Labrada must also belong to this group. The analogy with the Nahuatl object class *tlachtemalacatl*, used by both Aveleyra de Anda and García Payón, has held up well on one level: the objects are related to ballgames and ballcourt ritual. On the other hand, the static

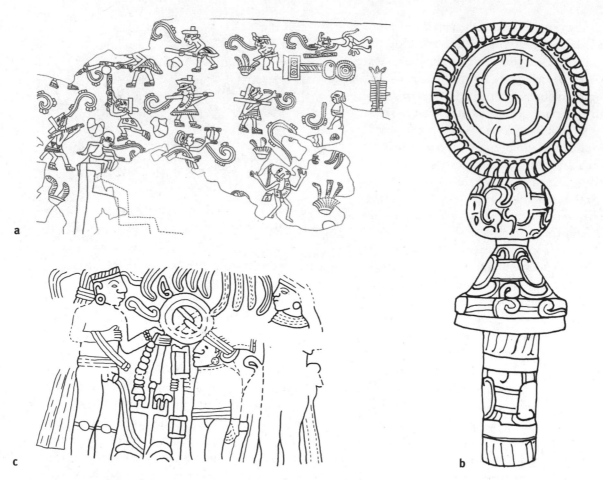

FIGURE 2.9. Depictions of the stick game and ballcourt markers/standards: *a,* detail of Tepantitla mural showing stick game with ballcourt marker, Teotihuacan (drawing by Jennifer Browder); *b,* La Ventilla composite stela, Teotihuacan (drawing by Linda Schele, © David Schele, courtesy Foundation for the Advancement of Mesoamerican Studies, Inc., www.famsi.org); *c,* detail of standard-raising rite on the south column of the Structure of the Columns, El Tajín (drawing by the author).

quality of the Late Postclassic *tlachtemalalcatl,* which was tenoned to the wall of the court, does not accord well with the wide range of contexts in which we find the device during the Classic and Epiclassic periods. These earlier examples are freestanding monuments erected on a platform, as in the Teotihuacan and Tikal examples above. Tenoned ballcourt rings do not appear until after the decline of Teotihuacan (Taladoire 2001) and are not found at El Tajín, in any earlier known Gulf lowland context, or in any Teotihuacan context.[8] Instead, these earlier, moveable devices are assumed to have served the same purpose as the permanent tenoned markers, thereby explaining the relationship of the moveable object to the ballgame in the imagery. These objects may very well have served as moveable markers of some sort in a specific variation of the Mesoamerican

rubber ballgame, as Taladoire (2003:319–320) has recently reconfirmed, but there is growing evidence that the objects had other functions as well.

Freidel, Schele, and Parker (1993:296–304) have convincingly argued that for the Maya these devices served as something akin to war standards in addition to any function on the ballcourt. The authors have identified depictions of the devices in scenes of warfare, such as the Late Classic Maya murals of Bonampak, as well as in what are warfare-related ballgame ceremonies (see also Uriarte 2006). In Bonampak Room 2, the battle scene is introduced by three participants holding standards of different colors and designs as the troops descend into battle (see Miller 1986:96–97 and Plate 2). These same standards appear in ballgame rites, such as the one illustrated by Coe

(1982:34–35), where two ballplayers are engaged in the game in front of a war standard that probably served as some sort of marker and/or trophy.[9] Further, the text on the Tikal stone effigy identifies the major rite enacted with this object not as a ballgame, but as a raising, or placing erect on a platform (Freidel, Schele, and Parker 1993:299). As argued below, the Tajín "ballcourt marker" shares important elements and contexts with these Maya standards and may be placed in the same category.

Although images of contemporary Maya standards show them in a number of contexts related to war and the ballgame, representations of standards at El Tajín show them exclusively as central ritual objects (Fig. 2.9c). This rare illustration of a standard in use at Tajín reveals several important traits of the object. The first is the structural similarity with the Structure 4 Panel standard, consisting of the pole surmounted by a circular disk. The disk does not have the petaled framing but does contain the same intertwined cord motif seen in petaled Tajín back mirrors (compare Fig. 2.8), pointing out the close relation between mirrors and standards at Tajín. Further, the standard is the center of what may be identified both here and elsewhere as a specific ritual involving male genitalia and maguey plants. The ritual context of Tajín standards in this program is discussed at length in Chapter 4, but it is important to point out here that standards do appear in Tajín imagery as objects that were held upright to serve as the focus of ritual.

By the time the Structure 4 Panel was carved, the manipulation of standards was already an old practice at Tajín, going back to what may be some of the earliest sculpture at the site (Cacahuatal phase, ca. AD 350–600).[10] In these early examples we see a frontal figure carrying a bag in the left hand and a standard in the right (Fig. 2.10a).[11] The surmounting disk here displays the same petaled frame seen in the Structure 4 Panel motif and in the Tajín back mirrors. The supporting pole is depicted more clearly than in the rather baroque Structure 4 example, where much of the support is hidden under the intertwined serpent motif. A very important panel, now in the Museo de Antropología de Xalapa, also exhibits this early standard rite (Fig. 2.10b). Here a single figure is shown holding a standard in the

right hand. Both the standard and its presentation are very similar to the early Tajín panel already discussed. When compared to the carving of the early Tajín piece, the handling of sculptural detail is much more assured in this example, especially in the numerous motifs in the headdress. These motifs are absent from the early Tajín example, but they arc crucial to the meaning of the piece and its relation to both Teotihuacan and later Tajín imagery. The figure's headdress (Fig. 2.11a) is defined in its lower portion by a rectangular frame that contains a central disk with two flanking zoomorphic heads. This configuration recalls headdress imagery from the apartment compounds of Teotihuacan (Fig. 2.11b), where a disk, here decorated with a skull and other symbols, is flanked by two profile serpentine heads. Another trait closely associated with Teotihuacan is the mosaic surface of the headdress, probably indicating that thcse headdresses were made of shell or other tesserae (Taube 1992a).[12] Note that the entire headdress of the Classic Veracruz figure is treated as a mosaic surface. As further confirmation of a close relation with Teotihuacan imagery, the figure wearing the headdress in the Xalapa museum example sports a mask-like face very close to the Teotihuacano norm. Given these close relations with Teotihuacan, it is worth pointing out that not only does the piece come from the state of Veracruz, but it also contains a Classic Veracruz scroll form (just to the right of the figure). Further, the iconography of a frontal figure holding just that type of standard is also firmly associated with the Tajín region's Cacahuatal phase (see Chapter 3), as is the panel format size and shape. In sum, the piece may be seen as an interesting blend of Teotihuacan imagery and style with very specific indicators of a Gulf lowland provenience and even some indication of ties specifically to the Tajín region.

Although there is no material evidence for a direct relation, some Maya monuments also have significant similarities to these early Tajín panels. Piedras Negras Stela 35 (see Stone 1989: Fig. 7), which is a later monument, contains a similar mirror disk and war-related serpent pair in the headdress, as well as the frontal figure holding the ceremonial pouch or bag in the left hand and a staff (here a spear) in the right. The Maya serpent (Fig. 2.11c) is not the mosaic war serpent of

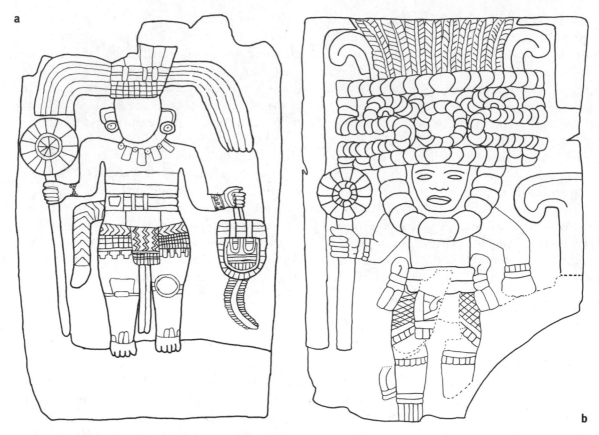

a

b

FIGURE 2.10. Standards in early Tajín region art: *a*, Arroyo Group Panel, El Tajín, probably Cacahuatal phase (ca. AD 350–600) (drawing by the author); *b*, Classic Veracruz panel resembling Cacahuatal phase works from Tajín region, Museo de Antropología de Xalapa (drawing by Daniela Koontz, courtesy Museo de Antropología de Xalapa).

Teotihuacan and the Classic Veracruz panel, but clearly a derivative motif, with a blade emerging from the open maw. As Stone (1989:158) notes, this mirror and blade-tongued serpent motif can be traced back to Early Classic Maya imagery, which would make it roughly contemporary with the Classic Veracruz stela and the Teotihuacan imagery. This may be a case of independent development of a common model, attributable to earlier Gulf Coast and Maya interaction with Teotihuacan. Such a reconstruction remains highly speculative, but we will return to the problem of the history of this iconographic complex in the final chapter.

Returning to the headdress of the Classic Veracruz figure and its central disk and flanking serpents, one may relate this imagery directly to a Teotihuacan cult of war, sacrifice, and fire centered on feathered serpent imagery (López Austin et al. 1991; Taube 1992a, 2000; Sugiyama 1993, 2005). The epicenter of this Teotihuacan

cult appears to have been the Feathered Serpent Pyramid (sometimes referred to as the Temple of Quetzalcoatl) at the center of that city. The cult is known principally through two bodies of evidence: the imagery of the temple facade and the enormous quantity of bodies and materials laid inside the building.

The Feathered Serpent Pyramid facade combines serpents and mirrors in ways closely related to, but not identical with, the Classic Veracruz panel. In what is now a well-rehearsed interpretation, the Teotihuacan facade (Fig. 2.11d) consists of repeating feathered serpents, all carrying the same mosaic headdress on their backs. Both the Feathered Serpent and the headdress emerge from petaled mirror disks, the latter very similar to those in the Classic Veracruz tradition, including the later examples at Tajín. The precise identities involved in this Teotihuacan cult (feathered serpent, mosaic headdress, and mirror) are still subject to debate (López Austin et al. 1991; Taube

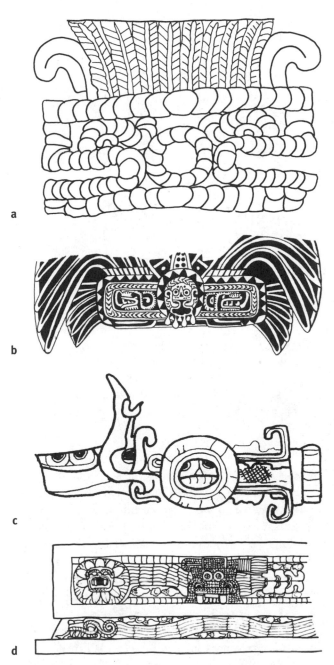

a

b

c

d

FIGURE 2.11. Headdresses with central disk and flanking serpent: *a,* detail of a Classic Veracruz panel (drawing by Daniela Koontz); *b,* detail of headdress in Room 10, Palace of the Jaguars, Teotihuacan (drawing by Daniela Koontz after Miller 1973: Fig. 47); *c,* detail of Piedras Negras Stela 35 (drawing by the author after Stone 1989: Fig. 8a); *d,* detail of Feathered Serpent Pyramid facade, Teotihuacan (drawing by Linda Schele, © David Schele, courtesy Foundation for the Advancement of Mesoamerican Studies, Inc., www.famsi.org).

2000; Sugiyama 2005:70), not least because the Teotihuacanos themselves seem to have debated the meaning and legitimacy of the Feathered Serpent Pyramid through a number of destruction, overlay, and looting episodes (Sugiyama 1998), and later developments throughout Mesoamerica melded local features and interests with aspects of the cult (Stone 1989; Taube 1992a, 2000; Sugiyama 2000).

Mesoamerican cults in general—and the Teotihuacan Feathered Serpent cult, in particular—may be characterized as dynamic sets of symbols and ritual practices that served to create shared religious, political, and economic institutions (Taube 1992a; López Austin and López Luján 2000; Pohl 2003; Ringle 2004; Sugiyama 2005).[13] Even with the understanding that such a central cult encouraged debate and conflict, and thus change, over the course of the Classic period and beyond, several basic characteristics identified by scholars appear to work well with the later variations on the cult as seen in the Gulf lowlands. The most fundamental is the Feathered Serpent as an extractor and donor of primary sacred forces and objects (López Austin 1993:238–240; López Austin et al. 1991:96; López Austin and López Luján 2000:38). This may have been literally true; workshops that produced the military hardware and other items associated with the cult seem to have been controlled by the state and were located nearby (Cowgill 1997:152; Carballo 2007). The Feathered Serpent as extractor is often pictured as carrying or presenting certain highly charged items. At the Feathered Serpent Pyramid we see a particular headdress carried on the body of the serpent (Taube 1992a), and other images at Teotihuacan have the entity bringing other headdresses (Sugiyama 2005:72). In one particularly important example (Fig. 2.12a), intertwined Feathered Serpents carry a headdress in a manner analogous to the Feathered Serpent Pyramid facade sculptures. At Tajín (Fig. 2.12b) the Feathered Serpent plays an analogous role as the extractor and donator of the mirror standard, which is comparable in function to the headdresses at Teotihuacan. Many of the precious goods associated with the Feathered Serpent have a martial aspect, and the Teotihuacan Feathered Serpent has been closely related to warfare (Taube 1992a). This is seen most clearly in the

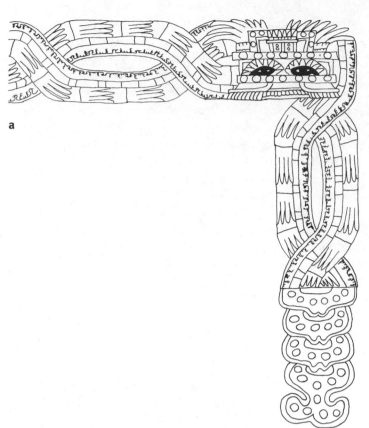

a

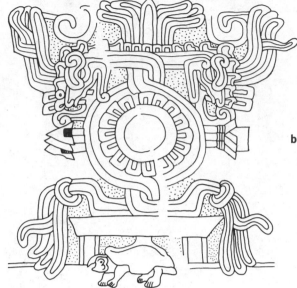

b

FIGURE 2.12. Intertwined Feathered Serpents bringing military gear: *a,* detail of mural with intertwined serpents and headdress, Tepantitla, Teotihuacan (drawing by Daniela Koontz after Miller 1973: Fig. 173); *b,* detail of Structure 4 Panel at El Tajín showing intertwined serpents and mirror disk standard (drawing by Daniela Koontz).

dedicatory sacrifices accompanying the construction of the building, in which 72 male victims were dressed as warriors before being dispatched. The figures may be identified as warriors on the basis of associated obsidian projectile points, trophy necklaces of artificial and real human maxillae and mandibles, and most important for this argument, slate disks worn on the small of the back (Cabrera et al. 1991:80). These disks are similar to the back mirrors seen in several areas of Mesoamerica from this time forward, including those represented throughout Tajín. At that site, a very clear iconographic reference relating the disk to warfare is seen at the very center of the Structure 4 Panel, where three atlatl darts or short spears cross the central mirror motif.

Taube (2000:274) associated the Teotihuacan Feathered Serpent cult to fire rites, citing both the fiery nature of several examples of the headdress figure and the use of fire by ritual celebrants related to the cult.[14] This relation is especially prominent at Tajín, where torches appear directly associated with standards in several contexts, including the central figure to the

right of the intertwined feathered serpents in the Structure 4 Panel discussed here. Related Classic Veracruz imagery also tends to emphasize this aspect of the cult. The iconography of the Soyoltepec stela, yet another panel from the Gulf lowlands associated with the Feathered Serpent cult, is emphatic in its relation of fire and the Feathered Serpent (Fig. 2.13). Here a figure is dressed in a serpent headdress, which in turn is surmounted by an elaborate feather headdress containing two burning torches (von Winning 1979). The figure holds another pair of burning torches, while below are numerous Classic Veracruz scroll forms of the type Stark (1998, 1999:148–149, 2001:339) has associated specifically with the south-central Gulf lowlands. In sum, the imagery of the Feathered Serpent Pyramid at Teotihuacan shares certain fundamental characteristics with what is identified here as the iconography of Feathered Serpents and mirrors in Classic Veracruz generally and in Tajín's Structure 4 Panel particularly. Given the discussion above, there appears to be a fundamental martial element in both programs, expressed mainly by

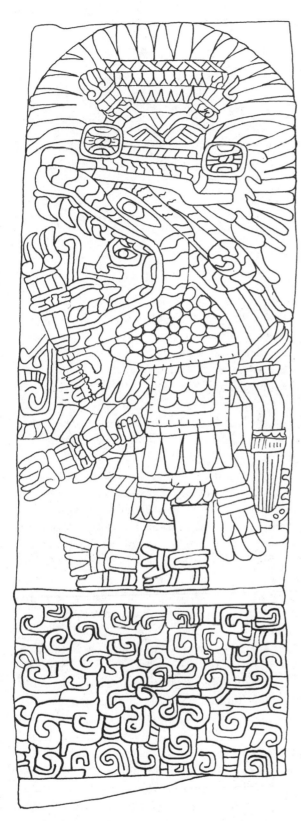

FIGURE 2.13. Soyoltepec stela (Classic Veracruz). Drawing by Daniela Koontz after Von Winning 1979: Fig. 24a.

rites associated with war and fire. The appearance of a highly charged object brought by the serpent is also central to both programs. Given our current understanding of the chronologies in the two areas, the primacy of the Feathered Serpent Pyramid at Teotihuacan is hard to ignore: when that building was constructed sometime around AD 200 (Sugiyama 2005:54), the site of El Tajín was a modest regional center (Pascual Soto 2004). Although avian serpents appeared in Mesoamerican art in the first millennium BC (Miller and Taube 1993:141), the Feathered Serpent Pyramid at Teotihuacan is the earliest instance of what is recognizably a Feathered Serpent cult (Nicholson 2001:397), and the working hypothesis among many scholars is that the imagery and ritual surrounding that building was foundational to Teotihuacan and the rest of Mesoamerica (López Austin et al. 1991; Taube 1992a; Sugiyama 2000:135–137, 2005:222; Nicholson 2001; Ringle 2004:214–215).

The Feathered Serpent cult seen at Teotihuacan eventually was appropriated by several groups of Mesoamerican elites. Scholars disagree on several aspects of the symbolism and the function of the cult in the appropriating communities, but it is becoming clear that once the cult was implanted in a particular area, the elite developed it to serve their own ends. In the Maya area, for example, particular Teotihuacano groups were associated with the spread of cult symbolism (Stuart 2000), while later Maya elites developed a specific variant of the cult for distinctly local and regional ends (Stone 1989). We are still investigating how and when it was appropriated by elites in the Tajín region and elsewhere in the Gulf lowlands, but sculptures such as the Classic Veracruz panel leave little doubt that it was. Given current evidence, it seems that the Tajín region was transformed in the Cacahuatal phase (c. AD 350–600) by its incorporation into a sphere centered at El Pital, in the nearby Nautla River drainage (Wilkerson 1999:132–135), and it is through that site and sphere that the imagery may have entered the area. There, too, it seems to have taken on specific regional characteristics. An important point of difference may be found in Teotihuacan's interest in headdresses associated with the Feathered Serpent, while Classic Veracruz appears to have been more interested in

standards associated with the cult. The iconography of standards is especially prevalent in the region around El Tajín.

With the exceptions of the stone effigies at Tikal, Teotihuacan, and Piedra Labrada, these standards do not survive in the archaeological record.[15] This is not surprising, for both descriptions and illustrations of these standards throughout Mesoamerica indicate that most were made of largely perishable materials, with an emphasis on elaborate featherwork (Uriarte 2006). Hundreds of examples of standards, shields, mantles, headdresses, and other examples of featherwork were sent to Europe at the time of the Conquest, but problems of conservation and centuries of neglect have reduced their number to fewer than ten pieces (Pasztory 1983:278–280). In addition to the stone effigies mentioned above, only one example of a probable standard, now in the Museum für Völkerkunde in Vienna, has survived. Standing over a meter high, it is constructed of feathers glued to maguey leaves and attached to a bamboo framework.[16] The feathers form a fringe around a central hole, just as the petaled rim encircles the depiction of the standard at Tajín.

Rites involving the manipulation of standards were important not just at Tajín, but throughout the contemporary north-central Gulf lowlands. The murals of Las Higueras depict at least two processions with standards (Sánchez Bonilla 1992; Morante López 2005:76, 116–117). The scene illustrated here is typical (Fig. 2.14). Instead of the central petaled motif seen at Tajín, Teotihuacan, and in the Maya area, most Higueras standards consist of a multicolored flag at the top of the staff. That difference noted, there are a host of similarities in the treatment of the objects as well as in the associated rites (such as the ballcourt decapitation scene in this program), suggesting that the difference in standard form belies close correspondences in standard rites between the two areas. Thus far we have identified a widespread iconography of standard rites in the Tajín region and beyond, and have linked these rites to earlier Classic period rites surrounding warfare. Specifically, we expanded the function of the former "ballcourt markers," which are also standards in contexts comparable to those on the Gulf, to include their manipulation in rites

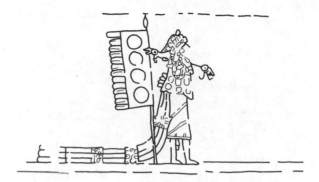

FIGURE 2.14. Mural scene in Structure 1, Las Higueras, depicting a standard rite. Drawing by the author after López Morante 2005:116.

of war. The main ritual action associated with these devices seems to be raising or erecting. We know from the inscription carved into the lower portion of the stone effigy standard from Tikal that these rites could include placing an object in a hole on a platform so that it could be raised upright (Freidel, Schele, and Parker 1993:299, 470). It is interesting to note in this context that both the Tikal and Teotihuacan stone effigies were found associated with a small platform with a central depression where the device stood upright, much as the object depicted in the Tepantitla murals. We do not have such a precise archaeological context for the Classic Veracruz example at Piedra Labrada, but it may be assumed that it too was raised or erected as a major ritual act. Recall that the Structure 4 Panel at Tajín contained just such a hole in the center of the piece, oriented to receive a standard (Figs. 2.6–2.7). In the illustration of the standard on this monument, the device seems to pierce the center of the bench in much the same way that a standard would pierce the panel itself. The hole in its center, as well as the illustration of what is probably the functioning base on its surface, strongly suggest that the panel served as a base for such a standard. This would explain several aspects of this otherwise anomalous sculpture: the horizontal positioning, the size, and the hole drilled through the middle of the stone, wide enough (17 cm) to serve as a steady base for a pole. The war standard represented in the center of the composition rises through this base, just as the physical standard would have risen through the central hole carved into the Structure 4 Panel itself. Both the func-

tion and iconography of the Structure 4 Panel, then, concern the raising of standards, as did the earlier effigy standards. According to García Payón (1973a), the panel was originally housed in the superstructure atop Structure 4. It would have been here, in this restricted space, that the raising of the standard would have taken place.

The Tajín rite involving standards was not limited to the superstructure atop Structure 4. Ringle (2004:183) noted a similar intertwined Feathered Serpent standard represented in the North Ballcourt, directly north of and adjacent to Structure 4 (Fig. 2.17c). Although this panel and others from the ballcourt with similar iconography have suffered significant areas of loss, one can clearly make out the basal turtle surmounted by the intertwined serpent tail, closely comparable to the motifs in the Structure 4 Panel. As we saw for the Classic Maya, these

Tajín standards are closely related to ballcourt ritual, although the heavy damage to this court's iconography and the absence of similar iconography in any other court make it difficult to be more specific.[17] Returning to the Central Plaza just to the south, there is yet more evidence for rites involving standards. Lining the foot of the Pyramid of the Niches on the Central Plaza side are more than a dozen monumental rectangular stone blocks (Fig. 2.15). Although these stones have always been considered enigmatic and were often ignored, they were certainly not an afterthought on the part of the designers: not only are they monumental, but the blocks are carefully laid out in a rather exacting row formation, with the three central blocks forming a triangular or hearth-shaped configuration. All contain carefully carved, deep holes of consistent diameter in the very center of their upper faces. The

FIGURE 2.15. Three of the fifteen bases for standards at the foot of the Pyramid of the Niches, El Tajín. Photograph by the author.

diameter of these holes is directly comparable to that found in the center of the Structure 4 Panel (ca. 20 cm compared to 17 cm) and would have been more than adequate to physically anchor a standard. If rites involving standards were documented in some of the earliest monumental art of the region, as argued above, and continued and expanded during the Epiclassic, as is argued here for the Structure 4 Panel and in Chapter 5 for other representations of standards, then it is very likely that these bases represent the architectural supports for such rites. Thus the iconography of the north and west sides of the Central Plaza, encompassing the foot of the Pyramid of the Niches and the summit of Structure 4, and probably the North Ballcourt just beyond, focused on the representation and performance of rites involving standards. Although the identification of an elaborate standard ritual as a chief Central Plaza rite is important, it raises the further question of the symbolism and social function of these rites.

In a greater Mesoamerican perspective, standards were one of several powerful objects that could be deposited at the base of pyramids. Sculpted figures able to support a standard are found both at the tops and bases of pyramids throughout Epiclassic Mesoamerica at sites such as Chichén Itzá and Tula. The foot of Structure 1 at the Epiclassic Maya site of Bonampak contains similar stones with central holes drilled for the reception of a standard, and the murals of the summit depict the banner rites discussed above (Miller 2001:215). It is possible that the Maya considered the stone stelae set at the base of their pyramids as somehow equivalent to these standards: the Classic Maya designation for these stelae, *lakamtun,* may be glossed as "great stone" or "standard (banner) stone," with *lakam* or a variant serving as the word for "standard" in several Maya languages (Stuart 1996:154). The linguistic association between standards and stelae, as well as the Maya penchant for commemorating the "raising" or "erecting" of both of these objects, suggests important correspondences in their meaning. Certainly both were imbued with powerful forces, and it appears that standards could be active participants in Maya military events (Bricker 1981; Freidel, Schele, and Parker 1993:327–334), just as stelae can be seen as vital

forces in the present (Stuart 1996). The "being" of Maya public monuments certainly deserves a more nuanced and detailed treatment than can be given here, but for our purposes it is enough to recognize the structural similarities between standards and stelae, both imbued with vital forces and acting on the spaces around them at the bases of pyramids.

An avenue for further exploration of the active forces at work in standards may be found in accounts of their associated rituals. The Mexica festival called the Raising of the Standards, or Panquetzaliztli, held yearly in the central ceremonial precinct of Tenochtitlan, re-created the paradigmatic war of this group's patron deity (León Portilla 1987). The descent of the patron from his mountain of birth and his immediate victory over his enemies were reenacted complete with ballcourt sacrifice and the raising of the standards—the latter two the same rites depicted in the Central Plaza of El Tajín. This conjunction of standards and ballcourt sacrifice suggests that perhaps other elements of the Mexica rites and the narratives associated with them may have some application to the Tajín case. Most importantly, during this ceremony the central pyramid of Tenochtitlan became a re-creation of the central sacred mountain of the deity's birth, suggesting that a fundamental trope used by the rite equated the central pyramid of the city with a key mountain in narratives of cosmic creation or ethnogenesis.

Snake Mountain Narratives

Since the dramatic rediscovery of the Mexica central temple in 1978 (Matos Moctezuma 1987), it has been shown that descriptions of the standard rites above were literally enacted at the base of the central temple, and that a substantial part of the meaning of these rites could be found in Mexica narratives and images concerning Coatépec, or Snake Mountain (León-Portilla 1987:50–61). Although the Snake Mountain narratives were created in the Late Postclassic by the highland Mexica, it is interesting to compare structural aspects of the narrative to the iconography found more than 500 years earlier at lowland Tajín. Some scholars have found the trope

to be a powerful organizing influence across Mesoamerican history (Schele and Guernsey Kappelmann 2001). The primary interest here is not in directly connecting the Tajín and Mexica cultures, but in teasing out certain fundamental patterns in Mesoamerican narratives concerning warfare and ceremonial space. These narratives are best and most completely known in their Late Postclassic or early Colonial examples, although their recording, largely by Spanish friars, presents its own set of interpretive problems (Gillespie 1989; Kellogg 2001). We will return to the problem of Postclassic analogies later, but what we will explore below is the possibility of a similar narrative structure regimenting both the Tajín and Mexica standard rites and their accompanying narratives.

Let us first examine the narrative context in which the standard rites were set for the later Mexica. The story forms part of the Mexica account of their own rise to power, told as a migration story. The Snake Mountain episode, and the closely related sojourn at Tollan, is contained in the account of their peregrinations throughout northern Mesoamerica and the eventual founding of their capital, Tenochtitlan. These accounts have been variously considered by researchers as histories, myths, or as a manipulative combination of the two (Boone 1991:139–140). Our concern is not with the mythic or historical nature of the content, but with the description of the architectural spaces they created at one of the early stops, and how those spaces may have expressed more widespread understandings of political legitimacy. Durán (1994:26) finds this to be a conscious Aztec strategy, and he refers to Snake Mountain as a "model" for the later capital of Tenochtitlan.[18] By this he means that the Mexica building types and their relationships received their meaning through the Snake Mountain story, summarized below.

On arriving at Snake Mountain, the Mexica built a temple for their patron deity, Huitzilopochtli. The god himself was given credit for building the adjacent ballcourt and skull rack. Huitzilopochtli then created a hole in the center of the ballcourt, called the *itzompan*, or Skull Place: "[Huitzilopochtli made] a hole in the middle, larger than a ball with which they now play the game, that is called *itzompan*, and then they filled it up halfway, leaving a triangle in the middle of the hole, which is called the well of water. . . ." (Tezozómoc 1878, Cap. II:228–229; translation cited in Leyenaar 1988:101).[19] From this Skull Place, water flowed to the crops that sustained the Mexica, who then settled in to farm and enjoy the fruits of their patron deity's creation of an agriculturally productive landscape. This paradise was not meant to last, however.

A group of Mexica called the 400 Southerners (Centzon Huitznahua) began to sow discord when they announced that Snake Mountain was the true ceremonial center and the final destination for the Mexica. Huitzilopochtli, angered at the hubris of this group, descended from Snake Mountain and sacrificed the 400 Southerners in the first war: "And Huitzilopochtli just then was born. . . . Then he pierced Coyolxauhqui, and then quickly struck off her head. It stopped there at the edge of Snake Mountain. And her body came falling below; it fell breaking to pieces; in various places her arms, her legs, her body each fell" (Sahagún 1950–1982, Book 3:2).

Tezozómoc (1992:35) located the sacrifice of Coyolxauhqui not on Snake Mountain itself, but in the Skull Place ballcourt below: ". . . and he [Huitzilopochtli] killed her in the ballcourt, and he decapitated her and ate her heart" (author's translation).[20]

After the physical birth and military victory of their patron deity, the well of the *itzompan* dried up, leaving the Mexica without food. Huitzilopochtli's victory was the first war of the Mexica and was treated as the paradigm for successful war, just as Snake Mountain was the paradigmatic monumental urban center. The myth thus expresses an understanding of the proper organization of military power linked directly to the shape of urban organization. These paradigms were viewed as so powerful that they were used to encode later military history, as Umberger (2007) has shown, when the 1473 war between former allies Tlaltelolco and Tenochtitlan was conceived through the structure of the Coatépec narrative.

The key moment in the Coatépec drama is the descent of Huitzilopochtli, which the Mexica conceived of as a hierophany, the birth of the physical body (*ixiptla*) of their patron deity

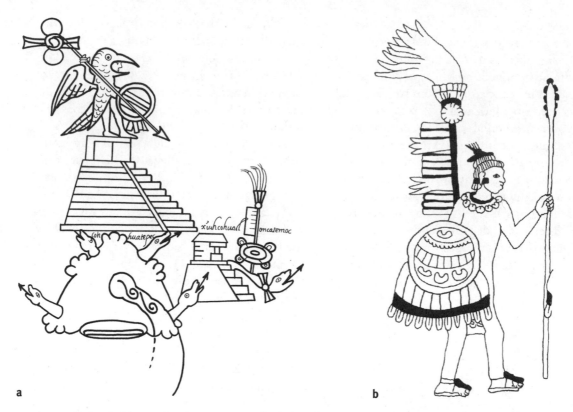

a b

FIGURE 2.16. Standards in Late Postclassic imagery: *a,* detail of standard raising at Snake Mountain, *Codex Azcatitlan* 11; *b,* detail of Aztec warrior with banner backrack, *Codex Mendoza,* fol. 67r. Drawings by Daniela Koontz.

(Boone 1991:134). The illustration of this event from the *Codex Azcatitlan* (Fig. 2.16a) shows a war standard raised at the foot of Snake Mountain as Huitzilopochtli descends. The standard, which resembles standards carried by the Mexica war captains in the *Codex Mendoza* (Fig. 2.16b), emerges from the back of the Xiuhcoatl, or Fire Serpent. Numerous standard-bearer figures were found in a deposit at the foot of the central pyramid at Tenochtitlan, where the texts locate the major Panquetzaliztli (Raising of the Standards) rites (Matos Moctezuma 1987:73). While the raising of the standard itself is not mentioned in the texts, it is clear from the codiacal depiction and the rituals surrounding this narrative that it was a crucial part of the story. In both ritual and myth the Mexica defined the foot of their sacred mountain, and its replica in stone, as the place of ballcourt sacrifice, standard raising, and war. We have already seen these same themes in the iconography of the two panels directly associated with the Central Plaza at El Tajín, with the Structure 2 Panel representing ballcourt decapitation sacrifice and the Structure 4 Panel repre-

senting standard raising and, by extension, war. In addition to these thematic similarities, at the foot of both the main pyramids is evidence for the performance of these standard-raising rites. El Tajín is exceptional in the richness of both the iconographic and archaeological evidence for these rites. Here we have drawn a specific analogy with Nahuatl materials because of the wealth of documentation on their ritual practices involving standards, but variations on the theme of the central mountain with standards and other critically charged bodies abound in several areas of Mesoamerica (Schele and Guernsey Kappelmann 2001). Most important to this argument is the identification of Tajín's Pyramid of the Niches as one of these central mountain pyramids. This is hardly surprising when one considers the amount of sculptural elaboration and the insistence on the trademark niche and flying cornice. We return to Kubler's (1973) original insight—that the niche and flying cornice were the architectural mark of Tajín identity—with the understanding that Tajín identity would be couched in indigenous terms. The building is an

exemplary case of the architectural style, suggesting its paramount status through the amount and quality of its decoration. In addition to these stylistic qualities, the building is placed in a central position in the indigenous narrative as the pyramid/mountain at the base of which the standards were raised. Thus in its decoration, placement, iconography, and ritual use, the Pyramid of the Niches is the central sacred mountain/pyramid of the site, analogous in several fundamental aspects to Snake Mountain of the Mexica and numerous other central mountain/pyramids in Mesoamerica.

The identification of the Pyramid of the Niches as the central mountain/pyramid at the site may help us understand the iconography of the figurative panels once installed in the now-ruined structure at the summit of the pyramid (García Payón 1951; Castillo Peña 1995:128–148). At least ten panels formed the original program, but all save one have suffered large areas of loss, and several are in a very fragmentary state. That said, an unusual number of deities are represented, all easily identified by the supraorbital plate that is diagnostic of this state at Tajín (Ladrón de Guevara 1999:107). This pronounced focus on the supernatural contrasts with the Central Plaza program and its chiefly human contingent of protagonists. Human protagonists are also the main actors in the other two major programs of public narrative sculpture, found at the South Ballcourt and the Mound of the Building Columns. That the summit panels from the Pyramid of the Niches concentrate on supernatural figures clearly sets it apart and suggests that the central pyramid/mountain was conceived as the seat of important deities and the place of foundational supernatural events, themes that run through the Mexica Snake Mountain narratives. A good example of the supernatural theme in the summit panels can be seen in Figure 2.17a. Here an

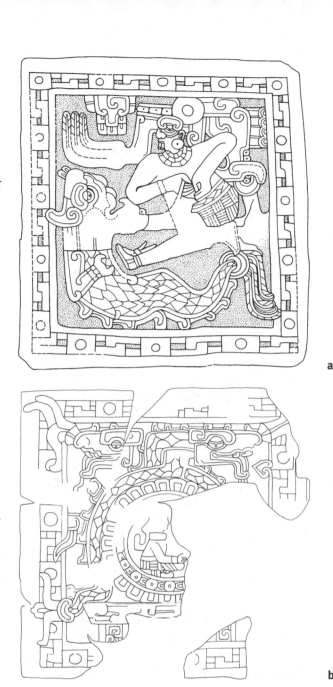

a

b

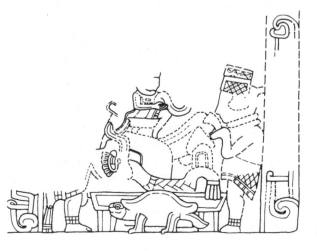

c

FIGURE 2.17. Panels depicting supernaturals at El Tajín: *a*, summit structure panel from the Pyramid of the Niches, after Kampen 1972: Fig. 6a (reprinted with permission of the University Press of Florida); *b*, Pyramid of the Niches summit structure panel (drawing by Daniela Koontz after Castillo Peña 1995: pza. 29); *c*, south-central panel, North Ballcourt (drawing by the author after Kampen 1972: Fig. 28b).

anthropomorphic supernatural, complete with supraorbital plate and protruding teeth, hovers over a limbed ophidian with a body marked with what elsewhere at Tajín are recognizable as feathers. While the upper figure may be identified by the fangs and supraorbital plate as what we will call the Principal Tajín Deity in the next chapter, the lower figure is certainly the Tajín version of the Feathered Serpent.[21] In another version of this beast from the same program (Fig. 2.17b), two identical serpents with feathers on their bodies and feathers protruding from their snouts rise from a base and intertwine in a fashion strikingly similar to the central motif on the Structure 4 Panel (Fig. 2.6) and what remains of a North Ballcourt panel (Fig. 2.17c). Note the same petaled disk in the center of the intertwined serpent as found in the Structure 4 Panel. Although the central pole support is not evident in the example from the summit panel, there is little doubt that we are dealing with the same standard motif, thus directly associating the iconography of the summit of the Pyramid of the Niches with the standard rites depicted below on Structure 4, in the adjacent North Ballcourt, and most of all in the Central Plaza. As Ringle (2004:181–183) has noted, other fragmentary panels from the Niches program depict Feathered Serpents with the standard, once again relating Central Plaza imagery to this ritual object.

When taken as a set, what has been added here at the Niches summit to the Structure 4 Panel iconography of standard raising is the addition of the Principal Tajín Deity (Fig. 2.17a). It will become apparent as we examine other Tajín programs that this figure is the other major deity at the site, along with the Feathered Serpent. Although most supernaturals depicted at the site inhabit the frames or other marginal settings, these two deities are central to the site's major narratives.[22] The Principal Tajín Deity is more concerned with ballcourt rites and the donation of power objects to the Tajín ruler, and thus has a specific narrative domain that remains distinct from that of the Feathered Serpent, which is involved with standard rites. An extended discussion of the Principal Tajín Deity must wait for Chapter 3, but it is important to note here that the iconography at the summit of the Pyramid of the Niches highlights only these two supernatu-

rals. The clear division of supernatural labor in the iconography, as well as the centrality of each supernatural in their own narrative domains, suggests that the Principal Tajín Deity and Feathered Serpent were the site's two main deities.

While far from explaining the totality of these intricate and little-understood panels from the pyramid's summit, we may say with some confidence that the supernatural narratives related there marry well with identification of the Pyramid of the Niches as Tajín's central mountain/pyramid. Further, one of the most widely depicted supernaturals, the Feathered Serpent, is shown both in action and as the central element in the standard that is in turn also featured on the summit of Structure 4, while a fanged deity that serves as the Feathered Serpent's major complement also appears here, uniting the two major Tajín deities at the summit of the central pyramid.

In addition to major deities inhabiting the summit, war associations, and the standards raised at its base, another primary characteristic of the Mexica Snake Mountain is its relation to the Skull Place ballcourt. Thanks to the well at its center, this ballcourt was the source of water and the cause of abundance for the entire polity. If the Pyramid of the Niches is analogous to Snake Mountain, then the ballcourts that frame the structure should include themes of water and abundance. The North Ballcourt, a smaller one just to the north of Structure 4, has a small canal that connects it to the Pyramid of the Niches and, farther on, to one of the arroyos that define the center of the site, mirroring the description of the Snake Mountain ballcourt as a source of water. No drainage system has been discovered in the South Ballcourt, the major court that frames the Pyramid of the Niches and is connected to the Central Plaza via Structure 5. However, all four corner panels of this ballcourt contain framing images of skeletal beings, depicted mainly as skulls, rising from water (Fig. 2.18). These images are always located towards the center of the court, where the Mexica describe the place of the skull and the well.[23] This iconographic pattern suggests that the center of this court was conceived as a source of water specifically associated with skeletal figures, and thus analogous to the Mexica Skull Place.

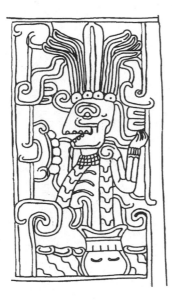

FIGURE 2.18. Detail of skeletal figure at the South Ballcourt. Figure is oriented toward the center of the court. Drawing by the author.

Conclusions

The analogies between the South Ballcourt and the Place of the Skull at the Coatépec ballcourt point up how similar fundamental symbolisms structured the two courts. We have seen earlier how the standards raised at the foot of both the Pyramid of the Niches and the Mexica Coatépec, as well as major deities inhabiting their summits, suggest that the analogy may be extended to encompass the central pyramids and plazas of each capital. That said, the several close similarities between the central Tajín program and the Mexica narratives and rites surrounding Coatépec are not adequate evidence for a direct historical connection: we know too little of how

these tropes functioned in the intervening 500 years. Instead, the similarities point to what are likely deep structural similarities in the way central urban space was conceived across large portions of Mesoamerica (Schele and Guernsey Kappelman 2001).

Perhaps one reason for the widespread distribution of the structuring trope of a central mountain with standards at its base is that it could be used to organize a polity's military might. For the Mexica, battle standards were the physical sign of particular warrior units (Hassig 1988:56–57). The larger standards were often directly connected to the unit commander and served as a principal signal for troops during battle, with the loss of the standard often catastrophic for the unit involved (Hassig 1988:96). It is not surprising, then, that the care and manipulation of these objects were highly ritualized, especially in the Central Mexican Panquetzaliztli rites and similar practices found at Tajín and elsewhere.

Thus the Pyramid of the Niches may be identified as the central mountain/pyramid of the Tajín polity, analogous to central pyramids that served similar symbolic functions across Mesoamerica. Further, the ritual performance of these symbolic functions involved ballcourt sacrifice and the manipulation of standards, with the latter objects likely used to organize the military units of Tajín. This identification of standard rites and their place in Tajín iconography is an important addition to what has heretofore been the primary field of Tajín iconographic studies, that of the rich corpus of images related to the ballgame. It is to the major ballcourt and its images that we now turn.

THE DIVINE BALLCOURT

The lower monumental center of El Tajín contains numerous ballcourts for the playing of the rubber ballgame and the performance of its attendant rites. Eleven courts have been identified in the heart of the site (Fig. 1.2; see Raesfeld 1992; Brüggemann 1992a:20), and six more in the immediate surrounding area (Lira López 1997:819). Ballcourts were a fixture of Classic Veracruz centers from the end of the Late Preclassic period (from ca. AD 100; Daneels 1997), but no other Gulf lowlands center yet studied has such a large concentration. Few Mesoamerican cities anywhere had as many ballcourts: to date only Cantona (twenty-four courts) and Chichén Itzá (thirteen) can claim more during this period (Taladoire 2001:114). Several of the Tajín ballcourts include stone sculpture with a complex iconography that contains clues to the courts' function and meaning. The subject of this chapter is the meaning encoded in the most prominent and elaborately decorated ballcourt, and what that may tell us about its function.

All ballcourts at El Tajín, including the central ballcourt that is the subject of this chapter, are framed by parallel masonry buildings. Parallel structures with a well-defined central alley are the basic architectural signature of the ballcourt, not only at Tajín but throughout much of Mesoamerica beginning in the Late Preclassic period (after ca. 400 BC; see Hansen 1998 and Taladoire 2001:109).[1] The identification of these architectural forms with the playing of a Mesoamerican rubber ballgame dates to early Colonial accounts of the game and its field of play (Durán 1971:314; Motolinía, cited in Taladoire 1981:575). This tradition was continued in the nineteenth century by several pioneering Mesoamerican archaeologists and applied to parallel structures unearthed

during that period (Nicholson 1988:11). Thus by the time Ellen Spinden (1933:237) observed two sets of parallel structures at Tajín in the late 1920s, she could confidently identify them as ballcourts.

Work at Tajín in the intervening 80 years brought numerous other ballcourts to light but did not show how the courts were related chronologically. To address this problem, Raesfeld (1990) trenched six of the ballcourts in the center of the city and examined their fill in order to determine their chronological relationships. The archaeologist found little difference in the ceramic fill of any of the ballcourt buildings.[2] Surface ceramic finds on other courts were similar to the fill in the six tested courts, thus suggesting roughly the same dating—the site's Epiclassic apogee—for all the visible courts in the Tajín center.[3] Continuing archaeological work should refine this chronology, but it is unlikely to change the fact that the great majority of Tajín courts now visible were built and in use during the site's apogee. Further, the data suggest that these courts were in use at the same time, as there is no evidence to suggest that any of the courts were abandoned before the site's general decline (Wilkerson 1991:50). In short, while we would like to have a finer-grained history of court building at Tajín, it is apparent that the ballcourts were generally contemporaneous.[4]

All Tajín courts may be assigned to one of two architectural types based on the proportion and form of the flanking buildings. The great majority of Tajín ballcourt structures consist of a long, sloping apron (talud) that ends in a low bench that defines the playing field.[5] Only the South Ballcourt and Ballcourt 30/31 (Fig. 1.2) are distinguished from the other ballcourts by their high vertical walls and abbreviated aprons (Raesfeld 1990:92).[6] These two courts are also the largest at the site, suggesting that both the form and size mark them as a special category of court. The lack of a true apron, certainly important to keep the ball in play, may signal that these two courts were not designed for ballgame play but instead had more-ceremonial functions (Brüggemann 1992b).[7] That said, even these two clearly marked courts can be arranged in a hierarchy. While Ballcourt 30/31 is located in the Great Xicalcoliuhqui, far from the Central Plaza and

the major concentration of decorated monumental architecture, the South Ballcourt is adjacent to the Central Plaza and contains the most elaborate iconographical program of any court at Tajín. Because of its size, position, and elaborate decoration, the South Ballcourt can be considered the most important ballcourt at the site. Further, the South Ballcourt imagery is in several ways exemplary, as bits and pieces of this program are reproduced throughout Tajín's other ballcourts and elsewhere at the site. Thus the reading of the iconography of the South Ballcourt is a crucial step in understanding not only this court, but the iconography of Tajín public sculpture in general.

The Basic Shape of the Ballcourt Program

The South Ballcourt is formed by the monumental platforms of Structures 5 and 6 (Fig. 2.2). These platforms serve as the benches of the court, while the pyramidal structures surmounting the platforms define the court's upper profile. No other court at Tajín has such a grandiose architectural frame. The South Ballcourt may be seen as much more than an alley where ballgames and related rites were performed: the court is integral to the entire ensemble of buildings at the center of the site and dominates the south side of the central area among several other ballcourts and major pyramids.

Structure 5 not only provides the north bench of the ballcourt but also forms the south side of the Central Plaza, thus directly connecting the South Ballcourt and Central Plaza programs. We have already noted how Structure 5 carried ballcourt symbolism into the Central Plaza program. On the Central Plaza side of Structure 5 is the single panel illustrating ballcourt sacrifice, shown as taking place in the ballcourt itself (Fig. 2.3). In addition to this iconographic relationship, there are complex and fundamental relations between the Central Plaza and South Ballcourt programs. As I will argue below, the South Ballcourt program relates directly to the rites of legitimacy, war, and statecraft outlined for the Central Plaza, continuing and amplifying themes of warfare, ballcourt sacrifice, and the legitimate transfer of power.

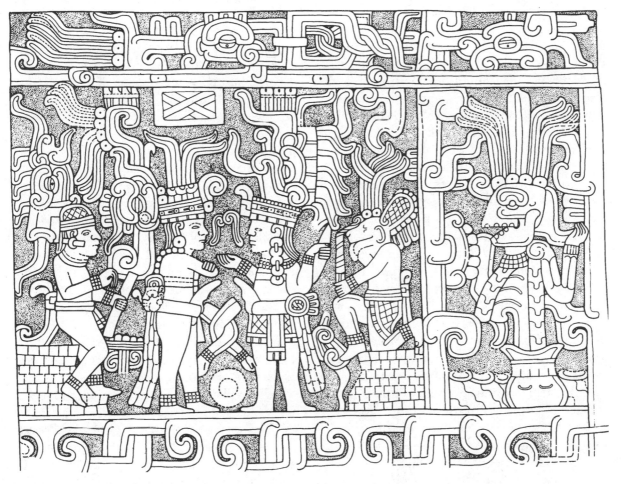

FIGURE 3.1. Northwest panel of South Ballcourt, El Tajín. After Kampen 1972: Fig. 22. Reprinted with permission of the University Press of Florida.

Format and Reading Order

The South Ballcourt themes are developed mainly in the six large panels distributed on the benches. Three panels are found on each side of the court at regular intervals, with panels at each corner and one placed in the center of each bench. Central and corner panels are differentiated by a strict adherence to different compositional formats, and as we will see, each group exhibits a distinct iconographic function as well (Wilkerson 1984). The basic structure of each corner panel consists of a rectangular central scene surrounded by framing elements on three sides (Fig. 3.1). Below the central scene is a basal band of scrolls that marks various sacred substances at Tajín, while beside the scene, and always toward the middle of the court, is a

skeletal supernatural rising from a pot resting in liquid. This is the same scene identified in Chapter 2 as analogous to the Skull Place of Mexica narratives. The skeletal supernatural is framed in turn by scroll forms that describe highly abstract features of Tajín zoomorphs. This skeletal figure scene does not exist in the central panels and is thus an important iconographic difference between the central and corner panels. The upper register of the corner panels also always includes a zoomorphic head and intertwined cords in a cartouche. The frame elements are consistent across the four corner panels; the central scene of each corner panel is the only variable element of the composition.

Figures and toponyms repeat not only in the frame, but also at various times in the central scene, strongly suggesting that the corner panels

form a related whole. The earliest commentaries on the panels assumed that this whole formed some sort of narrative (Spinden 1933; García Payón 1959, 1973b). A good argument can be made for such an assumption. While many of the framing elements remain constant, the central scenes of the four corner panels depict several personages in profile, engaged with each other in a variety of actions. Some of these figures are repeated over a number of the panels. When juxtaposed with the regularity of the framing devices, the main scenes emphasize variety and change, both in the figures themselves and in their actions. At this basic analytical level, we may say that the figures are given a regular frame in which to carry out specific, nonrepeating actions. The four corner panels may then be seen to meet Irene Winter's (1981:2) criteria for a simple pictorial narrative, which that author describes as having a structured content (the repeating elements found both in the frame and inside the central scenes themselves that provide the structure and continuity of the story), ordered by the "telling" (the various actions shown in the central scenes that give the story a temporal element).[8] We may say with some assurance that the corner panels of the South Ballcourt tell a story, but just what kind of story and read in what order are questions that have bedeviled Tajín iconographers from the discovery of these panels to the present, with no two scholars agreeing on either of these fundamental issues (compare Spinden 1933; García Payón 1959; Kampen 1972; Wilkerson 1984; Pascual Soto 1990; Castillo Peña 1995; Ladrón de Guevara 1999; Sarro 1995:234–237).

The South Ballcourt program provides good reasons for such fundamental disagreements among scholars, chief among them the complexity of the narrative. The sculptural program is one of the most detailed and extensive ballgame-related narratives we have for all of Mesoamerica. The six panels depict a large number of events in an unusual amount of detail. Although several of the scenes may depict activities in and around the ballcourt, none show the ballgame itself. As in other Mesoamerican traditions, the central monumental ballcourts were sites of ritual and pageantry as much as a place for sport (Day 2001:73), and even rites with clear relations to

the ballgame could be performed elsewhere than on the court (Miller and Houston 1987). Thus the designation of "ballgame-related" narratives is a wide one indeed. Because no other Mesoamerican ballcourt program contains all of the events depicted at Tajín, any analogies drawn from other representations of the Mesoamerican ballgame and related events are applicable to only a part of the South Ballcourt program. Simply put, we know of no Rosetta Stone for the iconography of the Tajín ballcourt: we have no known work with an established reading order that we can use to order the Tajín sequence. To reconstruct a viable reading order for the ballcourt panels, two major avenues of analysis suggest themselves: analogies with other Mesoamerican ballcourt ritual sequences in text and/or image, and intrinsic clues to the reading order based on specific characteristics of the panels themselves.

Intrinsic clues to the narrative order are straightforward and based on fundamental formal or iconographic patterns, such as repeating personages or places, changes in framing, and so on. The validity of extrinsic information, especially any analogy with other Mesoamerican ballcourt sequences, however, is less obvious. For one, it is not evident that there was only one Mesoamerican ballgame with historical variants that may be compared across time and place. Several scholars have long insisted on a plurality of ballgames throughout Mesoamerican history (Cohodas 1991; Orr 1997, 2001; Taladoire 2003), whereas others see real structural resemblances in the game across Mesoamerican time and space (Taladoire 2001:113; Gillespie 1991; Kowalski 1992; Fox 1996). The debate is one between historical particularists who foreground difference, and those who posit structural similarities and continuity over the course of the 3,000 year history of Mesoamericans and the rubber ball. For our purposes, the question of evaluating analogies is paramount: how can one judge the appropriateness of a comparison taken from another Mesoamerican ballgame tradition and then used to explain imagery at Tajín?

In an effort to limit the field of ballgame analogy, here we will deal mainly with a defined time span: the Epiclassic period (ca. AD 650–900/1000). I argue that there is good reason to compare ballgame imagery and function across

much of Mesoamerica during this period. It has long been noted that a rise in ballcourt construction, as well as the widest distribution of Classic Veracruz stone ballgame accouterments, occurred during this period, certainly signaling some shared conceptions of the meaning and role of the game (Tozzer 1957; Pasztory 1972; Ringle et al. 1998:196; Taladoire 2001:109–110). These shared conceptions would have expressed themselves in similar practices in the courts themselves, thus legitimating the analogies drawn below with other Epiclassic Mesoamerican traditions of ballcourt practice. Beyond the confines of the Epiclassic period, I examine later documents on ballcourt practices that may have descended from these Epiclassic norms, drawing on these when they shed light on specific aspects of Tajín iconography.

One theme that emerges from these comparisons is the relationship of the ballgame to warfare. This is nothing new, for many authors have noted this relationship throughout the Americas, beginning with Stern's (1949:96) classic statement on the American rubber ballgame as a substitute for war. Here, however, we want to explore more specifically how the ballgame and warfare are articulated at El Tajín, particularly in the context of public narrative. But before we speak of the meaning and function of this narrative imagery, we will examine what is known of the historical rise of such imagery in Tajín region ballcourts.

A History of Visual Narratives in the Tajín Region

While extensive and complex narratives are the hallmark of mature Tajín art (Diehl 2000:176), it is important to note that the earliest examples of public monumental sculpture in the Tajín region lack such a clear narrative thrust. Earlier public sculpture in the region leans toward a more iconic presentation of a single figure, where symmetry and frontality dominate the compositional arrangement (Brüggemann 2001a:379). The figure is shown with costume items and key accouterments, the latter providing some slight asymmetry and variation in the composition. This iconic format allows for little storytelling (Clancy 1985:69). A prime example of early

Tajín region art is the recently unearthed stela fragment from the nearby site of Cerro Grande (Fig. 3.2a), which shows a single figure posed frontally. There are no other figures, landscape items, or other elements with which the figure could interact to form a narrative. The frontal, single figure in this early stela is fundamentally different in its composition compared with the profile, multifigure ballcourt panels under discussion (Fig. 3.1) or the Central Plaza panels analyzed earlier (Fig. 2.6). Although the upper portion of the stela is missing, we can say that the basic composition exhibits a certain stiff, symmetrical quality in the pose of the body (Pascual Soto 2000:35). It is not completely symmetrical, however, for the figure holds a standard or spear in one hand and a decorated bag, often referred to as an incense pouch, or *copalxiquipilli* to the Aztecs, in the other. The standard or spear clearly speaks of war, but the incense pouch is more difficult to associate with any specific meaning, often being linked to priests and their burning rites, as well as to warriors (Stone 1989:159–160). Compositionally, the breaking of perfect symmetry is important, for it allows more complex characters and/or deeds to appear in what would otherwise be a completely iconic, non-narrative image (Clancy 1999:20). The Cerro Grande stela was found in archaeological context and dated to the Cacahuatal phase (ca. AD 350–600; Pascual Soto 2000), the period preceding the creation of the narratives of the South Ballcourt, which date to the Epiclassic at their earliest (Raesfeld 1990). Less well dated, but clearly related to the Cerro Grande figure, are several closely related stelae and fragments from the center of Tajín, which were recently sourced to the Plaza del Arroyo area south of the central ballcourt (Fig. 3.2b; Wilkerson 1987b). The Arroyo architectural group is unique in its huge open plaza bordered by long, rectangular bases with multiple superstructures. This group has been tentatively dated as the earliest large architectural group at the site (Wilkerson 1987b; Brüggemann et al. 1992:54; Castillo Peña 1995:150). The Arroyo sculptures are heavily damaged, but they too show frontal figures in fairly iconic poses. Closely related to all the above is a single-figure stela now at the Museo de Antropología de Xalapa (Fig. 3.3a). Here a frontal figure holds a staff in one hand and

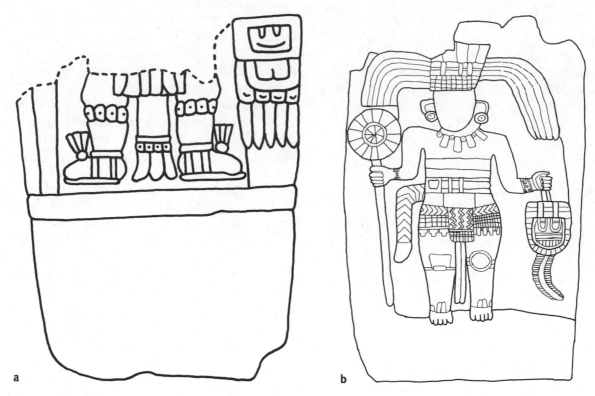

FIGURE 3.2. Classic period (Cacahuatal phase, ca. AD 350–600) sculptures from the Tajín region: *a*, Cerro Grande stela (drawing by Daniela Koontz after Pascual Soto 2000:35); *b*, El Tajín panel, possibly from the Arroyo Group (drawing by the author after Kampen 1972: Fig. 18a and Castillo Peña 1995: pza. 40).

wears an elaborate headdress containing two pro-file zoomorphs, a circular disk in the center, and a large spray of feathers surmounting the whole. Large areas of loss keep us from identifying what was represented on the figure's left side, but given the gesture of the left hand, it too probably held something like the decorated bag held by several other frontal figures. Like the other pieces in this group, the stone is dressed to a fairly rigid geometric shape, emphasized by a molding run-ning around its outside edge. The compositions enclose central iconic figures in all cases (Pascual Soto 1998:24). These frontal, rather iconic works from the north-central Gulf lowlands can be compared in turn to the stela tradition of Cerro de las Mesas, farther south, where the example of Stela 7 (Fig. 3.3b) shows the frontal pose and the splayed feet of the Cerro Grande figure (Fig. 3.2a). In addition to the similar pose, both works feature the staff and pouch. Stela 7 at Cerro de las Mesas has never been firmly dated (Miller 1991:34), but the similarities noted above suggest that it somehow relates to this Cacahuatal phase group of early Classic Veracruz works. Interest-

ingly, the Cerro de las Mesas stela does not have the strict rectangular panel format seen in both the more northern works, but instead has the rounded contours of the more well known fifth-to sixth-century monuments with texts, such as Stelae 6 and 8 (see Miller 1991) from the site.

Although early iconic monumental images in the Tajín region are markedly different from the later South Ballcourt narratives, some early buildings in the region show important similari-ties to the later Tajín building. The high vertical bench wall that differentiates the South Ballcourt from the great majority of Tajín ballcourts is con-structed of large cut stone blocks, or flags.[9] Gen-erally, masonry architecture in the region began with the Tajín apogee (Wilkerson 2001b:652), yet flagstone facades had been used in the region for some time to mark significant buildings, with the important Cacahuatal phase Building 9 at Morgadal Grande a prime example (Pascual Soto 1998:22). At this site, just 11 km from Tajín, two monumental, intertwined serpents were carved into the flags on the facade. It appears that the carving was done in situ after the flags were set

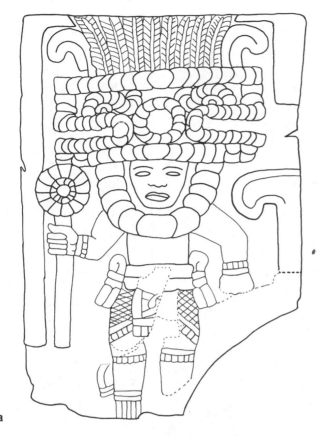

a

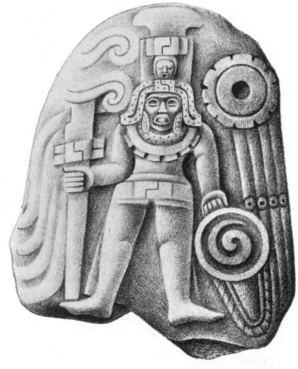

b

FIGURE 3.3. Classic Veracruz images related to Cacahuatal phase Tajín works: *a,* Classic Veracruz panel (drawing by Daniela Koontz, courtesy Museo de Antropología de Xalapa); *b,* Cerro de las Mesas Stela 7 (after Stirling 1943).

into the building. The same method of carving in situ flags was used later in the South Ballcourt at Tajín. Interestingly, the facade of Structure 9 at Morgadal Grande is immediately adjacent to, and directly faces, the site's central ballcourt, thus suggesting an early connection between ballcourt architecture and these flagstone compositions. What is important to note here, however, is the difference in the treatment of the monumental imagery inside a very specific continuous tradition of flagstone facades. Instead of carving one monumental image across the architectural surface, as at Morgadal Grande, the Tajín sculptors divided the bench surface into six discrete relief panels distributed equally along the bench. This change may be characterized as a shift from an overall pattern of decoration forming an icon (the intertwined serpents) at Morgadal Grande to the "window" of the discrete scenes in the South Ballcourt—or yet another example of the historical movement from icon to narrative. Whether one compares the South Ballcourt scenes to earlier stelae or earlier architectural decoration, the major historical movement is from icon to narrative in regional public art (Brüggemann 2001a). A figure that may be seen as transitional between the earlier, frontally posed single-figure panels and the later, profile-posed multifigure narratives was found in the fill of the South Ballcourt (Fig. 3.4a). An obvious but important point here is the dating of the panel, which is one of the few public sculptures at Tajín that can be securely dated in relation to other works. Its presence in the fill (presumably original) suggests that it was carved before construction of the South Ballcourt and the carving of the panels under study (García Payón 1950; Proskouriakoff 1954:85). Dating this panel in relation to the Cacahuatal phase panels cited above is more difficult, but there is no evidence to suggest that it is earlier than the Cerro Grande piece (Fig. 3.2a). The panel exhibits a single human figure, as in the other Cacahuatal phase compositions. This figure, however, is not posed frontally but in profile, surrounded by an earlier version of the scroll frame seen in the South Ballcourt examples. The Cerro de la Morena stela (Fig. 3.4b), from the area of Misantla, is very similar in compositional structure to the early Tajín ballcourt panel. This piece has been dated much later in the regional

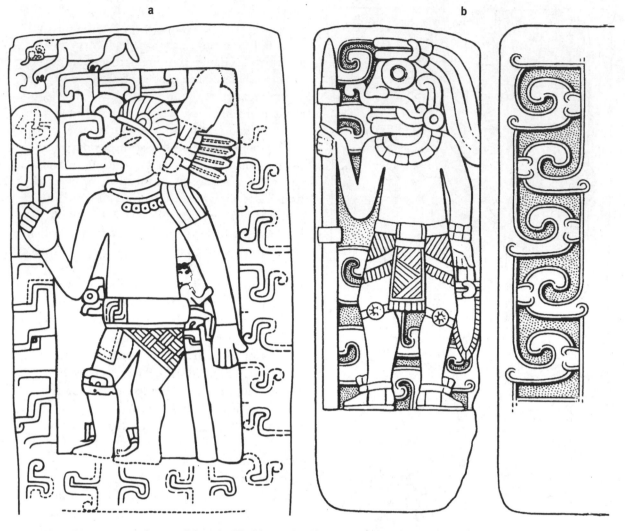

a b

FIGURE 3.4. Tajín region panels: *a,* panel from the fill of the South Ballcourt (Structure 5), El Tajín (drawing by the author); *b,* stela from Cerro de la Morena, Veracruz (after Proskouriakoff 1954: Fig. 9f; courtesy Carnegie Institution).

chronology on stylistic grounds (Proskouriakoff 1954:86), but here again we have a single figure posed in a regular rectangular frame. Instead of numerous scroll forms carved into the framing molding, as in the Tajín ballcourt panel and in many apogee period works at the site, a small number of relatively large scroll forms emerge from that molding, much like the single large scroll of the Cacahuatal phase stela examined above (Fig. 3.3a). Like the image on the Cerro Grande stela, the feet of the Cerro de la Morena figure are splayed on the ground line, and like several works in this early group, the frontal figure holds a staff (in this case probably a spear) in the right hand and a decorated bag in the left. The head, however, is seen in profile, like the

ballcourt panel figure, which along with elements such as the speech scrolls and fans indicate movement and thus a more narrative quality than the early frontal images. Taken together, these stylistic traits suggest that the Cerro de la Morena stela is not as late as has been previously proposed and is likely part of the Cacahuatal period set. Further, this stela has certain fundamental similarities to both an early Gulf lowlands panel and the Tajín ballcourt panel. While both the Tajín ballcourt and Cerro de la Morena panels may be seen as moving towards narrative, neither contains the elaborate multifigure composition of the later ballcourt panels.

This brief history of Tajín region public art makes it clear that the panels of the South Ball-

court were part of a regional development from iconic to more-narrative public art. Thus, returning to the problem of the reading order of the South Ballcourt panels, we have no "guide" in earlier Tajín visual culture for the narrative order of these panels. The argument made earlier—that we are dependent on analogies with Epiclassic ballcourt practices and their descendants—is all the more necessary given the absence of earlier, multipanel narrative programs in the region. While we have no direct historical thread that can be followed back in time, we do have a substantial visual record of ballgame-related imagery for Tajín's contemporaries. In the end, it is the belief that there was a historical relationship between the Epiclassic elites who designed these programs, and that these elites were sharing ballgame symbolism, that makes the narrative order and, eventually, an interpretation of the Tajín panels possible. Without directly related texts, it is chiefly in a shared symbolic language that can be related, patterned, and eventually interpreted that the researcher can hope to find substantive meaning for any single program like the one under examination. In the study below, I attempt to apply to the Tajín imagery the most appropriate analogies, including those taken from Epiclassic cultures with comparable ballcourt practices when possible, and from the descendants of those cultures when necessary. The reading order of the panels grows out of the arguments made for their meaning.

Ballcourt Alliance

The narrative sequence opens with the panel located on the northwestern corner of the court (Fig. 3.1). The panel's central scene takes place in the open space of the South Ballcourt itself, defined by a depiction of the profiles of Structures 5 and 6 (Kampen 1972:38; Wilkerson 1984).[10] In addition to the ballcourt location, another clear link to the ballgame in this panel is the yoke and *palma* combination (the thick belt with a projecting element towards the front) worn around the waist by both principal figures. Nevertheless, these would-be ballplayers are missing essential items of ballgame attire that appear in other scenes, such as kneepads and stepped

skirts. Thus the protagonists in this initial panel are represented with hints of ballgame-related activity in their dress, but they are not outfitted in the complete array of ballgame costume.

The main figure on the left in the central scene crosses his arms over his chest in a posture often interpreted as submission (Spinden 1933:251; Kampen 1972:55). While this posture does indicate submissive captives in several other Mesoamerican traditions, this is not the case at Tajín, where submission is indicated by raising the arms, as I will argue for the processing, tied, and stripped captives of the Mound of the Building Columns (see Chapter 4). In several related Mesoamerican iconographic traditions, the crossed-arms gesture is not submissive but instead indicates high rank for the person exhibiting the pose (Urcid 1993; Zeitlin 1993:126–127). The interpretation of the pose as indicating high status goes only a little way, however, in explaining the place of this image in the larger ballcourt narrative.

To make more sense of this scene, and specifically the relation of the two central protagonists interacting in a ballcourt, I will argue below that an aspect of the ballgame seen in Postclassic iconography is analogous to the iconography at Tajín. In the Postclassic scenes, elite ballcourt meetings are represented as immediately preceding a joint military effort by the ballcourt protagonists. In each of these cases the link between ballcourt rites and war is clear and immediate, suggesting that the ballcourt meeting scenes represent activity designed to forge alliances immediately before a military action. An important ballcourt meeting is represented on the first two pages of the *Codex Nuttall,* a Postclassic document from the Mixteca, Oaxaca (Fig. 3.5). In this scene, 8 Deer, a Mixtec ruler and epic hero seen here in the upper right, is cementing an alliance with 4 Jaguar and his followers in a ballcourt. A person from the entourage of 4 Jaguar, seen on the upper left, is offering 8 Deer a jewel in the ballcourt. War and conquest follow immediately on the next page (Caso 1966; Troike 1974:177–181; Williams et al. 1993; Joyce et al. 2004:283–285). It is important to note that these individuals do not appear to be natural allies; instead, 4 Jaguar and his entourage seem to be foreign to the Mixtec elite (Pohl 1994:83–108), and thus the

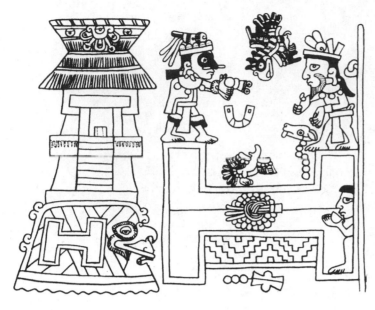

FIGURE 3.5. Ballcourt meeting, *Codex Nuttall* 45. Drawing by the author.

ballcourt meeting would have served as a fundamental step in solidifying their relationship. Similar ballcourt meetings followed by alliances and conquests occur in the *Codex Bodley* and the *Codex Colombino-Becker* in this tradition.[11] Taking these images of Mixtec ballcourt practice together, a pattern emerges in which ballcourt ritual is followed immediately by warfare conducted by the two protagonists not obviously related to each other previously. This suggests that the ballcourt ritual shown in the Mixtec codices functioned on one level as a pre-warfare alliance mechanism.

These Mixtec ballcourt alliances were part of a specific ritual sequence to obtain political power, according to Byland and Pohl (1994a:156–160). The alliance was not simply a method of acquiring help in conflict, but was part of a carefully orchestrated series of events designed to create an aura of political legitimacy around the actors. As we will see, the narrative sequence at Tajín may also be read as a roadmap to political power.

From the specific historical instances of ballcourt alliance ritual in the Postclassic Mixtec codices, we move to patterns in the K'iche Maya *Popol Vuh,* a key text that integrates ballgame and other ballcourt rites into a larger mythic context. Although this book was not set down in Latin letters until the mid-1550s, it is clear that the text

encodes Postclassic Highland Maya thought on the ballgame (Carmack 1981:195).

The *Popol Vuh* describes two types of ballgames that are contrasted rather starkly in the text itself. In the first ballgame passage of the book, 1 Hunahpu and 7 Hunahpu play ball with their sons. Unlike later ballgame passages in the *Popol Vuh,* no sacrifice is intimated. Instead the fathers and sons "would play each other in pairs" (Tedlock 1996:91). The text continues with an enigmatic phrase that in the original K'iche reads, "*Ta ke kuch mayihik Pa jom.*"[12] The compound *kuch mayihik* is used in the last part of this passage to refer to the nonsacrificial ballgame between the fathers and sons. It is not used in any of the later ballgame passages, where *chaah* is consistently the verb used to indicate ballplaying (see Edmonson 1971:114, 120, 126), and the possibility of defeat and sacrifice is strongly intimated. The first, nonsacrificial ballplaying compound derives from *kuch,* "to join together," and *mayih,* "to admire" and "to give gifts" (Ximénez 1985:235; Edmonson 1965:71).[13] A literal translation of this compound—to join through gift exchange—describes in words the same actions of alliance and exchange found in the Mixtec iconography discussed above, especially in the scene in *Codex Nuttall* 45 where the protagonists are literally exchanging precious items (Fig. 3.5). Several other examples of elite ballcourt reunions in the Mixtec codices take place in border zones, where contentious elite factions could resolve disputes and create alliances in a neutral environment and celebrate a shared history (Pohl et al. 1997).

In addition to the Postclassic Maya analogy for ballcourt alliance found in the *Popol Vuh,* there may be Classic period Maya antecedents for the alliance function of the ballgame. While a large amount of Classic Maya ballcourt imagery depicts sacrificial themes, a recently unearthed example clearly describes ballcourt rites with military allies (Zender and Skidmore 2004). Thus the language of ballgame alliance embedded in the *Popol Vuh* appears to have Classic Maya antecedents, at least in this case.

Finally, there is some archaeological evidence that central Gulf lowlands cultures had always used ballcourt rites to cement elite relationships and resolve conflicts. Daneels (2008) points out that from Late Preclassic times forward, Gulf

lowlands elites were regularly buried with yokes, and that ballcourt construction was a significant part of the rise of monumental architecture and complex social hierarchy in the region. Thus in the precocious Basin of Veracruz area (the south-central Gulf lowlands), the appearance of substantial ballcourt constructions and ballgame accouterments may be directly correlated with the rise of the elite. While there is little imagery or other evidence to connect the building of these central Gulf lowlands ballcourts directly to elite rites of alliance or conflict management, similar uses have been proposed for ballcourt rites throughout the Classic and Epiclassic periods (Santley et al. 1991).

The passage from the K'iche Maya *Popol Vuh,* taken together with the Mixtec examples, strongly suggests that Mesoamerican ballcourt ritual could serve as a mechanism for alliance, and that the mythological basis for this sort of alliance, at least among the K'iche, was the ballplaying of the original fathers and sons.[14] At Tajín the two central figures are shown engaged in this dialogue, and the two framing figures display items of Tajín regalia. In the Mixtec examples the alliance is directed toward a coming military excursion. Given the ethnohistorical data and the link between ballcourt construction and Gulf lowlands elites presented above, I suggest that this is also a major message of the Tajín ballcourt meeting panel—a point made clearer by the warfare-related iconography in the next panel.

The Supernatural Patron of War

The second panel in the ballcourt sequence, located on the southeast corner of the court, depicts another aspect of warfare, continuing the theme of the first panel. In this image (Fig. 3.6) a central figure is flanked by two seated figures. The individual seated on the left holds three spears in his left hand. The spears have the pointed tips of the Mesoamerican thrusting spear, a weapon of widespread use.[15] The figure is offering or exhibiting these weapons to the central figure, who gazes toward them while crossing one arm across his chest. Though the seated figure to the right is badly damaged, he too seems to be presenting or offering, but he may simply

be gesturing toward the central figure. The spears serve as the scene's focal point: all figures turn towards them. The figure grasping the spears has the supraorbital plate that marks supernaturals at Tajín, and in his headdress is an elliptical jewel, an object that appears as a pectoral on important Tajín supernaturals. The central figure, by contrast, is clearly marked as human. The spears seem to emerge from the disembodied supernatural zoomorph floating above the scene. The focal point of the composition—the spears—are thus directly connected to supernaturals who are presenting the weapons to the central human figure.

One may characterize this imagery very simply as the display or perhaps the donation of warfare items by a supernatural to a human. This is not an unusual theme in Mesoamerican iconography, for many traditions in this area required some sort of supernatural legitimation for war, often focusing on the supernatural donation of spears, shields, or other items associated with warfare.[16] As discussed in Chapter 2, Taube (1992a, 2000), in a fundamental synthesis, has shown that several Mesoamerican traditions used a specific supernatural zoomorph to move warfare items from the divine to the human plane (see also Sugiyama 2005). Taube dubbed this supernatural zoomorph the "War Serpent" due to its close associations with war and its general serpent character. While that author did not treat the iconography of Tajín, it is clear that in the scene from the southeast panel, the Tajín zoomorph from which the spears emanate exhibits the diagnostic traits of the War Serpent as defined by Taube, such as a sharply upcurved, voluted snout.

In addition to comparable features in the head of the zoomorph, a key similarity in War Serpent imagery is the emergence of war implements and/or a venerated warrior from the zoomorph's maw, such as the spears emerging from the maw of the upper zoomorph at Tajín. A well-known example of this function of War Serpent imagery comes from the roughly contemporary Maya tradition. A detail from Yaxchilan Lintel 25 (Fig. 3.7) illustrates the appearance of the *tok' pakal,* or flint-shield, a charged combination of war implements that may be viewed as analogous to the spears delivered by the War Serpent at Tajín (Freidel et al. 1993:305–310). The flint-shield is described in the accompanying hieroglyphic text

FIGURE 3.6. Southeast panel of the South Ballcourt, El Tajín. After Kampen 1972: Fig. 20. Reprinted with permission of the University Press of Florida.

as a key product of ritual, and it is illustrated in this image as a short spear held in one hand and a small round shield held in the other. The figure holding these implements is emerging from an elaborate rearing War Serpent that covers much of the left side of the composition. In addition to the shield and spear, the figure wears a "balloon" headdress, also associated with warfare for the Maya. The entire scene is evidence of rites designed to manifest (or *tz'ak*, "conjure," the verb used in the text) essential items of war (specified as the *tok' pakal* in the hieroglyphic text; see Houston 1983; Stuart 1995:301–304). Although there are significant differences in the iconography of the Tajín and Maya scenes, several important structural analogies are apparent: the implements of war appear from the maw of

a supernatural beast, they are accompanied by a supernatural, and they serve as a gift or exchange item for humans. Further, in both scenes the donation occurs via a similar zoomorphic supernatural. In the Maya example, the Tajín panel, and several other images across Mesoamerica during this period (see Taube 1992), the chief function of the War Serpent appears to have been the delivery of such implements of war.[17] In addition to the presence of a War Serpent–like zoomorph at the top of the Tajín composition, the figure seated on the left contains all the basic elements of the supernatural patron of war complex described above. His supraorbital plate and the elliptical element in his headdress are both associated with several other important supernaturals at Tajín. Like other Mesoamerican patrons of

war, such as the Yaxchilan figure discussed above, the figure displays implements of war, in this case spears, to human figures. Finally, the Tajín figure emerges from the maw of a (now badly abraded) zoomorph, much like the Yaxchilan figure.[18] The combination at Tajín of zoomorphic maws, supernatural figures, and implements of war in a single image strongly suggest that these figures may be seen as local variants of the Mesoamerican language of legitimate warfare. In the larger sequence of war-related rituals hypothesized here for the Tajín ballcourt, the second panel can thus be seen as the ritual legitimation of war following the alliance shown on the first panel.

The relation of warfare and the cult of the War Serpent, together with supernatural donations of arms, may have had its beginnings in the region in the previous Cacahuatal period. The Cerro de la Morena stela (Fig. 3.4b) discussed above as part of an early stela group contains the combination of a spear, held in the right hand, and the goggle

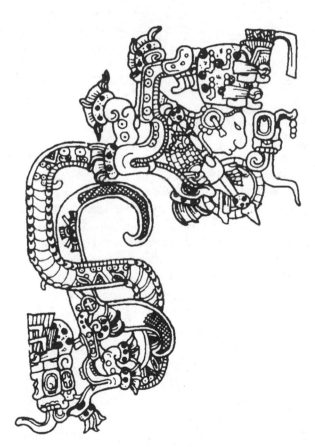

eye and fanged mouth of a specific supernatural connected to this cult of war for the Maya (see the Yaxchilan Lintel 25 example above; Stone 1989; Taube 1992a; Freidel et al. 1993). A similar Classic Veracruz stela (Fig. 3.3a)—related to the Cerro de la Morena stela and already discussed in relation to the early Teotihuacan evidence for this cult—contains a version of the War Serpent with the upturned snout seen in double profile as part of the headdress. Note the reticulate surface of the beast, a diagnostic characteristic for both Maya and Teotihuacan depictions.

Thus far I have argued that the first two panels in the Tajín ballcourt sequence speak directly to indigenous conceptions of war. Yet there are no clear depictions in the panels of warfare itself, nor are there in the panels that follow. The absence of scenes of actual warfare is not unusual in Mesoamerican public art: Mary Miller (1998:192) noted that for a large majority of Classic Maya art, public memorialization of warfare featured the treatment of captives in the victorious city, not the battles themselves. Stuart (1995:294–299) also argued that for these same Maya much public imagery related to warfare involved captive-taking and sacrifice, although he stresses that war had other or wider purposes not addressed directly in the public record. For whatever reason, the reporting of war itself, even in contexts intimately related to war, was simply not the stuff of Classic Maya public art.[19] The same seems to hold true for Tajín, not only in these panels but in other programs that may easily be associated with warfare rites but which do not depict the campaigns themselves (see Chapter 4).

Ballgame Decapitation Panel

The next scene in the narrative sequence is framed by a depiction of the same ballcourt architecture we saw in the first (alliance) panel (Fig. 3.8; compare Fig. 3.1). In addition to the identical location, the figure with the rounded net headdress is once again present. Here he appears on the structure to the right, holding the same baton he held in the first panel, leaving no doubt that this is indeed the same figure. The baton appears yet again in a subsequent ballcourt panel, pointing up its significance in these rites,

FIGURE 3.8. Northeast panel of the South Ballcourt, El Tajín. After Kampen 1972: Fig. 23. Reprinted with permission of the University Press of Florida.

as we shall see. Another item seen in the first panel, the lanceolate blade, appears again, this time with what has long been interpreted as a sacrificial victim at its point.

The entire composition balances on this central sacrificial act. The victim, displayed in the center of the composition, is seated on a now-effaced support. He is framed by two figures: the one to the left physically restrains him, while the figure to the right holds the lanceolate blade over his neck or chest. All three figures, including the sacrificial victim, wear elaborate costumes associated with the ballgame: a yoke around the waist, a *palma* attached to the yoke near the front, and kneepads. A skeletal supernatural dives from the upper band into the scene, in a pose analogous to those of other descending supernatural figures throughout the Tajín corpus who appear to claim the fruits of sacrifice.

Scholars agree that this panel of the South Ballcourt program depicts a sacrifice, but not on the type of sacrifice implicated. This is not a trivial point, for the type of sacrifice is an important aspect of the rite's symbolism. The knife in the hand of the sacrificer has been interpreted as hovering over the neck (suggesting decapitation) or over the chest (suggesting heart extraction). Although Spinden (1933:256–257), García Payón (1959:458), and Pascual Soto (1990:142–148) are noncommittal, Diehl (2000:178) suggests that the sacrifice is by heart extraction; however, most recent scholars (Kampen 1972:65; Wilkerson 1984, 1991; Sarro 1995:136) interpret this scene as representing decapitation sacrifice. The most significant evidence for this latter interpretation is found in a related panel from Tajín Structure 2 (Fig. 2.3), already discussed in relation to the Central Plaza program and its tie to the ballgame

(see Chapter 2). As noted there, the Structure 2 panel represents the decapitation sacrifice of a ballgame-related victim and is iconographically similar to several images found farther south along the Gulf lowlands during this period. Several fundamental similarities tie the Structure 2 panel to the South Ballcourt image: note the same location seen in the profile ballcourt structures framing the scene, as well as the presence of a figure with a yoke and *palma* who proffers a lanceolate blade. Also analogous is the attendant figure to the right, who once again wears diagnostic rounded headgear with a net pattern and holds a baton. Given the same sacrificer figure, attendant figure, basic compositional schema, and ballcourt location, it would seem that the

South Ballcourt panel depicts the same rite as the ballcourt decapitation sacrifice shown on the Structure 2 panel. The panels depict two different moments in the same ritual sequence, hence the variation in several details. The South Ballcourt panel depicts a moment before the actual sacrifice has been performed and the figure has yet to be decapitated, while the Structure 2 panel shows the moment after the decapitation event.

Bird Dance

The final scene in the Tajín corner panel sequence involves an anthropomorphic bird figure hovering over a human (Fig. 3.9). The scene takes place

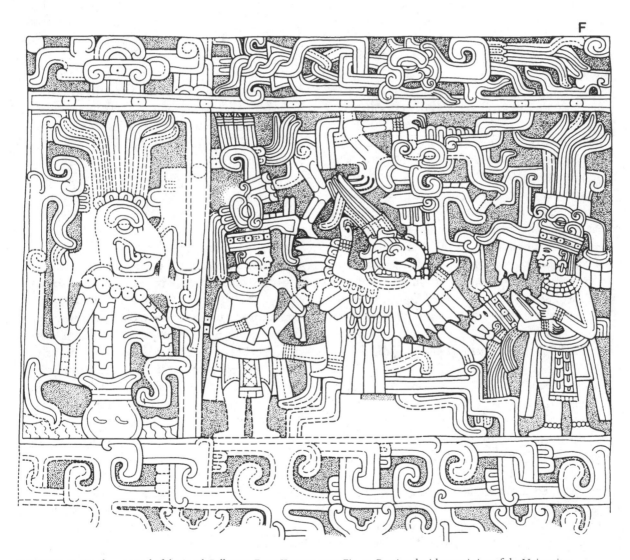

FIGURE 3.9. Southwest panel of the South Ballcourt. From Kampen 1972: Fig. 21. Reprinted with permission of the University Press of Florida.

in what Pascual Soto (1990:148) has identified as a mountain location, but it is probable, given the ballcourt location of the previous panel, that the mountain in this instance is a man-made pyramid or platform structure in the monumental center. Flanking the bird figure on both sides are musicians; the one on the left shakes a rattle, while the individual on the right beats a drum, suggesting that the central bird figure is dancing. A skeletal figure floats overhead, displaying the exposed chest cavity similar to other skeletal supernaturals at Tajín.

The central bird figure has a long, slightly hooked beak, brackets running along the crown of the head, and a bunched feather motif emerging from the crown. A beaded element rolls down the front of the beak. The wings consist of streamers attached to anthropomorphic arms. This bird figure is consistently associated with sacrifice at Tajín. An image from the Mound of the Building Columns (Fig. 4.2l) shows the same anthropomorphic bird descending on a disemboweled victim as another figure performs a decapitation. Note the diagnostic beaded object extending from the beak of the bird in both the South Ballcourt and Mound of the Building Columns examples.

Kampen (1972:37, 1978) has identified the natural model for this Tajín bird figure as a vulture. Diagnostic of this particular being is the long, slightly hooked beak, reminiscent of the King Vulture (*Sarcoramphus papa*) and relatives, and specifically opposed to the short, dramatically hooked beak of other bird figures at Tajín. While the beaded element hanging from the beak may represent the distinctive orange and red wattle of this largest of New World vultures, it certainly serves as the diagnostic characteristic of this Classic Veracruz avian figure. The raised brackets crowning the head, however, have no analog in the King Vulture. This bird and its relatives lack a crest, leading Wilkerson (1991:58) to suggest that this element represents the prominent crest of the harpy eagle. That this important figure could be a combination of two of the largest, most impressive carnivores in the lowland Veracruz sky is not surprising. Further, Kampen (1978) suggested that the human sacrificial rituals directly associated with this bird iconography would have drawn large numbers of these birds,

especially the vultures, to the monumental centers. They would have consumed any remnants of sacrifice, an act that may have been the natural model for images of the anthropomorphic bird consuming the victims' entrails. The bird dance, then, may have been based largely on the natural model of the vulture in pursuit of the carrion remaining after any human sacrifice.

A similar bird dancer is depicted in the panel cached in the platform fill of Structure 5 of the South Ballcourt (Fig. 3.4a). This panel was discussed above as a probable remnant of an earlier program at the South Ballcourt, but there is no doubt that the panel's themes and details relate to this portion of the later South Ballcourt program. In what must have been an earlier version of the bird dance iconography, the figure wears the top half of the vulture helmet, but instead of the full bird suit, he is dressed in a ballgame costume that includes a yoke with a bird-head *hacha,* a manikin figure on the back, and a single kneepad on the right knee. Scrolls extend from his mouth, and he holds a fan. Not only is the costume similar, but the figure may also show a relation both to music and dance, as we have already remarked for the later ballcourt panel. The scrolls emerging from the figure's mouth may be indicative either of speech or song, depending on the context. Further, the presence of a fan could indicate dance, as these objects were often used in dance ceremonies, and in some instances are the chief iconographic indicators of dance (Taube 2001). A closely related image on a *palma* from Coatépec, Veracruz (Fig. 3.10), shows the same vulture figure holding the head of the decapitated victim in one hand. The other hand holds the same lanceolate sacrificial blade seen in the previous Tajín panel showing decapitation sacrifice. The *palma* figure's vulture headdress contains not only the same long, slightly hooked beak seen at Tajín, but also the beaded element extending from the front of the beak that is diagnostic of this vulture figure. The Coatépec *palma,* then, securely links ballcourt decapitation and the vulture figure, and both images are seen in separate but related scenes at Tajín. Further, if one were to relate the two *palma* scenes in a continuous narrative, the vulture figure would appear during or just after the sacrifice has been made, given the severed head held by the figure. This makes a

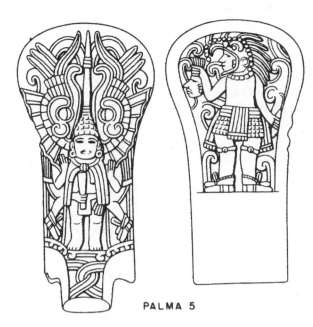

PALMA 5

FIGURE 3.10. *Palma* from Coatépec, Veracruz. After Proskouriakoff 1954: Fig. 6.5. Courtesy Carnegie Institution.

certain amount of sense given the carrion-eater model of the vulture, but it goes against every other reading of the Tajín panels, where the vulture dance is interpreted as a pre-sacrificial ritual, with the reclining figure described as the future victim. Javier Urcid (1993:148–152) identified an important pattern of bird dancers and reclining figures in Epiclassic Oaxaca (Fig. 3.11) and related it directly to the bird imagery at Tajín. In his Monte Albán example, a bird figure grasps a captive by one talon while acknowledging a reclining figure in the lower center of the composition. This pair of figures duplicates the central part of the Tajín panel (Fig. 3.9), as Urcid points out. The carved stone comes from a structure immediately adjacent to the main plaza ballcourt at Monte Albán, suggesting a connection with ballcourt activities that would parallel the Tajín context. The Monte Albán stone adds the submissive figure, probably a sacrificial victim, to the iconographical complex.

Most importantly, it is clear that the reclining figure in the Monte Albán carving is not a sacrificial victim, but the receiver of the sacrifice. The bird figure presents the sacrificial victim to the reclining figure, as Urcid demonstrated. One can make an argument that this is true for the related Tajín panel as well. The crossed arms gesture of the reclining figure at Tajín is associated with

high rank and the reception of sacrifice elsewhere at Tajín. This suggests that the Tajín figure is not the sacrificial victim. A post-sacrificial placement of the scene would also agree with *palma* imagery showing the vulture wheeling around the remains of sacrifice (Kampen 1978) as well as with the imagery on the Coatépec *palma* depicting the human vulture dancer holding the head of decapitation sacrifice (Fig. 3.10). Thus I agree with Urcid (1993:148, n. 17) that the traditional ordering of the Tajín corner panels, which ends with the decapitation panel, is probably wrong: instead of preparing the way for the final sacrifice, the vulture dance as illustrated at Tajín and Monte Albán must follow the decapitation of the victim in the ballcourt.

Images of the bird dancer in a ballgame context are not limited to Tajín and Monte Albán during the Epiclassic, but are found in several other key sites of the period. The most striking comparison is with a carving found in the sunken ballcourt (Ballcourt 1) at Tula Grande (Fig. 3.12). Its image of a bird dancer is remarkably similar to the Tajín figure found in the fill of Structure 5 (Fig. 3.4a). The Tula figure wears the hooked-beak bird headdress of this vulture complex, along with the large kneepad on the right knee and the tufted sandals also evident in the early Tajín panel. Speech scrolls emanate from the mouth of the figure, just as in the early Tajín panel. The figure raises his left foot in a posture that for the Maya (Grübe 1992) signals dance. Dance and music seem to be important elements in the ballcourt vulture iconography at Tajín as well, as we have seen. Around the figure's waist is a thick belt, almost certainly a yoke, as in the Tajín panel. Thus it seems that at Tula a vulture dance was also represented in a central ballcourt, in a panel format very reminiscent of that seen in an early example of the same imagery at Tajín.

FIGURE 3.11. Stone NP-5 from the shrine near the main plaza ballcourt at Monte Albán. After Urcid 1993: Fig. 13, middle. Courtesy of Javier Urcid.

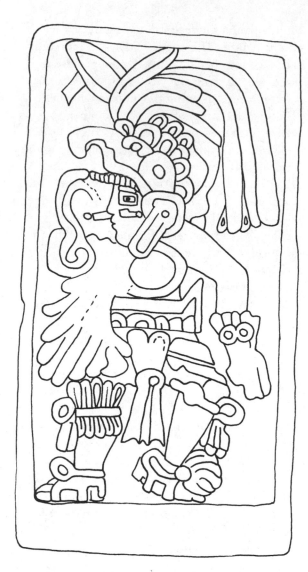

FIGURE 3.12. Panel from the sunken ballcourt (Ballcourt 1) at Tula. Drawing by Daniela Koontz.

The public imagery of Tula and Tajín have rarely been compared despite their relative proximity and at least a partial overlap in their histories. Tula is closer to Tajín than many sites with which Tajín has been compared, while distant Chichén Itzá is the leading comparative site for Tula. Previously, the lack of any substantial markers of interaction led researchers to suppose a hostile relationship between Tula and Tajín (Diehl 1983). The identification of a ballcourt dancer at Tula with specific iconographic ties to Tajín and Classic Veracruz is interesting not only in relation to the larger Mesoamerican bird dance/ballcourt sacrifice complex we have seen in several areas, but also as a marker of some sort of

relation between the Epiclassic/Early Postclassic capitals of this part of Mesoamerica. According to Acosta (1940:173), the excavator of the court, this ballcourt program at one time had many more panels, but these were lost when the court was brutally desecrated in pre-Columbian times (Acosta 1940:173). Given the strong similarity in what does exist, perhaps there was more ballcourt imagery here comparable to that of Tajín; of course, we will never know.

While there is a specific relation with Tula and the vulture dancer, the South Ballcourt at El Tajín contains a closer and more complex relationship with the Great Ballcourt of the site most often linked to Tula, Chichén Itzá. The Great Ballcourt was likely dedicated in the middle of the ninth century (Wren and Schmidt 1991:204–209), making it fully contemporaneous with the apogee of Tajín. The court's unusual form, with a high bench capped by a much reduced apron, is very similar to Tajín's South Ballcourt, but unlike the form of most other courts at Tajín, Chichén Itzá, and generally throughout Epiclassic Mesoamerica, which had long, sloping aprons.[20] Ringle (2004:170) has suggested that Chichén Itzá's Great Ballcourt was primarily a ceremonial space that served as a monumental effigy of a ballcourt and for that reason did not need to conform to more pragmatic considerations of ballgame play. The same argument can be made for the Tajín court, which has a very similar profile and is also outsized compared with other Tajín courts.[21] The decoration of the two courts has long been compared; each has six large, carved panels spaced evenly along the benches, with one on each corner and one at the center of each bench. Although the iconographic program is markedly different, they both feature ballcourt decapitation, though even this scene is depicted differently in each case. As already discussed, the representational convention that features a decapitated player with serpents emerging from the neck is found elsewhere at Tajín as well as in several of the important Gulf lowland sites between Tajín and Chichén Itzá, suggesting that variations on the ballgame cult could be found throughout the area. Most importantly, the figures in Chichén Itzá's Great Ballcourt panels sport a combination of yoke and *palma* around their waists. Stone yokes related to those of Clas-

sic Veracruz have been found in several Epiclassic Maya lowland contexts. The use of the yoke/ *palma* pair, however, is limited almost exclusively to the north-central Gulf lowlands (Proskouriakoff 1954), with a few interesting outlying examples from the south coast of Guatemala (Shook and Marquis 1996). In all known instances of ballgame decapitation imagery from the Gulf lowlands, the decapitated victim wears the yoke/ *palma* combination, as he does at Chichén Itzá. This suggests a further, specific ballgame decapitation cult working along the Gulf lowlands.

Freidel, Schele, and Parker (1993:383–385) convincingly argue that much of the imagery decorating the Great Ballcourt at Chichén Itzá drew directly on lowland Maya iconographic traditions. The Maya-ness of the Great Ballcourt is not at stake here; what begs to be explained is the sharing of very specific architectural forms, specialized objects, and iconographic conventions along the Gulf lowlands and into Yucatan. It is possible that some of these ballcourt rites and their associated imagery could even have been

innovated at Chichén Itzá rather than the Gulf lowlands, but there is too little imagery left to us to create anything like sufficient genealogies of Gulf lowland ballcourt imagery. Current evidence suggests that certain Gulf Coast objects, and perhaps rites, were being incorporated into this system in order to form a ballcourt sacrifice cult network up and down the Gulf Coast.

Central Panels: Supernaturals at the Ballcourt

The two remaining panels in the Tajín ballcourt sequence are located in the center position of each bench (Figs. 3.13, 3.14).[22] These central panels vary only slightly in their configuration from the corner panels described above. The framing is consistent on both and slightly more elaborate than that seen on the corner panels: the basal band of scrolls is a slightly more ornate version of those seen on the corner panels (compare Fig. 3.1), while on the sides, four columns of repeat-

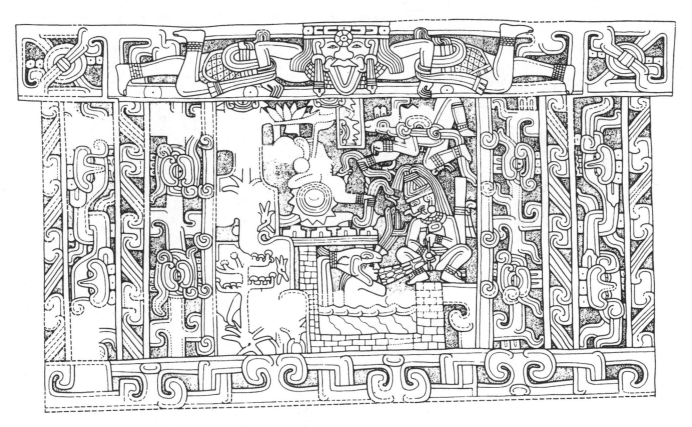

FIGURE 3.13. South-central panel of the South Ballcourt, El Tajín. After Kampen 1972: Fig. 24. Reprinted with permission of the University Press of Florida.

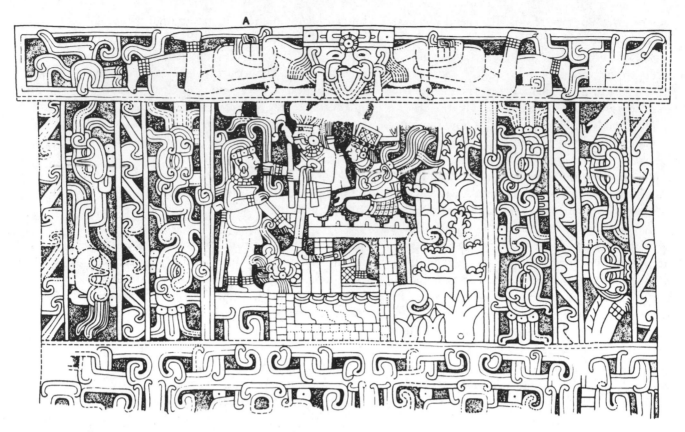

FIGURE 3.14. North-central panel of the South Ballcourt, El Tajín. After Kampen 1972: Fig. 25. Reprinted with permission of the University Press of Florida.

ing motifs, not seen in the corner panels, contain columns of zoomorphic heads alternating with columns of interlocking scrolls. The interlocking scroll design contains a line carved in the middle of the straight portion, which in many other contexts at Tajín appears to represent bone (García Payón 1963:247).

The frames serve to unify the central panels and distinguish them from the corner panels of the South Ballcourt program. Like the corner panels, however, the central element in each composition is a complex narrative scene. Three major features in these two scenes are identical: a temple filled with liquid and surmounted by stepped roof ornaments, a mountain covered in flowering plants, and a specific central protagonist. The consistent location (the same temple and mountain) and the consistent main character strongly suggest that the central panels express closely related themes and may contain a continuous narrative.

The central actor in both scenes is marked by the supraorbital plate indicative of Tajín super-

naturals. Other diagnostic traits include the curved fang set into the corner of the mouth, surmounted by an element that runs along the top of the mouth and curls at either end. The same curved fang and lip curl are found in numerous representations in Classic period Teotihuacan, Epiclassic Xochicalco, and in Late Post-Classic Central Mexico. The Nahuatl speakers of Central Mexico called the fanged supernatural Tlaloc, a name now generally attributed to any representation of this figure without respect to the language used at the place of manufacture. The correspondences between the Mesoamerican Tlaloc imagery and the central figure of the Tajín panels led García Payón (1963:248, 1973b:35) to identify the Tajín representation as Tlaloc.

Delhalle and Luykx (1986:118) identify this figure as Ehecatl, another Late Postclassic Central Mexican deity with wind associations, citing the single curved fang at the side of the mouth as the diagnostic iconographic characteristic of both the Tajín and the Late Postclassic Central Mexican deities. Perhaps more important to their

argument is the identification of the Tajín figure with creative acts later associated with Ehecatl-Quetzalcoatl. While the Tajín figure's role as creator similar to the Late Postclassic Ehecatl-Quetzalcoatl is well established (see below), many other acts and accouterments associated with the Late Postclassic Central Mexican deity never appear with the Tajín figure. Ehecatl often has a curved fang at the corner of his duck-billed mask in Late Postclassic codices, but the absence of the duck bill on the Principal Tajín Deity, its appearance on other beings at Tajín, and the Principal Tajín Deity's close relationship with lightning (not a main trait of the later Central Mexican deity) argue against a complete identification with Ehecatl. The most important example of Ehecatl-Quetzalcoatl traits associated with other Tajín figures occurs on these same central ballcourt panels, where a figure hovers just over the central frame, doubled in body but sharing one central, frontal face (Fig. 3.15). This figure wears the duck-bill mask later diagnostic of Ehecatl (O'Mack 1991; Bertels 1991; Ladrón de Guevara 1999:104–105), but in other respects it is fundamentally different from both the Tajín deity pictured below and the Late Postclassic Ehecatl. Most importantly, the hovering Tajín figure does not have the supraorbital plate of deities at the site, but instead has clearly human eyes and thus must be a human ritualist wearing a duck-billed mask. The distinction between human deity impersonators and the deities themselves is famously fluid in Mesoamerican thought, but in the Tajín iconographic system there is a careful distinction between the two, forcing us to consider what was clearly an important categorical distinction for the creators of the iconography. This distinction may have been crucial not only to Tajín elites, but across the Gulf lowlands, as evidenced by the corpus of small-scale sculpture

and ceramic figures brought together by Medellín Zenil (1957), which includes mainly deity impersonators with duck-billed masks. The creator of the famous Tuxtla Statuette, which may be a Late Formative ancestor to this figure, also took pains to identify the wearer of the mask as human. Any substantive relation between these two Gulf lowland duck-billed impersonators, dated more than half a millennium apart, awaits the historical treatment of the figure begun by Medellín Zenil, a task well outside the scope of this book. What is important here is that multiple Tajín deities and impersonators contain aspects of the Late Postclassic Ehecatl-Quetzalcoatl. The latter simply cannot be identified with any one Tajín deity.

Thus the identification of the primary deity of the central ballcourt panels raises many of the problems endemic to the study of supernaturals in Tajín imagery, and indeed to any iconographic study at the site. The use of analogy is again one point of contention: can we productively use Central Mexican deities and deity systems when referring to a Tajín god? Even before the complexities outlined above became apparent, many students of Tajín iconography had moved closer to a negative response. In an important work on vultures and bats in the iconography of the region, Kampen (1978) found important deities and deity impersonators that seemed to have no direct connection with any Central Mexican deity. He thus became an early proponent of a Tajín deity system irreducible to Central Mexican analogs. Other iconographers have since reestablished important resemblances between several Tajín deities and Central Mexican or other Mesoamerican analogs (Taube 1986; Delhalle and Luykx 1986; Ladrón de Guevara 1999:103–108). As we found in other aspects of Tajín iconography, the most productive analogies are those

FIGURE 3.15. Detail of figure in the top frame of the south-central panel of the South Ballcourt, El Tajín. Drawing by Daniela Koontz.

with multiple points of resemblance combined in similar formations. In this specific case, the fanged deity of the central court panels at Tajín is not limited to aspects of the later Tlaloc, but combines elements of several later Central Mexican deities in a distinct fashion (Ladrón de Guevara 1999:105). Many aspects of the deity seem much more analogous to later Nahua beliefs tied to Quetzalcoatl, as well as to traits found in the Maya deities Chaak and God H (Wind God).[23] Crucial to this story, but only now coming into view as evidence, is the tantalizing but small sample of earlier (Cacahuatal phase, ca. AD 350–600) representations of this deity in the region, especially as a major figure of early tripod cylinder decoration (Pascual Soto 2000:30). We simply do not know enough about this regional deity's history to posit a similar combination of elements to that seen at El Tajín, but it is likely that as more iconographic evidence is discovered in the region, this deity will be found ancestral to the Tajín fanged god and may be somehow related to other contemporary versions of the Teotihuacan Tlaloc, or Storm God, with that deity's fangs and associations with lightning.

Returning to the supernatural at the center of the Tajín ballcourt compositions, although this deity is undeniably linked to a Mesoamerican complex of fanged deities associated with lightning, I prefer the designation "Principal Tajín Deity." The Tajín version is found in very specific contexts that often do not reflect later Aztec definition and use, nor does it seem to follow in its entirety any other specific Mesoamerican tradition. As we will see, this deity combines supernatural traits found throughout Mesoamerica to create a specific, localized deity. Most importantly, this deity served as patron of the site, dispensing items crucial for power and serving as a fundamental creator.

In both the central narrative scenes (Figs. 3.13, 3.14), the Principal Tajín Deity is associated with two interrelated toponyms: a structure that includes a base filled with liquid and a roof surmounted by ornaments with a step design (referred to as the Water Temple for reasons that will become evident below), and a mountain dotted with flowering plants (referred to as Flowering Mountain). The band above Flowering Mountain contains symbols known to represent stars or other astral bodies. The main elements in this scene—the Water Temple, Flowering Mountain, and the Principal Tajín Deity—appear nowhere else in the South Ballcourt program save these two panels, suggesting that the narrative scenes of the central panels are to be read as a pair. Thus, like the frames that surround them, the narrative scenes of the two central panels are distinguished from the rest of the program, yet closely related to each other.

Of the two central panels, the narrative scene best understood occurs on the south-central panel (Fig. 3.13). Here four figures are composed around the Water Temple and Flowering Mountain. The topmost figure in the central scene is an anthropomorphic rabbit with the supraorbital plate of a supernatural. Beneath this figure are two other anthropomorphs. The individual on the left is badly abraded, but one can make out a disk over the abdomen with the telltale scalloped markings of stellar symbols at Tajín. Both this figure and the upper anthropomorphic rabbit hold undulating, highly conventionalized forms that have long been identified as lightning serpents (Taube 1986:55). A twisted cord connects the two serpents. The final figure, squatting before the Water Temple, is the Principal Tajín Deity, who performs autosacrifice by perforating his penis and letting the blood flow into the Water Temple (Tuggle 1970). Sitting inside this structure, receiving the blood offering, is a partially submerged human figure with a fish mask.

Taube (1986:54–56) and Delhalle and Luykx (1986) have both suggested that this portion of the scene mirrors the later Nahua creation saga found in the *Leyenda de los Soles* (Bierhorst 1992:145–146).[24] The cited passage recounts the creation of humanity through the sacrificial acts of deities. The hero of the narrative, Quetzalcoatl, must go to the Land of the Dead (Mictlan) to recover the bones of a previous set of humans. After leaving the Land of the Dead, he performs autosacrifice (specifically penis perforation) on the bones, and mankind is born. Taube (1986:54–56) suggests that the Principal Tajín Deity is here analogous to Quetzalcoatl in the *Leyenda de los Soles* narrative. The principal deity's autosacrifice, however, soaks a man in a fish mask, not the "precious bones" mentioned in the later Nahua text as the raw material of human creation.

Nevertheless, the logic of these passages suggests fish and bones may actually be the same thing. Taube and Delhalle and Luykx cite a parallel passage from the Nahua creation saga in *Histoire du Mechique* in which the bones of human creation are clearly linked to the people of the previous creation (Garibay 1965:104–106). These beings were a flawed humanity eventually destroyed by floods and turned into other creatures, most notably fish in the *Leyenda de los Soles* version (Bierhorst 1992:143).[25] Additionally, and closer in space to Tajín, the Huastec to the north describe the peoples of the previous creation as fish in creation epics collected in the twentieth century (Alcorn 1984:60–61). Returning to the Tajín image, the fish-masked man can be seen as a representative of the beings of a previous creation, and thus the proper raw material for the creation of humankind. The Principal Tajín Deity's auto-sacrifice is the supernatural action necessary to initiate the process, directly analogous to Quetzalcoatl's autosacrifice in later Nahua creation sagas.

The way in which the Principal Tajín Deity is shown to generate humanity deserves further comment. While similar scenes of autosacrifice via penis perforation or the like are shown elsewhere at Tajín (see Fig. 3.17a) and are depicted in related Huastec art (Fig. 3.16; Wilkerson 1991:68–69), these sacrificing figures are shown standing. The Principal Tajín Deity, on the other hand, appears in a specific squatting posture that elsewhere in Mesoamerican art is consistently associated with childbirth (Klein 1976; Fox 1993). On one level this is entirely appropriate, given that the deity is here "giving birth" to humans by creating them, even though the deity is clearly male.[26] Around the scene describing the creation of humankind are other allusions to primordial time, specifically the "raising" or setting of the sky in place at the beginning of time. This is not surprising given the context, for raising or setting the sky is a principal activity in most if not all major Mesoamerican narratives treating the creation of the cosmos. In the *Leyenda de los Soles,* the later Nahua text cited above as an analogy for the creation of humans, the establishment of the sky is referred to in the passage immediately preceding the creation of humans through supernatural sacrifice (Bierhorst 1988:144–145). Other

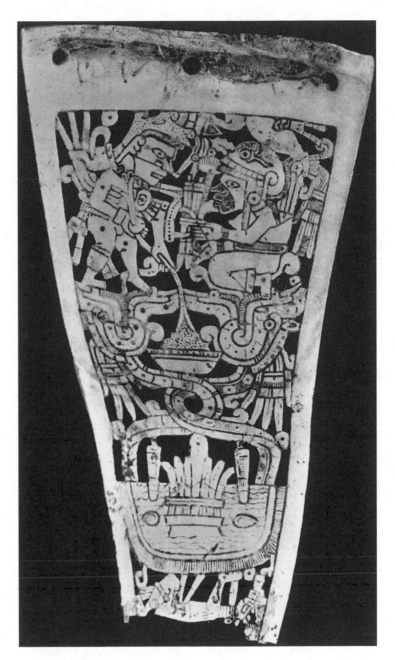

FIGURE 3.16. Huastec gorget with sacrificial scene. After Beyer 1934.

Nahua cosmogonic narratives, such as the *Histoire du Mechique* (Garibay 1965:105–106) and the *Historia de los mexicanos por sus pinturas* (Garibay 1965: 25, 32) also link human genesis with the setting of the sky by deities. In the Tajín cosmogony, while the Principal Tajín Deity creates humankind below, the Flowering Mountain seems to support the sky, the latter represented by a star band. The same sort of star band is used as the symbol for the newly created sky in other Mesoamerican accounts of creation, such as that found in

the later Mixtec *Codex Vindobonensis* (Furst 1978; King 1990).

Other iconographic aspects in this panel also suggest the setting or raising of the sky. The anthropomorphic, star-marked rabbit figure hovering over the scene has been identified as the moon (Wilkerson 1984:126). The lunar rabbit is a well-known symbolic figure across Mesoamerica and can appear in ballgame narratives that include decapitation (Knauth 1961:192). It is not unusual in Mesoamerican cosmogonies for the lunar rabbit to appear as the sky is created (López Austin 1993:333). Interestingly, it is the nearby Huastec that brought together fish-people, creation, and rabbits very clearly: in a contemporary creation tale, as people of a previous creation were turned into fish by a flood, a wise rabbit was saved by floating on the rising waters on a large chest. He disembarked on the moon, where he remains today (Alcorn 1984:60–61).

A modern Huastec tale with many of the same elements as a pre-Columbian Tajín panel offers yet another bit of evidence for a coherent body of Mesoamerican beliefs and practices, especially as they concern lunar rabbits and the creation of the universe (López Austin 1996:1–7). There may be a more historically explicit link to this Huastec/Tajín congruence, however, for one can trace specific iconographic compounds seen on the Tajín panel forward in time to Postclassic Huastec art. Both Delhalle and Luykx (1986:119–120) and Wilkerson (1991:68–70) cite a Postclassic Huastec gorget with several key iconographic elements seen also in the Tajín panel (Fig. 3.16). The top left portion of this carved shell shows a figure grasping his penis and holding a connected tube that leads the blood flow to a bowl beneath. Although this figure is standing, not squatting, it is clear that a penis perforation sacrifice similar to that seen in the Tajín panel is occurring here. Also, below the sacrificial bowl is a container of liquid that is comparable to the Water Temple in form and function. The presence of shells identifies this area as a watery environment, and the floating feathered platform serves the same function as the temple motif surrounding the Tajín water place. Taube (1986:52) cites another Huastec gorget with a figure performing penis perforation sacrifice over a small temple and a single

fish (see Beyer 1934: Fig. 37). Here again, as at Tajín, the autosacrifice is related to watery temple places.

Although the larger context of the autosacrifice shown on the Huastec gorget must remain open, it is clear that the protagonists are gods or their impersonators, as in the Tajín case. Beyer (1934) identifies the male figure on the left as a Huastec version of Mixcoatl, largely due to the characteristic face paint, the deer-hoof earplug, and the single eagle plume in the headdress—all markers of the deity in the Late Postclassic and early Colonial Central Mexican codices. Beyer brilliantly identifies the cut shell ornament worn by this Huastec version of Mixcoatl with the actual shell object in question: one can make out the typical S-curve of the shell gorget near the back of the Mixcoatl figure's neck. Beyer goes on to identify this deity on related Huastec shell objects, specifically in fire-drilling scenes. Fire-drilling is often connected to creator deities, particularly in Postclassic Mesoamerican narratives (Nicholson 1971:400). A creator deity also drills fire in the more recent Huastec creation narrative cited above (Alcorn 1984:61). The Huastec deity of penis perforation and fire-drilling may thus be related to Mesoamerican cosmogonic narratives, also the main theme of the Tajín penis perforation sacrifice. The Epiclassic Tajín and Postclassic Huastec creation imagery depicts closely analogous sacrificial rituals combined with analogous sacred places, suggesting a related tradition of cosmogonic narrative and ritual.

In addition to the autosacrificing male deity, the Huastec gorget shows us a female ritualist whom Beyer (1934) identifies as a deity or avatar. The face paint associates her specifically with the Huastec goddess recognized most readily by her Nahuatl appellation, Tlazolteotl, but known in Huastec as Ixcuinan. She holds two darts that she seems to be presenting to the male figure. Her headdress also speaks of war and death in the form of a skull with a sacrificial blade emerging from the nasal cavity. The skull is surmounted by a fish, once again closely associating fish and bones, and it is tempting to see this as a reference to the narrative of the creation of humans from earlier fish peoples. On her back she carries an elaborate feather ornament or bundle. The

Tajín panel also has a partner for the central deity, but that figure has no female markings and is probably male. This latter figure is not involved in the manipulation of warfare items, as is the Huastec female, but earlier in the Tajín sequence we saw just such a delivery of arms by a supernatural on the second panel in the sequence (the southeast corner panel; Fig. 3.6). The female on the Huastec gorget may be engaged in the same donation of arms, although the human recipient is not as clearly indicated here. If this is the case, then the Huastec gorget may be read as a compressed version of the Tajín ballcourt imagery, with the donation of war implements and the autosacrificial rite of the deity here joined in a single scene. The deity genders may have shifted, and the narrative is compressed, but given the specificity of the engendering autosacrificial rite paired with the donation of arms, it is probable that the Huastec gorget expresses certain supernatural roles and rites that are directly analogous to those in the Tajín panels.

Returning to the Tajín ballcourt narrative, in the final central panel narrative scene (Fig. 3.14), the Principal Tajín Deity and another supernatural sit on top of the Water Temple. The Principal Tajín Deity holds a baton in his right hand and has a cloth draped over his left arm. The deity offers these two objects, along with a curved element that has been interpreted as lightning (García Payón 1973b:38; Taube 1986), to the human standing before him. The human points to a bundled, reclining figure with a distinctive hank of hair, a supraorbital plate, and an elongated upper lip. Ladrón de Guevara (1999:109) has rightly identified this figure as a sacrificial victim. More specifically, the traits seen in the head of the reclining figure appear in only one other instance at Tajín: as two severed head offerings marked by the same hank of hair and elongated lip (Fig. 3.18b). Given the scarcity and specificity of this figure in Tajín imagery, the bundled figure seen at the bottom of the South Ballcourt central panel can be identified with the sacrificial severed head, here as a full-figure personification. To summarize the hypothesized narrative movement to this point, then, the corner panel sequence that features decapitation sacrifice in the ballcourt would have produced the severed head. The result of this ritual is now being laid at the foot of the Principal Tajín Deity, just as the severed heads of ballcourt sacrifice are laid at the foot of important Tajín personages throughout the site's iconography.

In return for this sacrificial offering, the Principal Tajín Deity offers the cloth and baton to the human. These two items appear constantly in the iconography of this ballcourt, as well as in other key images at Tajín. For example, the left flanking figure of the northwest panel holds an identical baton at the beginning of the ballcourt sequence (Fig. 3.1). Above both central panels the floating figure has what must be the same cloth wrapped over his arm in much the same way as the sash drapes the arm of the Principal Tajín Deity below. The cloth and baton are easily the most prominent objects in the South Ballcourt imagery and must have been central to the rites held there. But what did these objects signify? To attempt to answer this question we must leave the South Ballcourt and examine related imagery both at Tajín and elsewhere across the Gulf lowlands.

The relation of the baton to ballcourt decapitation sacrifice is not limited to El Tajín, but appears in other Classic Veracruz imagery. An important example is the Coatépec palma (Fig. 3.10) discussed above which presents the vulture dance with a severed head, a key element of the Tajín ballcourt ritual. On the other side of this palma, a single individual is depicted frontally wearing an elaborate cape and holding a baton, thus directly connecting the taking of a head and the wielding of a baton, as in the South Ballcourt sequence at Tajín.

It is the presence of the cape on the palma figure that further connects the scenes to a particularly telling Tajín sequence elsewhere. The only Tajín scene where the baton and cape appear together is in the Mound of the Building Columns sequence (Fig. 4.6b), in which a figure with a cape and quechquemitl (a triangular garment usually worn by females) stands between a human figure holding a baton on the left and the Principal Tajín Deity on the right. The deity holds a large, soft, rectangular object. Given its pairing with the baton and its associations with the Principal Tajín Deity, as well as the soft quality of the

material, this must be a large version of the cloth seen elsewhere. I will argue at length in the following chapter that this scene is the culmination of the Mound of the Building Columns program and represents the accession of the caped figure, named 13 Rabbit, to high political office. The evidence for reading this scene as accession is complex but includes clear markers of such rites throughout Mesoamerica, such as the donation of specific objects to humans by patron deities, sacrificial rites legitimating the proceedings, specific scaffold rites used during the inauguration, and the proclamation of the new ruler's prowess at war. If this argument is accepted, the association of the cloth and baton with 13 Rabbit suggests that the two items are central emblems of authority at Tajín. The combination of baton, cape, and decapitation sacrifice in the *palma* imagery would be another example of this regional imagery of accession. Most importantly for us, and remaining within the bounds of Tajín iconography, the close correspondences between the cloth and baton donation scenes in the Mound of the Building Columns and the South Ballcourt would strongly suggest that the ballcourt scene describes the main character's accession to political office.

While central to the argument for meaning presented here, firmly identifying depictions of accession or other ceremonies of fundamental political import is not evident for Tajín. We have no texts from Tajín describing accession ceremonies, as we do for the Maya. Maya texts were fundamental to the identification of accession ceremonies in Classic Maya imagery, as were name glyphs and recognizable accession dates for the Aztec and Mixtec. Nor are there colonial records for Tajín with images of the pomp surrounding the transfer of power and the clearly identified items involved in those rites, as we have for the Aztecs and others in Late Postclassic Mesoamerica. We have no burials that would qualify as those of rulers of the site, and thus no archaeological records of possible regalia. To bring the rites portrayed at Tajín into better focus, we do have recourse to well-known Mesoamerican similarities in the context and structure of accession ceremonies (Stuart 2001). Certain important aspects of the context we have thus far

sketched at Tajín mesh well with general patterns of Mesoamerican accession: chief among these is the donation of certain items (here the baton and cloth) from gods to humans. These items are obviously imbued with great power for those who hold them, hence their centrality in rites of accession. Also central to many Mesoamerican rites are the sacrificial ceremonies surrounding accession, such as the ballcourt decapitation rite seen in the South Ballcourt, as well as the proclamation of the new ruler's prowess in war, seen in the supernatural donation of the implements of war and the parading of war captives in that program. In sum, the major scenes and the most prominent iconographic motifs of the South Ballcourt may be best understood as an accession narrative.

Creation and Political Power

When viewed together, the central panels of the South Ballcourt at Tajín structurally equate ballcourt sacrifice and the accession of a ruler with the creation of the cosmos and humans. Both events are shown at the Flowering Mountain/ Water Temple location, and both are presided over by the Principal Tajín Deity. By setting the legitimation of political power through ritual in the same context as the creation of the cosmos and of humans, the authors of the South Ballcourt program anchored human ritual and its attendant power in the pristine moment of creation.

This simple equation between ballcourt sacrifice, accession, and creation reveals the logical relationship between the sacrifice of the corner panels and the actions of the gods in the central panels (Taube 1986:55; Wilkerson 1984, 1991:63–65). The corner panels, with their depiction of alliance, supernatural sanction, and sacrifice, describe the rituals necessary to obtain the victim and the proper method of sacrifice. Widely distributed ritual complexes, such as ballcourt alliance, supernaturally sanctioned warfare, the War Serpent, decapitation sacrifice, and the bird dance anchor the sequence in the Mesoamerican vocabulary of legitimation. The ballcourt sacrifice serves as the linchpin, uniting

the preparatory rites of the corner panels with the supernatural actions of the central panels. In his discussion of the logic of sacrifice, Edmund Leach (1976:84) argued that "the donor provides a bridge between the world of gods and the world of men across which the potency of the gods can flow." More specifically, the logic of sacrifice in Mesoamerica consistently involves recourse to the beginning of the practice at the dawn of time, when the covenant between gods and humans was established (Monaghan 1990:566). In the case of the Tajín panel, the donor of the severed head provides the sacrificial bridge across which the items of legitimacy may flow, and that exchange is likened to the creation of humans and their environment through the sacrifice of the gods.

The Place of Pulque

The central panels' imagery of creation and accession is located in an environment defined largely by Flowering Mountain and its large maguey plants. Given the importance of these plants to the setting, several earlier interpretations of the central panels explored a possible pulque cult (Garcia Payón 1973b:34–48; Wilkerson 1984, 1991). The maguey plants are shown in various stages of growth and harvest, some of which certainly could produce pulque (Bye and Linares 2001:39). It is important to note, however, that the large plants with prominent stalks in flower could not be used to produce the beverage: the flowering stalks must be cut back very early in their growth cycle to allow harvesting of the sap for pulque production (Parsons 2001:6). The large, flowering stalks on some of the most prominent maguey plants on the central panels would have made these plants unfit for pulque production, but obviously still valuable as a symbolic motif. It appears, then, that the representation of maguey at Tajín is symbolically rich, but may be conceived only in part as a reference to the production of pulque. The presence of pulque maguey (*Agave salmiana* and related) in these scenes is not explained by the above reading that privileges the creation of the cosmos and humans. The interpretations of the Flower-

ing Mountain location based on pulque are not without their problems, as we shall see, but they do explain the otherwise anomalous appearance of this plant at the lowland site of El Tajín. These hypotheses are so embedded in the literature and so important as a supplement to the creation narratives above that they deserve a detailed discussion here.

The presence of maguey in Tajín imagery is anomalous because maguey does not grow well in the Tajín area under normal circumstances. Kelly and Palerm (1952) found no evidence for maguey cultivation or use in their treatment of indigenous agriculture in the mid-twentieth century around El Tajín, nor is there any mention of agave cultivation or pulque production in the early Colonial records from the area (García Payón 1965). A brief mention of induced cultivation and remnant agaves in the area deserves further research, but it has yet to be firmly documented (Cortéz Hernández 1989:181). While the importance of pulque for Mesoamericans is well documented, the most intense area of production and consumption was and is the arid highlands of Mexico, especially those areas over 1,800 m in elevation (Tajín is at 180 m). Variants of pulque were not unknown in northern Veracruz—the Postclassic Huastec were described by the Nahua and the Spanish as great drinkers of the beverage (Stresser-Péan 1971:599)—but many Huastec lived at over 1,000 m and would have had much easier access to maguey cultivation. It is clear that the maguey necessary for pulque production would not have been a significant presence on the landscape in the immediate Tajín area.

Both García Payón (1973b) and Wilkerson (1984:126) assume a pulque cult at Tajín without directly addressing the paucity of maguey in the area. The lack of maguey is not an insurmountable obstacle, however: the lowland Maya also had a culture of pulque drinking (Houston 2000:156) even though large areas of the territory are less than ideal for maguey cultivation. A pulque cult in an area without maguey is possible given the evidence for the later movement of *aguamiel* (the concentrated sap of the agave) through trade and tribute (e.g., *Codex Mendoza* 26v), as well as the movement of the processed *aoctli* ("yellow pulque") variety over relatively

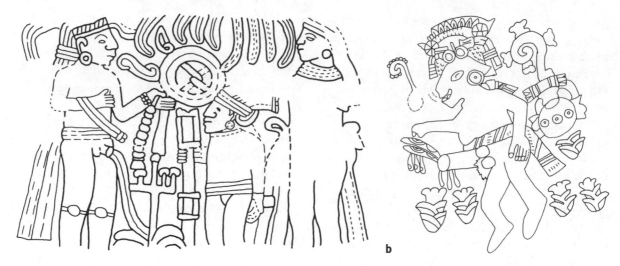

a b

FIGURE 3.17. Maguey rites of autosacrifice: *a*, detail of figure and maguey on the south column, Structure of the Columns, El Tajín (drawing by the author after Kampen 1972: Fig. 33c); *b*, figure painted on patio floor, La Ventilla, Teotihuacan (drawing by the author after Zuñiga 1995:184).

long distances. *Aoctli* was ready to drink, more easily transported, and reserved for the nobility, thus becoming an important item of tribute (Bye and Linares 2001:39). Both García Payón and Wilkerson assert that what we have termed Flowering Mountain in the Tajín panels may be identified with the later Nahua Pozonaltepetl, or Mountain of Foam, from which pulque originated. Wilkerson goes on identify the rabbit hovering over the scene as representing the 400 Rabbits of Late Postclassic Nahua narrative, figures with strong pulque associations.[27] Finally, the Water Temple is in this argument identified as a pulque vat, and the autosacrifice of the Principal Tajín Deity as the transformation of blood to pulque.

While Flowering Mountain has clear associations with maguey and pulque, the identification of the Water Temple as specifically a pulque vat, and the rabbit solely as a stand-in for the 400 Rabbits of pulque lore, is less convincing. The representation of the liquid in the central panel, with its gently undulating forms, resembles depictions of water elsewhere at Tajín and throughout later Mesoamerican art. Pulque is usually shown with a rising head of foam at the top of the liquid (Nicholson 1991). The rabbit figure contains a serrated sign on his chest that at Tajín is clearly related to stars or other astral bodies, and the presence of rabbits in related

creation accounts from Central Mexico and the Huasteca cited above explains most effectively the presence of such a being in the sky.

A final consideration is the water imagery elsewhere in the South Ballcourt imagery and its relation to the central scenes. We saw earlier that each of the corner panels in the South Ballcourt contains a frame with a skeletal figure rising from a jar, the latter floating in what is depicted as the same liquid seen in the central panels (Figs. 3.1, 3.6, 3.8, 3.9). I identified these panels as marking Skull Places at the center of the court, which according to Central Mexican analogies were the place from which water and, by extension, fecundity were seen to flow. In short, while agave and pulque are undeniably important to the iconography of these central scenes, the reduction of all liquid references in the program to pulque is problematic. We return to the iconography of maguey at Tajín with this problem in mind. Although the depiction of maguey is rare in Tajín iconography, we have already seen one other instance where a rite centers on the male member and maguey (Fig. 3.17a). In this image a human figure is holding a bead string and a cloth—important prestige goods at Tajín—while a liquid flows from his penis onto the flowering maguey directly before him. Note that the Principal Tajín Deity also holds a cloth around the arm in one central panel, and in the other this same deity is

shown in a related autosacrificial rite. Given the presence of the cloth, a maguey plant, and the rite centering on autosacrifice using the male member, it is likely that the human figure here is enacting some variant of the primordial rite performed by the Principal Tajín Deity in the central panels.

Despite the close ties with the Principal Tajín Deity's blood sacrifice, the liquid dripping from the human has been interpreted as several substances, most importantly semen (Kampen 1972: Fig. 33c). Liquid falling from a male member onto maguey plants also appears in the art of Teotihuacan (Aguilera and Cabrera Castro 1999; Rivas Castro 2001:58–60). Here (Fig. 3.17b) an ithyphallic figure seems to be irrigating the maguey plants directly below. The drops falling from the end of the oversize phallus are clearly white, suggesting that the substance is semen, one of several materials proposed for the analogous Tajín scene. However, another stream of liquid emerging from the penis moves toward a drain carved into the patio floor directly in front of the figure (Zuñiga 1995:189). This liquid is marked with the "eye" motif that often indicates water at Teotihuacan (Von Winning 1987, II:69). Further, the drain that is the end point of the Teotihuacan stream is real, not a representation. The water imagery thus moves into a real drain, imitating the flow of water in the patio itself. The Teotihuacan imagery seems to indicate that the liquid flowing from the penis in this scene of maguey fertilization may be conceived of as both water and semen. These two vital, life-giving liquids may be related to the general theme of human and vegetal fecundity that we noted for the associated Tajín image (Fig. 3.17a).

Castro-Leal (2001) and Tuggle (1970) noted a similar pattern of the conflation of life-giving liquids (specifically water and semen) and penis sacrifice in the Tajín panels. In addition to the semen noted above, the Tajín imagery adds blood, in the form of a clearly indicated bloodletting by the Principal Tajín Deity, to the fecund liquids associated with the male member. In this last instance the blood enlivens the fish-being of a previous creation to create the present race of humans, as we have seen. The fish-being is generated in a pool of water, and water also defines

other significant and fecund locales at Tajín, both in the South Ballcourt and elsewhere. Semen, blood, and water are intimately related in this set of generative acts at Tajín, where several key liquids that course through living beings are given a cosmogonic and ritual primacy. Modern Mixtec also associate pulque with blood, semen ("male blood"), and fecundity in rites centered around the beverage (Monaghan 1990:566). At Tajín, these associations are placed in the context of vegetal and human fecundity, attained through the ritual actions of an elite male and the (male) patron deity. Castro-Leal (2001) astutely observes that this may be read as the capture of woman's reproductive ability by male manipulation of the penis in ritual contexts. This observation accords well with the birth posture assumed by the male deity.

Let us return for a moment to the Teotihuacan image (Fig. 3.17b) to investigate further the iconography of fecund liquids at Tajín. First, the stream of liquid marked with the "eye motif" at Teotihuacan is related to the stream shown emerging from the Principal Tajín Deity's autosacrifice in the south-central panel of the South Ballcourt (Fig. 3.14). Both show the liquid as a stream with elliptical shapes closely and regularly spaced inside the rectangle. This is a rather specific relation, as nowhere else at Tajín is liquid depicted in this way. Additionally, behind the ithyphallic Teotihuacan figure is a jar with three circle motifs. Emerging from the jar's covering is a scroll motif decorated with the flower of the maguey plants seen below. The maguey flowers may suggest that the vase contained pulque (Cabrera Castro 1996:24; Rivas Castro 2001), although as we have seen, if left to flower, the maguey will not produce the *aguamiel* necessary for pulque. The same conjunction of vase and maguey plants is also found at Tajín, where the most important example may be seen in the South Ballcourt itself, in the central image that contains both Flowering Mountain and the human protagonist holding the vase (Figs.3.14, 3.17). Again, this vase has been interpreted as a container for pulque (Garcia Payón 1973b; Wilkerson 1984, 1991), but it is closely associated, if not identical, to the water vases shown throughout the South Ballcourt program in the

scenes interpreted here as showing the Skull Place as a water well (Fig. 2.18).

What is crucial to understand is the interrelationship of these three liquids at Tajín, their fundamental relationship to fecundity, and the fact that they form a rather fuzzy set, where elements of one may blend into another, as Castro-Leal (2001) pointed out for these liquids. These associations are almost certainly based on the analogies of primary liquids that run through living bodies: *aguamiel* through the maguey, blood through the human, and water through the earth. The close symbolic relationship of water and pulque was made clear later in Central Mexico, where the pulque deity Mayahuel displayed attributes of the water goddess, Chalchiutlicue (Bye and Linares 2001:39; Nicholson 1971:420), and other pulque deities were associated with rain/mountain deities (Nicholson 1991).

The Tajín scene involving autosacrifice or ejaculation and maguey thus has an important correlate at Teotihuacan in which the fertilizing aspects of the act and its relationship with water are emphasized. The history of the relationship is not fully understood at this time: the Teotihuacan scene was done substantially earlier, dating to ca. AD 400–500 (Cabrera Castro 1996:26). Not only is the Tajín scene later, but it is also part of a complex narrative program representing events mainly at the center of Tajín itself (see Chapter 4). Several references to Tajín architectural features, such as specific step-fret balustrades and flying cornice elements, argue for this. Thus the iconography of the rite involving maguey is located at Tajín, where the plant does not thrive, but may be traced back to Teotihuacan, where maguey clearly did thrive.

It is interesting that one can trace this precise maguey/autosacrificial rite iconography to Teotihuacan, for Taube (1986:54) would have the entire maguey iconographic complex at Tajín refer to Teotihuacan. At the latter site, maguey production is well documented, and there is a long history throughout Mesoamerica of borrowing Teotihuacan symbols and employing them in local environments in order to derive legitimacy from the metropolis (Stone 1989; Taube 1992a:69–70). Yet this Teotihuacan derivation, if true, does not fully explain the appearance of the

iconographic complex later at Tajín. Even though Teotihuacan was the ultimate source of any number of Mesoamerican symbols and practices, it was in full eclipse as a political power by the time Tajín's major programs were carved, strongly suggesting that the relations intimated by highland maguey and accompanying rites involving autosacrifice did not simply recall the past glory of the metropolis, but had more concrete and contemporary aims and associations for the Tajín elite.

Other producers of maguey may be associated with the Tajín realm in a more tangible way than Teotihuacan. Epiclassic sites with clear Tajín affiliations occur into the Sierra de Puebla and onto the altiplano to the west, where pulque maguey could have been cultivated (Wilkerson 1999:121; Pascual Soto 1998; Seler 1990–1998, 2:144). Yohualichan in the Sierra de Puebla, the most well known of these Tajín-related sites, exhibits clear associations with Tajín at its apogee in the use of the niche and flying cornice among other architectural conventions (Palacios 1926). Yohualichan itself sits at only 600 m above sea level and is thus not in a maguey pulque producing area, but parts of the region are mountainous, reaching 2,000 m, where one may find maguey fields today. Other, less well documented sites in the maguey-growing areas of Puebla and Hidalgo that have Tajín ceramic, architectural, and/or sculptural associations would have been logical sources of the beverage. Yohualichan, a site that so closely followed Tajín monumental architectural forms, could have served as a major staging ground for such trade (Koontz n.d.).

The Economy of Heads: Decapitation in Context

As we have seen, the rite that allows entry to the Flowering Mountain landscape of the central panels is ballcourt decapitation. It seems self-evident to assert that a main purpose of ballcourt decapitation sacrifice is the taking of a head. What a severed head means in this context, however, calls for closer scrutiny. Interestingly, in Tajín imagery the severed heads of sacrifice are often depicted and sometimes specially marked

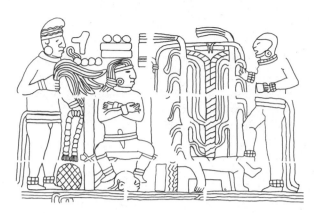

a

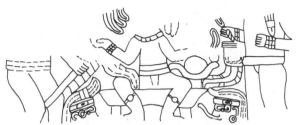

b

FIGURE 3.18. Severed heads in Tajín iconography: *a*, detail of scaffold scene on the north column, Structure of the Columns (drawing by Daniela Koontz); *b*, detail of enthroned figure with two severed heads at his feet on the south column, Structure of the Columns (drawing by the author).

in ways that give us clues to their indigenous meaning. We already saw this when comparing images of heads laid at the feet of a seated figure (Fig. 3.18a). In one instance the representation is badly abraded, but it is clear that it is a human head, now inert. In a comparable context in the same sculptural program (Fig. 3.18b), already treated above, the two heads laid at the feet of this figure are represented with additions around the mouth and the supraorbital plate that marks supernaturals at Tajín. Thus in one instance the severed head is portrayed fairly realistically, while in the other a supernatural identity has transformed or enlivened it. We see the same duality of living and dead heads in Classic Veracruz *hacha* imagery: some have the eyes closed and are obvious trophy heads, while others are alive and given zoomorphic and/or supernatural characteristics (Scott 2001:59). This evidence suggests that Classic Veracruz peoples, including those of El Tajín, considered the product of decapitation sacrifice as somehow transformed and more specifically enlivened. Gillespie (1991:326) noted this propensity to animate the severed head of ballgame

sacrifice throughout the Americas. At Tajín, this animate severed head takes on a full-figure form when offered to the Principal Tajín Deity as the fruit of ballcourt sacrifice (Fig. 3.14). Thus it is no exaggeration to posit that this animate head is the fulcrum on which the entire ballcourt program rests: on one side are the rites surrounding the sacrifice (corner panels), while on the other are the actions of the gods in response to receiving the sacrifice (central panels, see Wilkerson 1991).

The South Ballcourt decapitation sacrifice is represented as occurring in the playing alley of the South Ballcourt, or a similar structure, as indicated by the flanking architectural features. We have already seen how the center of this playing alley was defined as a Skull Place (see Chapter 2) out of which fecundity and water flow. The decapitation sacrifice shown in this panel takes place between the two ballcourt structures, suggesting the center of the court was more literally the place of the skull, or the decapitated head, due at least in part to the decapitation sacrifice. Additional iconographic elements seem to point to this relationship of the center of the court and decapitation: the diving skeletal figure in this scene resonates with the sacrifice below, while above each of the central panels stood frieze-like skeletal figures emitting skulls from their maws (García Payón 1973b:38). It would be a mistake, however, to connect skull imagery to a cult of death and power in a simplistic manner. The skulls in the Tajín court are directly associated with water and Flowering Mountain, and hence with fecundity and creation given the general message of the program. The Flowering Mountain symbolized not fecundity in general but a specific fecundity based in part on the intertwined categories of water, semen, and blood, but also on the regional sphere needed for pulque trade. Thus the central place of the autosacrifice performed on the male member and its relationship to maguey may be brought into better focus. Just as important is the rite's ability to generate legitimate political power via the donation of the implement of rule by the patron deity to the human supplicant.

Mapping these rather complex interactions between the acceding ruler, patron deity, and sacred landscape in Tajín narrative was made pos-

sible through the development of a multifigure compositional format—a format that seems not to have existed in the previous Cacahuatal phase, before the rise of El Tajín as a major urban center. The ballcourt images proclaim Tajín as just such a center, with the mechanism of ballcourt ritual serving as the path to rule. The documenting of these rites involves few figures beyond the central protagonist and the involved deities, and each panel is limited to one narrative moment. This clear focus on a few individuals and one scene is significantly less complex in its composition than the next program we will analyze, that of the Mound of the Building Columns.

THE TAJÍN COURT
THE MOUND OF THE
BUILDING COLUMNS

The Mound of the Building Columns is situated at the top of the rise that defines the northern edge of the ceremonial center (Fig. 1.2). The entry to this complex of buildings and plazas contained a colonnade decorated with elaborate narrative scenes. The iconography of those scenes, which is the chief subject of this chapter, forms a narrative program that may be compared with the two major programs already discussed: those of the Central Plaza and the South Ballcourt. Unlike the rather compressed narratives with few characters found in the South Ballcourt and around the Pyramid of the Niches, the reliefs carved at the entry to the Mound of the Building Columns contain a large number of characters engaged in a variety of activities (Figs. 4.2–4.4). These reliefs present not only the actions of a Tajín ruler, but of more than a dozen of his subordinates and other key human players, as well as a host of participating supernaturals. No other program at Tajín contains the number of figures or the variety of ritual practices seen in this program. Identifying these figures and their actions has been a central preoccupation of the scholarship on the Mound of the Building Columns and is a major focus of this chapter as well. Why the Tajín designers shifted to numerous figures and detailed accounts of a host of actions has not been explored in any depth previously, but here it will serve to frame our examination of the program.

The care with which individual figures are differentiated from each other, as well as the hierarchical relations that I will argue are encoded in their relationships, suggest that this Tajín imagery presents a particularly rich picture of elite social relations. These relationships can be understood in terms of a court structure, where "court" is defined as the web of social practices and spaces

that relate the ruler to the surrounding nobility (Inomata and Houston 2001). Several of the major iconographic traits found at the Mound of the Building Columns may be interpreted most productively through the lens of courtly rites and relationships. An important example is the presence of thrones in key scenes, for Mesoamerican thrones are perhaps the most important material evidence for the presence of a clearly ranked social space with ruler and attendants (Miller 2001:201; Harrison 2001). In addition to thrones, the imagery prominently displays the cloth and baton of rule. The patterning of royal seats and accouterments reveals that the relationship of ruler and nobility is a central theme of the imagery. The Mound of the Building Columns is not the only program featuring royal accouterments: imagery of the cloth and baton of rule is also found in the South Ballcourt program. Unlike that program, however, the desire of the columns' designers to depict and name large numbers of individuals in the context of regal ritual, and to detail their costume and ritual duties, can be interpreted as a desire to present a much more detailed account of key courtly offices and behaviors.

The Architectural Context

The architectural context of these presentations of courtly practice is one of the most striking at the site. The Mound of the Building Columns is situated at the pinnacle of central Tajín, to the north and far above the Central Plaza and South Ballcourt (Fig. 1.2). The southeastward orientation of the entry creates a vista that encompasses all of the monumental core. Much has been made of the dominant position and orientation of the complex, with several scholars suggesting that it was both the ruler's residence and the most important building at the site (Brüggemann 1991:100; Lira López 1995a, 1997). We will return to the problem of building function later, but for the moment we may say without hesitation that the Mound of the Building Columns had a singular and privileged status.

Although the column reliefs are often referred to as simply "coming from" the Mound of the

Building Columns (Kampen 1972), this designation refers to two things in the literature, and it is helpful to distinguish and define them here. On the grandest scale, the Mound of the Building Columns refers to a complex of buildings, platforms, and plazas measuring over 22,500 m², or more than 5 acres—the largest such complex at El Tajín. The architects formed the complex from a natural promontory that was artificially leveled before construction of the huge courtyard and surrounding buildings. The complex was very little understood until recently, owing in no small part to the fact that until 1991 the area was private property, and archaeological investigations had been restricted to preliminary clearing and initial investigations (García Payón 1954:40–41; Lira López 1995a:93). Apart from the main building discussed below, much of the complex has still not been investigated in any depth. The main building in this complex, also often referred to as the Mound of the Building Columns, is actually a pyramidal base surmounted by a structure with a sizeable sunken patio surrounded by rooms. I refer to this building as the "Structure of the Columns" to differentiate it from the larger Mound of the Building Columns complex.

The Ascent to the Mound of the Building Columns Complex

One entered the Mound of the Building Columns complex from the area of Tajín Chico, immediately below, by walking up a staircase, through an open colonnade, and up yet another staircase and onto a small plaza (Fig. 1.2). Tajín Chico, the point of departure, was a rather restricted space, set well above the lower monumental area of the site centered around the Pyramid of the Niches. The Mound of the Building Columns and Tajín Chico may be seen as a single architectural assemblage marked off from the lower ceremonial center by a monumental retaining wall that runs along the entire length of the southern portion of Tajín Chico. Not only is this portion of the site set above the temples and ballcourts of the lower center, but the buildings here are of a significantly different plan than those found below: many are multiroom structures,

often referred to as palaces. Sarro (2006) conceived of the Tajín Chico/Mound of the Building Columns area as a single large palace complex, an important point for the context of these sculptures that we will return to in Chapter 5. For now it is important to emphasize the marked separation and elite nature of the entire area.

Access to both Tajín Chico and the Mound of the Building Columns complex was controlled via a small number of stairways. The steep staircases ascending from Tajín Chico to the Mound of the Building Columns, as well as the open colonnade in the middle of the ascent that could have served as a guard post or other checkpoint, suggest that entry to the Mound of the Building Columns complex was even more tightly controlled than access to Tajín Chico from the lower area (Sarro 1995:48–49). Thus the audience for the relief sculptures at the entry to the complex would have been significantly different from that experiencing the public, open South Ballcourt or Central Plaza programs. Once on the small plaza and turned toward the Structure of the Columns, one faced a portico supported by the

three carved columns, the iconography of which forms the main focus of this chapter (see model, Fig. 4.1; Lira López 1995a:97; Ladrón de Guevara 1999:73). The vault of the portico consisted of concrete scalloped on the underside and flat on top; large remnants of this element remain at the site. Although there have been attempts to hypothetically reconstruct the portico and show how it articulated with the building and platform immediately behind it (Wilkerson 1987b:50–51), the paucity of well-recorded archaeological material coupled with the extensive destruction in this area make any arrangement tentative. What is certain is the presence of three columns supporting a concrete vault that somehow articulated with the platform and building behind. Equally certain is that this portico served as the chief entrance not only to the Structure of the Columns, but to the entire Mound of the Building Columns complex. Thus the images carved on the columns were the introductory proclamation for anyone entering the complex.

The imagery on the columns is all that is left of a larger iconographic program deployed

FIGURE 4.1. Model of the entrance to the Structure of the Columns as seen from Tajín Chico. Courtesy of the Museo de Antropología de Xalapa.

throughout the Structure of the Columns. Although there were major figurative painting programs inside the structure (Ladrón de Guevara 1999:39–40), free-standing sculpture (Lira López 1995a:106), and a smaller set of carved columns (Wilkerson 1987b:50–51; Ladrón de Guevara 1999:73), these are lost to us in all but their most general outlines. Only the imagery of the columns remains as the statement in monumental figurative art on the meaning of this restricted space. It is to the iconography of these columns that we now turn.

The Iconography of the Columns: First Approach

Scholars examining the imagery of the columns before 1995 were hampered by the idea that there were as many as six carved columns.[1] If this were the case, the amount of extant sculpture could not complete more than half the proposed columns, suggesting that much of the program was missing. This made it difficult to convincingly discern themes or relate groups of scenes to others, for it seemed that we were viewing only a small portion of the entire program, and thus any patterns were necessarily incomplete. The careful work of Yamile Lira López (1995a) has shown instead that there were only three column bases fronting the portico of the complex. Sara Ladrón de Guevara (1999:72–93) has gone further and proposed a reconstruction of the three columns, complete with the precise location of most of the extant imagery. Together these scholars have shown that while fragments of the program (especially many of the faces of figures) are missing, the original program consisted of little more than the reliefs we now have. This, in turn, allows us to treat the column imagery as a complete and coherent narrative program, in contrast to the earlier scholars who felt they were dealing with only bits and pieces of a much larger story.

Since the argument below follows Ladrón de Guevara's reconstructed placement of the column imagery, the methods that she used to arrive at the reconstruction deserve comment here. The columns were constructed from separate drums, each about 1 m in diameter and 30 cm thick, which were stacked without mortar or other

structural support and then carved in situ in the portico. Ladrón de Guevara (1999:75) noticed that the drum that served as the foundation for each column was uncarved, as was the lower half of the drum directly above. She was able to match the smooth parts of the two lowest drums through both physical fits and early photographs showing the original fall pattern of the pieces. Other drums could be placed because they were still near their base in the earliest photographs. Because the drums were carved in situ in the portico, scenes would often cross from one drum to another, allowing Ladrón de Guevara to continue reconstructing several of the more elevated portions of the column.

The Columns and Their Place in Tajín Narrative Programs

Before we treat each of the three columns in detail, let us consider the general characteristics of the narrative system. The artists of the columns laid out scenes in horizontal registers that wrapped completely around the drums (Figs. 4.2–4.4). Each of the major narrative registers was separated from that above through the addition of a thin register depicting supernaturals amid scroll forms. The simplest organizational technique inside each narrative register features a procession around the drum (Fig. 4.4b) creating an endless or reentrant composition, a type seen nowhere else at Tajín. In other instances the column artists created several scenes in a single horizontal register by simply turning the figures to face each other in order to form groups, while figures standing back to back mark off two individual scenes (Fig. 4.4a). In both formats the same actors can recur, so that the image moves through a series of related actions involving the same people. Alfonso Caso (1953:342) noticed that the iconography of the columns included glyphs with bar and dot numerals surmounted by schematic depictions of animals and objects (Fig. 4.5), always associated with one of the human figures. These glyphs did not seem to be organized as a series of successive historical dates, but instead named the personages in the scenes. Most later scholars accept Caso's premise, making the Structure of the Columns program the only

i.

j.

k.

l.

FIGURE 4.2. South column, Structure of the Columns, El Tajín. After Ladrón de Guevara 1999:78, courtesy of Sara Ladrón de Guevara.

example at Tajín of major public iconography with named personages in a historical narrative (Tuggle 1968; Wilkerson 1984:110).

It is not just the presence of clearly named historical individuals that is unique to this pro-

gram. As noted above, one of the major problems posed by the iconography of the Structure of the Columns is its exceptional place in the Tajín narrative corpus. Earlier we noted the general historical movement in Tajín art from single figure,

e.

f.

g.

h.

FIGURE 4.3. Central column, Structure of the Columns, El Tajín. After Ladrón de Guevara 1999:77, courtesy of Sara Ladrón de Guevara.

a.

b.

c.

d.

FIGURE 4.4. North column, Structure of the Columns, El Tajín. After Ladrón de Guevara 1999:76, courtesy of Sara Ladrón de Guevara.

iconic compositions to more complex narratives such as those shown in the South Ballcourt (see Chapter 3). The column imagery clearly historicizes the complex narrative. In addition to the historical character of the narratives, other unique characteristics include the large number of figures, the compositional format, the descriptions of rites seen nowhere else at Tajín, and the relatively few direct references to the ballgame. Those few direct references, however, will help

us place the program in relation to those already studied. A particularly important cognate scene is the donation of the baton and cloth to the human protagonist (Fig. 4.6a–b), seen in both the columns and South Ballcourt programs. Not only are the objects similar in both scenes, but the active presence of the Principal Tajín Deity in both rites strongly suggests that these are two instances of the same type of ceremony. In the South Ballcourt example (Fig. 4.6a), the rites were interpreted as culminating the narrative sequence with the accession to political power of the human protagonist. It follows that the column scene also depicts an accession (Fig. 4.6b), but in this instance of the named ruler 13 Rabbit. In addition, the host of participants represented around 13 Rabbit allow us to examine the courtly relations created or solidified during the accession ceremonies.

Scaffolds and Sacrificial Stones

Returning to the Structure of the Columns portico and the reconstruction of the imagery, the three columns were aligned approximately north to south, facing southeastward towards the small plaza and eventually to the entire monumental core (Fig. 4.1). The northernmost column, or right column as one faced the portico and the Structure of the Columns, has been called the Column of 13 Rabbit due to the multiple appearances of that figure in this column's imagery (Fig. 4.4). As we will see, it is not only on this column that representations of 13 Rabbit occupy a central position: the accession mentioned above as the central event in the program is the accession of 13 Rabbit, which appears on the central column. This culminating event will be treated later; for the moment we will look at a particularly important set of rites related to the accession.

In addition to multiple representations of 13 Rabbit, the northern column contains the most elaborate representation of ritual seen at Tajín, with a cast of more than two dozen actors participating in what I will argue is a continuous narrative over the space of two registers (Fig. 4.4b–c). Tuggle (1968) and Kampen (1972) reconstructed much of the imagery over these registers, and later Ladrón de Guevara (1999) was able to add several important details. Because they introduce many of the themes and individuals seen throughout the column narratives, these

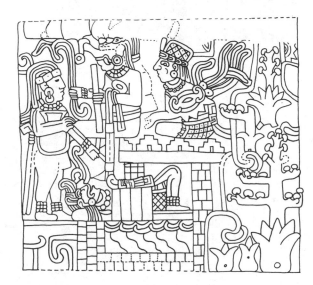

a

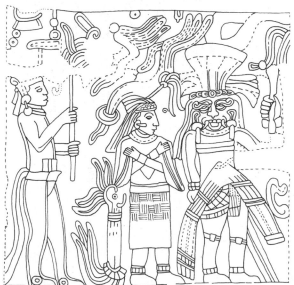

b

FIGURE 4.6. Accession imagery depicting presentations of the baton and cloth: *a,* north-central panel, South Ballcourt; *b,* scene at the apex of the central column, Structure of the Columns. Drawings by Daniela Koontz.

registers serve as a good point of departure for examining the program.

The upper register of this two-register set depicts a procession of captives and their captors looking toward a seated figure with arms crossed (Fig. 4.4b). The processing captives on either side are shown with their arms upraised and their genitals exposed, while their captors hold them by the hair in the Mesoamerican gesture of capture. Several of the captives are associated with atlatl darts: one of them, his right hand tied behind his back and his hair held from behind, raises three darts in his free left hand. Bundles of burning wood are closely associated with two of the captives. The surviving glyphs name most of the participants, both captives and captors. All of the processing figures move toward a lashed scaffold structure containing a reclining sacrificed figure (Fig. 4.7). The central figure, immediately to the left of the scaffold, is seated with arms crossed. To the left is a figure named 4 Ax who proffers a string of beads and a bundle of feathers; both of these objects are seen in scenes of tribute or elite exchange throughout Mesoamerica. At the central figure's feet is the severed head of the scaffold sacrifice. This central figure is the recipient of the major offerings in the scene, as well as the figure towards whom all of the war captives are being processed. It is clear that he is the focal point of the composition and the ranking member of the group.

The central sacrifice is crucial to the meaning of this scene and was identified by Taube (1988) as one example of the widespread Mesoamerican practice of scaffold sacrifice. Taube also identified a significant number of Classic Maya examples of this sacrifice. Schele and Mathews (1998:93) and Freidel and Suhler (1999) discussed further archaeological evidence for the importance of this rite throughout Classic Maya history. Importantly for us, many if not all the Maya scaffold sacrifices were featured in accession rites, and a related Zapotec rite was associated with the royal line (Boone 2003:213). Schele and Miller (1986:116–117) and Taube (1988) describe a Maya accession rite in which a sacrificial victim was dispatched on the scaffold and then removed as the acceding king mounted the structure. In the Tajín scene, we have elements organized in a similar fashion, with a seated figure directly

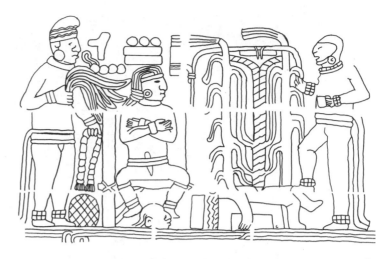

FIGURE 4.7. Detail of scaffold sacrifice scene on the north column, Structure of the Columns. Drawing by the author.

juxtaposed with the victim of scaffold sacrifice, suggesting that the Tajín scene also depicts one of the rites of accession.

In addition to scaffold sacrifice imagery, processions of war captives combined with scenes of sacrifice and offerings of precious materials like those seen at Tajín may be found in contemporary Maya programs. Miller and Samoya (1998:65) describe the captive presentation scene in the Bonampak murals in this way: "The war captain holds out a jade bead and a bundle of quetzal feathers, the valued attire of the defeated warriors shown at the captain's feet. Jade and quetzal feathers also describe the attire of the Maize God . . . they 'husked' their captives; not surprisingly, a severed head, like a harvested ear of corn, also lies at the feet of the lords."[2] The feather bundle, severed head, and war captives circulating around the ruler all mirror the Tajín scene (Wilkerson 1984:112). Even the jade is probably present here, as the string of beads held by 4 Ax on the left is colored blue-green in a related Classic Veracruz program.[3] Moreover, the idea that the victim was "husked" in the manner of corn is also shown at Tajín, where the scaffold victim is clearly intertwined with maize foliage, and his severed head has been laid at the feet of the central seated figure. We know that the Bonampak murals document the acquisition and sacrifice of captives to sanctify the designation of the heir to the throne (Miller 1986). The substantive iconographic similarities between the Bonampak and Tajín scenes suggest some similarity in the

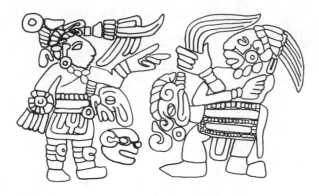

a

b

FIGURE 4.8. Delivery of feathers: *a*, Río Blanco style ceramic (drawing by the author after Von Winning and Gutiérrez Solano 1996:52); *b*, detail of *Codex Mendoza*, fol. 46r (drawing by Daniela Koontz).

function of the rites depicted, which in this case involves the taking of political office. The offering of feathers and jade beads at El Tajín likely represents specific tribute obligations and not just a simple donation of a few highly valued items. Recall that the key power objects at Tajín are the cloth and the baton (Fig. 4.6). The feathers and beads in the column imagery seem to be serving a purpose other than principal regalia. The offering of a bundle of feathers and/or a string of jade beads is shown throughout Classic Veracruz iconography, both in murals and on fine carved and modeled vases (Koontz 2008). The carved and modeled vases, often referred to as Río Blanco style (Von Winning and Gutierrez Solano 1996), contain images that are strikingly similar to the Tajín example (Fig. 4.8a). In several of these images, including the one seen here, the donor kneels in front of the receiving figure, offering the feathers in one hand, strongly suggesting that this figure is in a subordinate position vis-à-vis the receiver of the precious items. Farther south in the Gulf lowlands, similar bunches of feathers are shown offered to rulers or high-ranking officials in contemporary Maya painted pottery, where they have been interpreted as tribute offerings or closely associated elite gift exchanges (Stuart 1998:411). Interestingly, a crossed-arms gesture similar to that of the central Tajín figure serves as the posture of tribute reception in Maya imagery (Stuart and Jackson 2001:226). In the early Colonial *Codex Mendoza*, feathers presented in exactly the way 4 Ax presents them, in a bunch, along with strings of jade beads, are two of the key items of tribute from the province of southern Veracruz (Tochtepec) to the

Mexica royal court (Fig. 4.8b). At Tajín there is also a wrapped ball, almost certainly of rubber, at the feet of 13 Rabbit. Rubber balls were another important *Codex Mendoza* tribute item from Tochtepec province; both the Tajín and codex examples are shown wrapped, which often indicated their status as offerings (Stone 2002:35). The wrapped ball in combination with the jade and feather ensemble held by 4 Ax, then, strongly suggests a tribute offering to 13 Rabbit in the midst of the scaffold sacrifice.[4]

In addition to accession and tribute, there may be even more specific political symbolism shared between the Maya and Tajín versions of scaffold sacrifice, although here we are entering more speculative territory. In his discussion of Mesoamerican scaffold sacrifice, Taube (1988) discusses another Maya example that ends in the burning of the victim. The Tajín scaffold scene exhibits two burning bundles, both associated with sacrificial victims, and a related scene in this program shows a burning bundle clearly attached to the body of a sacrificial victim and set alight. This suggests that at Tajín, too, the scaffold sacrifice involved burning, at least for some of the victims. In the Maya area, this burning seems to have taken on a special political significance. The burning bundles in the Maya sacrifice noted by Taube are analogous to the sign used for historical founders of the ruling groups of many Maya sites (Schele 1986). If the sign for the historical founder and that burned with the victim are related in meaning, then we can suppose that what is being burned is not just a sacrificial victim but also the prestige of the highest-ranking elite group. Although they do not cite this logic,

both Wilkerson (1990) and Castillo Peña (1995) interpret the Tajín scaffold sacrifice as a political subjugation of the victim.

Assuming a link between scaffold sacrifice, burning bundles, and the subjugation of lineages may be an overinterpretation of the Tajín scene—Mesoamerican rulers could place captives in poses of subjugation without requiring a large-scale political takeover—but the burning of a founder's physical sign as a powerful statement of conquest and subjugation was not limited to the Maya. Although there are important differences in the conception of the divine (Houston and Stuart 1996), in Central Mexico the shrine of the patron deity (intimately related to the founder) was burned to signal the conquest of a community (Nicholson 1971:410), and the Mixtec burned sacrificial victims on a scaffold pyre to signal the destruction of the lineage (Byland and Pohl 1994b:124). Such practices involving scaffolds, founders, and burning are not identical and are not on the same order of close relationship as other aspects of Maya and Tajín scaffold sacrifice cited above, but it is important to note that Maya, Tajín, and Mixtec scaffold sacrifice may be linked to a larger pattern of Mesoamerican rites associating the right to rule and the establishment of territory with a burning rite indicating the subjugation of an ancestral fount of political power.

Newsome (2003), like Taube (1988), links the Classic Maya scaffold rites to the Late Postclassic Tupp K'ak' ceremonies of the Yucatec Maya, which also combined burning rites and the scaffold. More importantly, these ceremonies connected the right to rule and the definition of territory with the scaffold. In addition, analogous scaffold rites in the Highland Maya area (Von Akkeren 1999), among the Late Postclassic K'iche, attest to their widespread use by this time. In this latter area the captive was shot by arrows while trussed to the scaffold, or burned on the same structure, and the whole ritual took on the symbolism of the hunt. This in turn intersected with migration tales related to the right of land tenure, in which the hunter was establishing rule over the territory. In fact, the migration tales associated with many Late Postclassic polities may be seen as declarations of sovereignty over specific areas, as well as records of alliances with other groups contacted on the sojourn (Pohl 2001). The scaffold rites were performances encoded with mythopolitical information that was fundamental to the rite's meaning. The fact that territoriality and rule are integral to these Late Postclassic scaffold rites strongly suggests that they also formed an important part of earlier scaffold rites, such as those at Tajín and among the Classic Maya. This would marry well with the well-attested and more fundamental meaning of the rites as critical to accession.

While similarities in meaning between Tajín and the Classic Maya scaffold rites may reflect larger Mesoamerican understandings, in this case there may be a direct historical connection: as Taube (1988) noted, important scaffold sacrifice imagery may be found from Tajín in the north to the Mixtequilla in the south-central Gulf lowlands (Fig. 1.1), which is adjacent to the western Classic Maya area, where much scaffold imagery is found. The scaffold imagery from all these areas is largely Epiclassic in date. Thus there is a continuous band of contemporary scaffold sacrifice imagery along the Gulf lowlands and reaching into the Maya area, suggesting the existence of some sort of interaction sphere circulating this rite and its meanings. Further, a comparative analysis of scaffold rite contexts in these two areas suggests an intimate association with political power, as we have seen above.

Scaffolds and Gladiatorial Sacrifice Among the Mixtec and Aztec

Another analogy from the Late Postclassic may help us further understand the relationship between political power and sacrifice on the Epiclassic Mesoamerican scaffold. The *Codex Nuttall,* a Mixtec (Oaxaca) document from the end of the Late Postclassic, purports to record practices not far removed in time from the Tajín carvings. The scene we are concerned with (Fig. 4.9a–b) is clearly related to the cult of scaffold sacrifice and burning documented above, as previously noted by Taube (1988). At the bottom right of page 84 (Fig. 4.9a) is the Mixtec variant of the scaffold sacrifice, showing the victim trussed to the scaffold and pierced with arrows or darts. Below the scaffold, the victim's blood drains into a stone

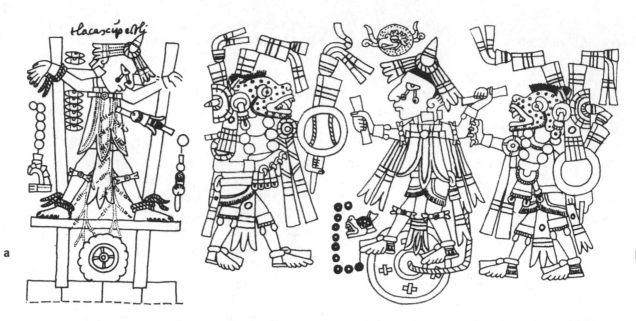

FIGURE 4.9. Scenes of Late Postclassic Mixtec scaffold/gladiatorial sacrifice: *a, Codex Nuttall* 84; *b, Codex Nuttall* 83. Drawings by the author.

made for that purpose. Paired with the scaffold sacrifice is the gladiatorial sacrifice shown at the top left of page 83 (Fig. 4.9b). In this image the victim is attached by ropes to a stone and holds symbolic instruments of defense, here depicted as small batons. Opposing the victim are warriors dressed in full jaguar costume and carrying superior weapons. The pairing of gladiatorial sacrifice with the scaffold rites in the Mixtec codex is not fortuitous; these rites were an integral pair across much of Mesoamerica by the Late Postclassic. Interestingly, the scaffold is already supplemented by the gladiatorial rite at Epiclassic Tajín, where the register immediately below the scaffold scene shows an analogous gladiatorial sacrifice (Fig. 4.10a). On the left side of the image is a captive held by a rope that runs around his waist, over the arm of his captor, and hangs to the ground. He holds a feathered spear that will eventually fail him. The sacrificer with the rope draped over his arm also holds a rope attached to the victim's neck. In front of the standing captive is another who has fallen and is being eviscerated. In the flanking scene to the right is another of these gladiatorial sacrifices (Fig. 4.10b). In this example, the captive, who like the previous victim has a rope around his waist, faces a person with a spear while he has only the small batons for defense. These batons closely resemble

those held by the sacrificial victim in the Mixtec example (Fig. 4.9b). As a sign of further humiliation, the Tajín captive's headdress has been removed and floats just to his right. The identification of these Tajín rites as gladiatorial sacrifices, along with Taube's identification of the scaffold sacrifice on the register immediately above, show that these rites were linked at Tajín as they were for several Late Postclassic Mixtec.

The Mixtec and Tajín examples of gladiatorial sacrifice in turn contain elements of the Postclassic Central Mexican calendar festival Tlacaxipehualiztli (Seler 1963, 1:129–131; Broda 1970; Carrasco 1995). Both of the sacrificial rites described above, the scaffold and gladiatorial sacrifices, were performed during this cycle of rituals in several Central Mexican areas (Nicholson 1971:424), probably taken up after the Mexica conquest of a significant portion of Oaxaca, where the Mixtecs and the Zapotecs already practiced the rite (Barnes 1999). Sahagún describes a major Mexica rite held during the Tlacaxipehualiztli festival:

After having finished fighting and killing the captives, then all those present, the priests, nobles, and the owners of the slaves, started to dance their dance around the stone where the captives had been killed. And the patron of the captives, called Cuitlachueue, took the ropes that tied the captives to

the stone, and raised them to the four world directions, as if he were giving reverence or respect, and doing this went crying and wailing like one who was mourning the dead. (Sahagún 1992:103; author's translation)[5]

According to Sahagún's account, the end of the Mexica gladiatorial sacrifice involved choreographed movements with the ropes used to tie the prisoners to the sacrificial stone. In the native language text on the gladiatorial sacrifices, these ropes were collectively called *tonacamecatl,* or "rope of sustenance" (Sahagún 1950–1982, Book 2:52).[6] The display of ropes is also a key element in the Tajín gladiatorial scenes. The central scene of the lower register at Tajín (Fig. 4.10a) depicts a figure named 13 Rabbit, clearly indicated by

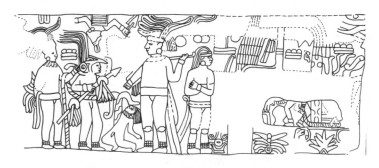

a

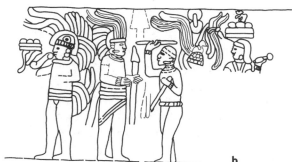

b

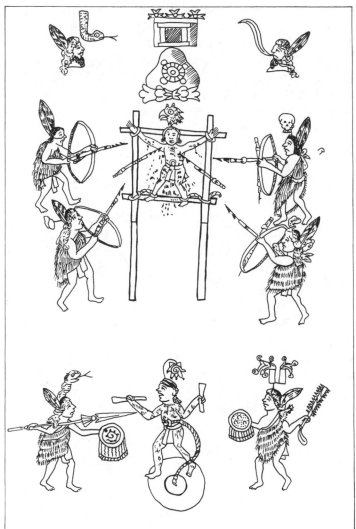

c

FIGURE 4.10. Scaffold/gladiatorial sacrifice: *a* and *b,* details from a single register, Structure of the Columns, El Tajín; *c, Historia Tolteca-Chichimeca,* fol. 28r (drawing by Daniela Koontz after Kirchoff et al. 1989: fol. 28r).

his name glyph immediately above, holding a rope, certainly the same rope used in the flanking scenes to attach the victims to the ground. Looking back on the Tajín scene's associations with other Mesoamerican scaffold and gladiatorial sacrifices, we see a striking resemblance over the two-register sequence to Late Postclassic Tlacaxipehualiztli and related sacrifices in the highlands of Central Mexico and Oaxaca. The Tajín upper register shows the scaffold sacrifice and display of captives mentioned in the sources, while the bottom register depicts the associated gladiatorial combat and display of ropes. The close resemblances in aspects of these rites suggest they must be historically related across the 500 years that separate them, but it is also clear that these traditions are not identical. For example, the flaying of victims that is so central to some later scaffold sacrifices is not depicted in the Tajín iconography. Nevertheless, the basic ritual patterns are so congruent as to suggest similar functions for these rites across time. We will return below to the problem of continuity and disjunction in the history of the Mesoamerican scaffold and gladiatorial sacrifices and how that history may pertain to the Tajín context. Before examining further the function of the sacrifices, however, we should establish the identity of the central figure in the Tajín representations of these rites, thus setting the stage for investigation of the historical context.

The Identity of 13 Rabbit

A fundamental iconographic problem posed by the scaffold scene is the identity of the central seated figure (Fig. 4.7). The name glyph contains the number 13, but the nominal glyph is too effaced to attempt any reconstruction. It has long been argued that this central figure is 13 Rabbit, the main protagonist of the entire program (Wilkerson 1984; Ladrón de Guevara 2005:45) and, by extension, the ruler thought to inhabit the Mound of the Building Columns complex (Lira López 1997:820). Other scholars (Pascual Soto 1994; Ladrón de Guevara 1999:81) have urged caution when identifying this figure.[7] Although the name glyph only partially relates

the figure to 13 Rabbit, other formal and iconographic factors strongly suggest that the seated figure is indeed the program's main protagonist. The first and most fundamental factor is the centrality of the figure in the legitimating act of scaffold sacrifice. Recall that the seated figure in related Maya scenes of scaffold sacrifice can be identified as the ruler. In other contexts in the Tajín program the central figure is marked with the name glyph or costume of 13 Rabbit, especially the feathered staff headdress shown elsewhere in this scene and clearly related to 13 Rabbit (see Fig. 4.4b, second figure from the left).[8] Immediately below the scaffold sacrifice scene stands 13 Rabbit (Fig. 4.10a)—here once again clearly tagged with his full name glyph, as we have seen—grasping the ropes central to the ritual's symbolism. Returning to the scaffold scene above (Fig. 4.7), the figure on the left offers key items of tribute normally produced for Mesoamerican rulers, suggesting again that the seated figure is not just central, but regal, a fact in line with the view that this program's main protagonist is the ruler of Tajín. While no single argument for the identity of this figure is definitive, the centrality of this figure, the importance of his actions in the midst of a rite specifically associated with political power, and the offering to him of highly valued elite items strongly suggest that the central figure marked 13 in the scaffold sacrifice scene is 13 Rabbit, and that this figure was a ruler at Tajín (Wilkerson 1984, 1991).

One of those central actions firmly associated with 13 Rabbit is the display of ropes following the scaffold sacrifice, as we have seen (Fig. 4.10a). Directly below the rope-wielding figure is a flowering maguey plant. As noted in the discussion of depictions of this plant in the South Ballcourt (Chapter 3), maguey is not native to the region and is rare in the iconography of the site, with only one other instance outside these two examples in the entire corpus. Thus we may assume that its presence here is related to the Flowering Mountain motif described for the central panels of the major ballcourt. As argued earlier, Flowering Mountain is a common Mesoamerican trope for a sort of paradise, with maguey at El Tajín specifically associated with paradisal fecundity. In this scene 13 Rabbit

manipulates the rope—later called the *tonaca-mecatl,* or rope of sustenance—directly above the plant specifically associated at the site with fecundity. Recall in the register just above that another of the victims is intimately associated with corn, as the leafy vegetation intertwines with the rope-like material emerging from victim's abdomen, and his head has been husked as if it were a cob (Fig. 4.7). The sacrifice of these captives via scaffold and gladiatorial sacrifice is thus directly associated with agricultural fecundity, as Taube (1988) argued for the Classic Maya, and many have argued for the Late Postclassic Tlacaxipehualiztli ceremonies.

It is tempting but simplistic to interpret the sacrifices described above as simply an exchange of human blood for agricultural fertility. As Michel Graulich (1988) points out in a study of related Aztec rites, these sacrifices with multiple immolations (such as the decapitation and evisceration depicted here) had multiple supernatural audiences and complex symbolisms. Leaving aside for the moment the question of how agricultural fertility intersects with ideas of sacrifice and divinity, there is the brute fact of the human victims and the question of their origins. Whether one looks at contemporary Maya imagery, that from Tajín, or the later highland evidence for scaffold and gladiatorial sacrifice, they all require human victims. These individuals are assumed to be captive warriors, a conclusion taken both from the documentary evidence of Late Postclassic practices as well as earlier imagery that shows the victims as young adult males. The upper register of the Tajín scaffold/gladiatorial sacrifice scene is explicit in this regard: male captives are paraded in, tied with ropes, and stripped naked before being deposited before 13 Rabbit. In addition, several of the captive figures are held by the hair, a widespread Mesoamerican gesture indicating capture in warfare. Not only does 13 Rabbit preside over the sacrifice from his scaffold seat, but he also brings in a captive with hair in hand on the far left, suggesting that a successful battle was a necessary prelude to sacrifice. We saw the same relation of warfare to later sacrificial activities in the South Ballcourt, where the donation of darts preceded the ballcourt sacrifice. In the column imagery, the material object that ties all the mili-

tary activities and sacrifice together is rope, first seen used as constraints on the captives and later manipulated by 13 Rabbit. These ropes, as we have seen, were not only a practical physical constraint, but also symbolic of fecundity.

The Descent of the Principal Tajín Deity and the Accession of 13 Rabbit

The other major example of rope iconography in the program occurs in the top register of the central column (Fig. 4.11; 4.3e). Here the rope imagery is directly associated with yet another rite focused on 13 Rabbit. The combination of ropes and 13 Rabbit suggests that this scene is directly related to the scaffold/gladiatorial sacrifice scenes just described. Further, the location of these scenes, at the apex of the central column, suggests their importance to the entire program.

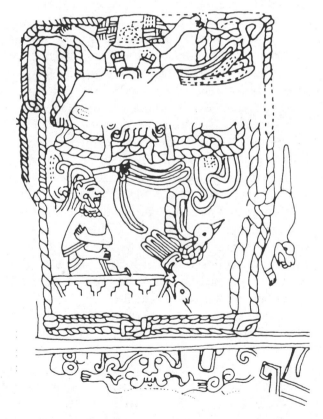

FIGURE 4.11. The Principal Tajín Deity descending among ropes toward the seated figure of 13 Rabbit. Detail of the central column, Structure of the Columns, El Tajín. After Ladrón de Guevara 1999:85, courtesy of Sara Ladrón de Guevara.

As we will see, these scenes do indeed serve as the culmination of the entire columns narrative, ending in the same accession rite that was central to the South Ballcourt program.

The upper register of the central column may be divided into three discrete scenes (Fig. 4.3e). Moving from left to right on the rollout image, there is first a meeting of deities and humans at an architectural complex. This scene is closed by the old figure on the right who proffers a piece of tied cloth as he turns to face the other protagonists. The center of the register is taken up with a scene completely framed by ropes. This scene depicts 13 Rabbit, seated on a platform and again marked with the feathered staff headdress, and the descending figure of the Principal Tajín Deity, the latter somewhat effaced but clearly sporting the diagnostic curved fangs at the side of the mouth. This is the same character we saw in the central panels of the South Ballcourt, where he creates humans and offers the cloth and baton of rule.

The rightmost scene (Fig. 4.6b) represents the critical moment in the narrative. The scene again includes both 13 Rabbit and the Principal Tajín Deity, but here the latter offers a large, soft rectangular object—likely a piece of cloth—while the figure immediately to the left of 13 Rabbit offers a baton. The cloth and baton are the same two items the Principal Tajín Deity offered the human in the South Ballcourt (Fig. 4.6a). The cloth depicted in the column imagery is somewhat larger and of a different weave, but given that it is paired with the baton and offered by the Principal Tajín Deity, there is little doubt that it too functions as Tajín regalia (see Chapter 3). Due to the numerous similarities between these programs and other Mesoamerican accession rites, it was argued at length in Chapter 3, and again throughout the scaffold and gladiatorial passages of this chapter, that the donation of the cloth and baton indicate accession.[9] Thus the apex of the central column culminates in the same act of accession that ends the South Ballcourt sequence. That said, it is helpful to go over some of the details of this register in order to examine differences, as well as similarities, between it and the South Ballcourt accession scene.

Although the accession scene with the Principal Tajín Deity and 13 Rabbit may be consid-ered the key scene in the register, the scene that links this register to the sacrificial imagery of the north column is the rope scene, also involving 13 Rabbit and the Principal Tajín Deity (Fig. 4.11). The deity is shown descending with legs splayed in a very particular pose, the same one the deity strikes in the penis perforation scene in the South Ballcourt (see Fig. 3.13). In the column imagery, however, the deity is inverted and thus appears to dive into the scene. As noted in Chapter 3, this pose has long been associated with birth imagery in Mesoamerica, and the ballcourt example at Tajín shows a clearly male deity giving "birth" to humans through his sacrificial act. Thus the splayed leg pose of the Principal Tajín Deity descending amidst ropes echoes the fecundity associations already noted for the ropes in other contexts.

The specific associations with human birth at this juncture in the accession ceremony may go some way to explaining the triangular blouse (*quechquemitl*) worn by 13 Rabbit. Later Mexica reserved the garment for female deities (Ana-walt 1982), and *quechquemitl* were associated with females throughout much of Mesoamerica. This was especially true of the Epiclassic Gulf Coast, where important female figures wearing *quechquemitl* may be found at nearby Las Higueras (Morante López 2005:78) as well as in abundance farther south, in the Mixtequilla. Although later Postclassic Mesoamericans ascribed specific female deity associations to the Gulf Coast (Nicholson 1971:420–421), we know so little about Epiclassic Gulf Coast female deities or how the *quechquemitl*'s gender associations played out in this area that it is better to reserve judgment on the gendered meaning of 13 Rabbit's clothing choice here until further regional studies have been done. Finally, Javier Urcid (1993: Fig. 17) collected examples of the crossed arm posture throughout Mesoamerica, noting that they are associated with venerated ancestors in Epiclassic Oaxaca. Several examples from Oaxaca and else-where wear the *quechquemitl*, perhaps indicating venerated females, but it must be noted that the gender is not always clearly marked beyond the *quechquemitl*.

While we know little of the *quechquemitl*'s significance in the context of accession, the association of ropes at Tajín with divine presence,

birth, and agricultural fecundity follows wider Mesoamerican patterns. Looper and Kappelmann (2001) have discussed the Tajín rope imagery in the context of Mesoamerican images of the cosmic umbilicus, conceived of as a source of life and fecundity throughout the region. Specifically, the authors propose that these ropes function as the channel or conduit for divine energy, an appropriate interpretation here given the descent of the god amidst the ropes. These authors cite comparative Mesoamerican material in the form of Classic Maya examples in which gods are born or appear in the midst of ropes. Not only do Maya ropes or other cord-like materials behave like Tajín ropes when they serve to help give birth to the gods, but the Maya also linked evisceration sacrifice with these cords. Miller and Samoya (1998:62–63) show the divine substance removed from the Maya Maize God via the navel, much like the Tajín disemboweled scaffold victim sprouts corn-like vegetation and rope-like material via the navel (Fig. 4.7). In the case of Tajín, it is clear that this conduit is directly tied to the capture and sacrifice of warriors, as the ropes serve first to bind these captives (Fig. 4.4b) before they take on their associations with agricultural fecundity (Fig. 4.10a) and birth, and, in the case of this image of the descending deity, serve as the channel or path of the divine.

To summarize the argument thus far, by tracing the display of ropes it is possible to link the scaffold and gladiatorial sacrifices (Fig. 4.10) with the series of three images culminating in the accession of 13 Rabbit (Figs. 4.6b, 4.11). In Ladrón de Guevara's reconstruction, this latter scene served as the apex of the central column, a fitting place for the culminating rite. The iconography of accession shown here closely follows the pattern seen in the South Ballcourt, including the donation by the Principal Tajín Deity of a cloth and baton to the chief human protagonist.

In a site-wide perspective, the imagery of both the South Ballcourt and the Structure of the Columns may be read as narratives of accession, a conclusion largely driven by the Principal Tajín Deity's delivery of a cloth and baton to the central human protagonist in both cases. That said, they are not equivalent in format, presentation, or detail, and it is still important to note the differences as well as the similarities. One

principal difference is the inclusion of gladiatorial and scaffold sacrificial rites in the columns imagery. The representations of these rituals were the venue for the display of numerous allies and adjuncts of 13 Rabbit—in other words, the Tajín court. This fact is critical because the inclusion of these secondary figures and the mapping of their courtly relations is precisely what sets the iconography of the columns imagery apart from the other major public programs at the site, including the otherwise closely related South Ballcourt program. But why these rites, in this context and no other? How do the scaffold and gladiatorial sacrifices fit into this larger strategy of inclusion and the mapping of courtly relations? One way to better situate the scaffold and gladiatorial rites and their place in the presentation of the Tajín court is to examine their social function in several Mesoamerican contexts. Understanding what was accomplished by these rites in other contexts could help explain why they are represented in the Structure of the Columns and not in the other major accession scenes at El Tajín.

Historia Tolteca-Chichimeca: The Politics of Scaffold and Gladiatorial Sacrifice in Late Postclassic Central Mexico

The *Historia Tolteca-Chichimeca* is, among other things, a valuable early Colonial record of the political use of gladiatorial and scaffold rites in the Central Mexican highlands (Puebla) during the preceding Postclassic.[10] While it is dangerous to transfer wholesale the function and context of the Tajín rites to a different environment 500 years into the future, several specific congruences in the two programs suggest the similarities are more than casual. For example, a page from the *Historia* (Fig. 4.10c) shows the same combination of scaffold and gladiatorial rites with the same emphasis on the transfer of politically charged objects during the rites (compare Figs. 4.10a, b). Note the figure trussed to the scaffold paired with the figure tied to a gladiatorial stone (Fig. 4.10c), the latter wielding the same small batons with which to defend himself as seen in both the Tajín (Fig. 4.10b, central figure) and Mixtec (Fig. 4.9b, central figure) examples of gladiatorial sacrifice. The accompanying text of the *Historia* explains

that the sacrificial captives had been taken in war by the Tepilhuan Chichimeca on behalf of their overlords, the Toltec rulers of Cholula:

... then they took prisoners who were enemies of the Toltec, whose tlatoque were named Quauhtzitzimitli and Tlazotli, Tzompantli, Yauhtlicuiliuhqui. And when the Chichimeca took them prisoner they brought them to Cholula where the tlatoque celebrated a sacrificial festival with them. (Kirchoff et al. 1989:184–185; author's translation)[11]

The two main Toltec rulers of Cholula, Icxicouatl and Quetzalteueyac, are depicted as busts that float above the scene of scaffold sacrifice.[12] Their witness to the rites unfolding below are crucial to the scene's political meaning. The accompanying text describes the arrival in Cholula of the Chichimec and their captive warriors. The Chichimec immediately build the *cuauhtzatzaztli,* or scaffold, where some of the captives were trussed and shot with arrows. Other captives were tied to the *cuauhtemalacatl* and sacrificed in gladiatorial combat (Kirchoff et al. 1989:185). Through these scaffold/gladiatorial sacrificial rites, the Chichimec, and in particular Moquiuix and Tecpatzin, became the "adjuncts" of the two main lords of Cholula. One function of the these rites, then, was to ally lower-ranking groups with central authorities through warfare and captive sacrifice. Further, the two main Cholulan lords were also important in earlier rites that gave the Chichimec groups their nose-plugs, an important sign of political legitimacy throughout the Mixteca-Puebla region (Pohl 2003:62–64): on folio 21r of the same codex, Icxicouatl and Quetzalteueyac perforate the septum of Tecpatzin and a lord named Aquiauatl, who also appears in the gladiatorial sacrifice on folio 28r. According to the text, this rite established the Chichimec leaders as *tlatoque,* or rulers:

... then Icxicouatl and Quetzalteueyac perforated the noses of the Tepilhuan Chichimeca with the bone of the eagle and the bone of the jaguar. Here is the sign in which appears the manner in which they were established as tlatoque[13] [rulers] the Moquiuixca, the Quauhtinchantlaca; how they blossomed, how they were greeted, how the arrows of the Tepilhuan Chichimeca appeared for the first time. (Kirchoff et al. 1989:171; author's translation)[14]

It is clear from this passage that the nose piercing done by the Cholula rulers gave the Chichimec not only the right to a certain political hierarchy, but also the right for their arrows "to appear," a metaphor for making war. The nose piercing ceremony in the *Historia Tolteca-Chichimeca* consummates the right of the Tepilhuan Chichimeca to make war under the aegis of the Cholula elite and for the latter's benefit. The Chichimecs then took captives for their Toltec overlords, sacrificing them using the scaffold and gladiatorial rites seen in Figure 4.10. The scaffold and gladiatorial sacrifice conducted under the aegis of their overlords gave the Chichimec a further right: that of going to war for themselves, to conquer and found their own land. This is clear in the post-sacrificial oration of Icxicouatl and Quetzalteueyac, the Cholulan overlords:

You have honored your Toltec kinsmen and the *calpolleque*! Oh Chichimecs, go, travel, meet the plain, the divine land, merit your city! [The Chichimecs] answered: "You have shown us mercy, you have allowed it your heart; We have finished with our duty, we have aided your city." Now they give women to the Chichimecs. (Kirchoff et al. 1989:186; author's translation)[15]

After destroying the enemies of the Toltec rulers of Cholula, the Tepilhuan Chichimec were given the right to found their own city and were also linked to their overlords through marriage. The scaffold-gladiatorial sacrifice was the alliance mechanism that cemented this relationship, investing Cholulan (here "Toltec") power in the Chichimec through warfare alliance.

If the Postclassic scaffold and gladiatorial sacrifice as represented in the *Historia Tolteca-Chichimeca* was an alliance mechanism used to ally lower-ranking warrior groups with paramount rulers and guardians of legitimate power, then how may this scenario be applied to analogous rites represented at Tajín? First and foremost, characterizing the rites as an alliance mechanism provides a strong justification for the inclusion of large numbers of figures in the Tajín compositions. In the corpus of public sculpture from the site, this is the only program that displays so many figures, even though the culmination of the iconography is identical to that shown in the

much less populated South Ballcourt program. At the same time, it is the only program at the site that displays this scaffold and gladiatorial sacrifice. These two unique traits make good sense together if the sacrificial rites served to bring these large numbers of figures together in order to legitimate complex courtly hierarchies and dole out a myriad of courtly rights and obligations. The *Historia Tolteca-Chichimeca* analogy suggests that 13 Rabbit had more at stake in the columns imagery than simply illustrating a particularly detailed accession ceremony. Instead, the chosen imagery specifically highlights the roles and relationships of many individuals, or the Tajín court as we defined it above.

Epiclassic to Late Postclassic Historical Processes: Two Models

I have insisted on the use of Late Postclassic analogies of scaffold and gladiatorial sacrifice because they help us to see how these rites actually functioned in Mesoamerican political contexts. As Ringle (2004:204) pointed out, the Late Postclassic sources place the origins of scaffold sacrifice in "Olmeca," or Epiclassic times, and a host of iconographic data supports the notion that the rite had been widely adopted during this earlier period. It is still troubling, however, that one must move directly from Epiclassic lowland El Tajín to Late Postclassic practices in the highlands, even with the close symmetries between multiple aspects of the rites, as well as allusions to its historical underpinnings. One can fall back on overarching general Mesoamerican patterns as explanations—citing the Late Postclassic documentation as holding for much or all of Mesoamerican history—but these explanations are ultimately unsatisfying when it comes to the social functions of practices as specific as the scaffold and gladiatorial rites. An important recent discovery of an effigy scaffold sacrifice (specifically a *cuauhtzatzaztli,* or arrow sacrifice) at a major palace in Classic Teotihuacan indicates a significant time depth for some variation of the rite (López Luján et al. 2006), but it does not guarantee a continuity of function and meaning. While the debate on change and continuity is an old one in Mesoamerican studies, it is helpful to continually justify the assumption of continuity in any particular historical problem (Quilter 1996). Patterns like those seen in the 1,000-year history of Mesoamerican scaffold and gladiatorial sacrifice force the questions: How is the Epiclassic the foundation for later social practices and iconographic patterns, when often we have little evidence for the intervening events? What is the interpretive rationale for linking the Late Postclassic ethnohistorical data with the Epiclassic imagery beyond the linking of multiple iconographic patterns? What is missing from the analysis above, of course, is an intervening history of the scaffold and gladiatorial rites—a sense of the historical construction of these continuities between Epiclassic El Tajín and the Late Postclassic.

As alluded to earlier, recent scholarship has attempted to bridge the gap between Epiclassic and Late Postclassic by constructing models of Epiclassic social and religious practice that systematically account for the clear continuities with later Mesoamerican practices. The models recognize the enormous shifts and reorganizations set in motion by the decline of Teotihuacan at the beginning of the period (Diehl and Berlo 1989), and then set out to show how the responses over the course of this period created foundational structures for later Postclassic events. In one important model, López Austin and López Luján (2000) propose a pan-Mesoamerican symbol system, dubbed "Zuyuan," circulating among the Epiclassic elite that would have served as a basis for later elite symbol systems and social practices across the region. The Zuyuan system overlaid traditional relations among ruler, patron deity, and populace with references to more global elite power, the latter based on territory. This globalizing system encouraged relations that went well beyond traditional ethnic or regional divisions, superseding the localized patron deities with a more universal Feathered Serpent. While the specific argument for this model is complex and based on an extensive review of later ethnohistoric references to Zuyuan practices, for our purposes the model's most important contributions are the direct relations of political iconography it posits between several Mesoamerican areas,

including Central Mexico, Oaxaca, the Yucatan, and highland Guatemala. In relation to the *Historia Tolteca-Chichimeca*'s rise of the Chichimec, the authors remark that the Cholulan overlords were civilizers of the "barbarous" Chichimecs well before the scaffold and gladiatorial sacrifices, having received the Chichimecs during their migrations and introducing them to the Nahuatl language and maize. In this the entire Cholula episode takes on a mythic aspect as yet another paradigmatic migration saga in which a group of nomadic barbarians are civilized by urban Mesoamericans. Although they may have migrated from the north at some point, the Chichimec were already fully Mesoamerican and sedentary by the time they arrived in Cholula, and not the roaming "barbarians" they claimed to be (Martínez Marin 2001). Instead, the needs of the narrative and of mapping current social alignments necessitated the rags to riches, barbarism to civilization tale. The whole may be seen as a "rite of passage" in which the group was seen to merit its place in the civilized Mesoamerican world (Boone 1991). Although López Austin and López Luján do not directly identify a shared scaffold and gladiatorial sacrifice as part of the model, it is important to note that they do conceive of Zuyuan symbolism as focused on an elite symbol system that spoke to issues of political power and, especially, to control over territory—a focus we noted for the scaffold and gladiatorial sacrifices and their references to hunting territory (Taube 1988; Pohl 1994:147).

Another recent model of Epiclassic social and religious practice (Ringle et al. 1998; Ringle 2004), also based on the universalizing Feathered Serpent deity, emphasizes the distribution of rites and symbols of leadership during the Epiclassic and Early Postclassic in the Yucatan, but with ramifications across Mesoamerica. Ringle (2004) posits several legitimating rites—including penis perforation, blowgunning, human sacrifice, the ballgame, and specifically scaffold/gladiatorial sacrifice—as forming a distinct language of political power in place by the Epiclassic and continuing in various forms throughout Mesoamerica until the arrival of the Spanish. Ringle is especially interested in systems of investiture, where client elites would receive legitimation

from their overlords, as in the Cholula episode of the *Historia Tolteca-Chichimeca*.

Both of the models cited above contain sophisticated, detailed arguments of the movement of this elite iconography across the region and through time that will be discussed below when the Tajín material warrants. What we are engaged in here, however, is a justification for using Late Postclassic analogies that goes beyond simply citing multiple correspondences in the iconography, as close or convincing as those correspondences might be. These overarching models of Epiclassic political legitimation give us just that, for if either model above is considered a productive one for Mesoamerican history, then the continuity of the scaffold and gladiatorial sacrifices in rites of accession may be explained as part of the symbolics of power shared among networks of many elite Mesoamericans from the Epiclassic period onwards. That is not to say there existed a monolithic text or set of rites followed by Epiclassic elites; the absence of the scaffold and gladiatorial rites in some areas and their suppression in other public programs at Tajín are instructive and alert us to the existence of difference and variation as much as consistency in these programs. That said, the models provide us with a space in which to view Epiclassic iconographies of power as substantively interconnected as well as historically germane to later developments. We will have cause to revisit both these topics below.

The Raising of the Standards

The next group of rites centers around the manipulation of standards, a theme already defined as vital to the Central Plaza program (see Chapter 2). Recall that the rite was represented and enacted inside the superstructure of a building on the Central Plaza (Structure 4), and that monumental stone bases lining the front of the Pyramid of the Niches were used to hold yet more standards. The columns imagery shows two related but distinct rites focused on standards: one at the apex of the north column, and another in the center of the south column. Both of these

may be shown to relate to the Central Plaza rites, as we will see below.

Before investigating the specific standard iconography at Tajín, it is important to note the antiquity and widespread nature of the standard rite in this region of Veracruz. A key early stela at Tajín depicts this same rite performed with a disk surmounting the pole that is very reminiscent of one of the standards below (Fig. 3.2). This is probably not an isolated example, as other early fragments show parts of such standards, suggesting that this small, round standard type was an important ritual object for some time before the apogee of the site. This localized standard motif may in turn be associated with imagery from the wider Classic Veracruz sphere where it appears on a stela closely related to the early Tajín examples (Fig. 3.3a). Later, representations of a similar rite make up a large part of the Las Higueras mural program to the south of and contemporary with Tajín (Sánchez Bonilla 1992:154–155; Morante López 2005:111–121). Thus the manipulation of standards as a central rite has a long history and an important place in the region's iconography.

The Raising of the Serpent Standard

Returning to the columns imagery, standard rites are represented on both the north and the south columns. Both examples center on the standard as a ritual object, but they are clearly differentiated by changes in dress and accompanying ritual acts. In the scene from the north column (Fig. 4.4a), pairs of figures confront each other across the width of the register. The three pairs on the left in this rollout have clearly legible body poses, while the last two pairs have suffered large areas of loss. Four of the five pairs clearly contain a burning bundle in the center: the same sort of bundle shown with the captives in the procession towards the scaffold in the register immediately below on this north column, and also in the standard-raising rite on the Structure 4 Panel (Fig. 4.12b). Recall also that these bundles could be attached to victims as part of the sacrificial rite. Given the proximity to the scaffold sacrifice as well as the shared burning bundles, it is prob-

able that this standard rite was directly associated with the scaffold rites. The standard that gives these rites their diagnostic characteristic stands beside the flaming bundle in the second pair from the left. A detail of this register (Fig. 4.12a) shows the standard on the right, topped with an intertwined serpent motif and framed by one of the pairs. The figure to the left of the standard, named with the number 8 and an unreadable glyph, touches the standard. He wears several elements of the ballgame costume including a yoke, a *palma,* and what appears to be a glove or wrapping on his right hand. His back assemblage consists of a back mirror with a short, feathered train surmounted by feathers and a pole with a disk at its center. The facing figure, who holds the standard, is the only participant in the composition who does not wear the back assemblage described for his partner. Between these two figures is a flaming bundle similar to that seen in the depiction of this rite in the Structure 4 Panel (Fig. 4.12b), but here standing upright.

To the left of the standard-bearing group (Fig. 4.14a), 13 Rabbit, identified by his name glyph and the feathered staff in his headdress, faces 8 Cloud Scroll in a similar scene. The back assemblage of 13 Rabbit contains what would have served in combat as military insignia, shown just behind his head. This standard worn on the back is very similar to depictions of the back standards of later Mexica war captains, as we have already seen (Fig. 2.16b). Recall also that as Hassig (1992:140) pointed out, these back standards were crucial for communication in actual battle, strongly suggesting that this scene is war related. The position and gestures of the 13 Rabbit/8 Cloud Scroll pair mirror those of the alliance panel of the South Ballcourt (Fig. 3.1), providing further evidence that the ballcourt scene is indeed a martial rite. Eight Cloud Scroll assumes the position and crossed arm gesture of the personage on the left in the ballcourt panel, while 13 Rabbit assumes the same position and gesture of the figure with the sacrificial knife (Tuggle 1968:48). The same alliance ceremony is being performed by the group to the right of the standard. The figures who wear the back standards associated with actual warfare are here shown allying themselves, emphasizing the importance

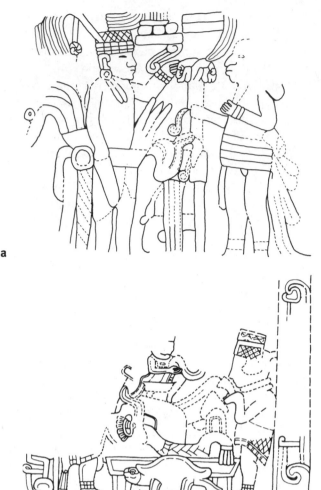

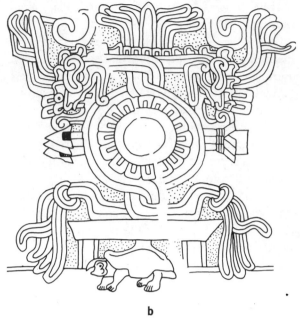

FIGURE 4.12. Standards at El Tajín: *a*, detail of the north column, Structure of the Columns (drawing by the author); *b*, detail of central image on Structure 4 Panel (drawing by Daniela Koontz); *c*, south-central panel, North Ballcourt (drawing by the author).

of the standard rite in the massing of groups for warfare at Tajín.

Raising the Mirror Standard

The standard scene on the south column (Fig. 4.2k) is one of a series of discrete ritual scenes that also show close ties to the ballcourt and Central Plaza programs. From left to right on this rollout drawing, a typical Tajín evisceration sacrifice, related to the scaffold scene on the column opposite, occurs on a stepped location marked with intertwined bands (Pascual Soto 1990:96–99, 214). Two badly abraded figures flank the scene. Immediately to the right of the evisceration sacrifice, three figures are grouped around a standard (Fig. 4.13a). The circular motif surmounting a pole is not unlike the standard seen in the Structure 4 Panel (Fig. 4.12b), and

indeed the intertwined band motif in the interior of the circle is seen elsewhere at Tajín on petaled mirrors very similar to the Structure 4 example (Fig. 4.20a). The figure to the left of the standard is dripping liquid from his penis onto a flowering maguey plant. We discussed this scene in relation to the autosacrifice/maguey iconographic complex seen at Tajín and Teotihuacan, noting that liquids flowing from the male member in conjunction with flowering maguey was a specific complex associated with fecundity at both sites (Fig. 3.17a, b). In his left hand he holds the string of beads associated with sacrifice and tribute throughout Tajín, and specifically here as it is offered to 13 Rabbit during the scaffold sacrifice event (Fig. 4.7). Returning to the standard scene (Fig. 4.13), draped over his right arm is the cloth that is distributed by the Principal Tajín Deity as one of the emblems of rulership (Fig. 4.6). Given the display of the cloth, as well as the auto-

sacrificial rites connected to flowering maguey, this clearly human figure is playing a ritual role similar to that of the Principal Tajín Deity in the South Ballcourt panel (Fig. 3.14), where the latter performs autosacrifice on the being from a previous creation while behind him maguey plants flower. This scene relates the columns imagery to the South Ballcourt creation sequence, but the clear differences in actor and context make it hard to define the association further. In the columns imagery, the figure performing autosacrifice speaks as the other two figures look on, the smaller of whom holds the standard.

The next scene in this register, found just to the right of the standard scene, shows a prone figure on a pyramid (Fig. 4.2k, left). The building includes a typical Tajín flying cornice and is marked with scrolls in the interior of the talud. The personage on the right gestures toward the building. In between these figures a ball rests in a holder, suggesting a link with the ballgame iconography of the South Ballcourt.

The last scene treated in this register depicts an enthroned figure's reception of two severed heads (Fig. 4.2k, right). The composition of the figures reflects that of the group around 13 Rabbit in the scaffold sacrifice scene on the north column (Fig. 3.18b). In both of these images of decapitation sacrifice, a ball rests near the central figure. The figure on the left in the south column scene holds a ceremonial pouch seen throughout Tajín on subsidiary figures. What is probably the ball in its rest occupies the space between this figure and the central one. Much of the right

figure is gone, but this personage seems to be holding a small standard or other ritual object of a type not seen elsewhere at Tajín. Two severed heads rest at the central figure's feet, but unlike the head in the scaffold scene, these are carved to represent the reclining supernatural offering on a South Ballcourt central panel (Fig. 3.18a). These severed heads may be related to ballcourt decapitation sacrifice due to the presence of the ball in its rest nearby as well as the close relation to the South Ballcourt program and the sacrificial figures there.

Given the close relationship of this decapitation sacrifice to the ballgame at Tajín, it is important to note that in this same column, just above the throne scene, is a representation of a ballgame (Fig. 4.14). Ballgame representations are extremely rare in Classic Veracruz visual culture in general and at Tajín in particular, and it follows that this unique scene is not well understood. To the right we see the mirror standard disk emerging from the maw of a zoomorph. Two figures in an active pose frame the zoomorph, while to the left of this scene is the ballgame itself. Here a human is sending the ball off the knee, while a skeletal figure with scrolls emanating from its body rests just to the left. Whatever the meaning of this scene, its incorporation into the columns program speaks to the inclusion of ballgame rites in a program where standards and scaffolds are foregrounded. In addition to the two scenes with standards in the columns imagery, another detailed depiction of a ceremony based around standards at Tajín occurs on the Structure 4 Panel (Fig. 4.12b). Although the standard rites of the Structure 4 Panel were identified in Chapter 2 and we have already noted a resemblance to those on the columns imagery, we are now in a position to make closer and more specific comparisons that place 13 Rabbit's strategy in the greater context of political imagery at Tajín. As we have seen, the composition of the Structure 4 Panel is symmetrically arranged around the depiction of a standard. This device is a combination of the two standards described above in the columns imagery: a circular motif framed by intertwined serpents. As in the columns imagery, figures flank the device, interacting with it and each other. We have already seen how burning rites, indicated by the flaming bundle held by the left cen-

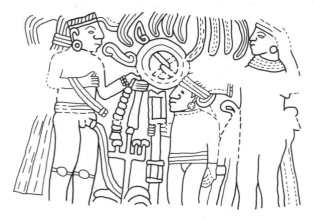

FIGURE 4.13. Raising the mirror standard. Detail of south column, Structure of the Columns, El Tajín. Drawing by the author.

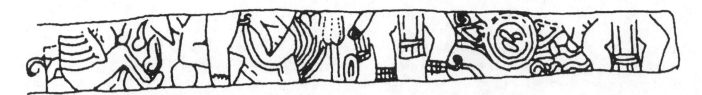

FIGURE 4.14. Ballgame scene on the south column, Structure of the Columns, El Tajín. After Ladrón de Guevara 1999:89, courtesy of Sara Ladrón de Guevara.

tral figure, are a major aspect of standard rites on the columns as well, as in the Structure 4 Panel iconography.

The Feathered Serpent standard is also shown on several of the panels in the much smaller North Ballcourt, just to the north of the Central Plaza. Like the main South Ballcourt, this court is decorated with six evenly spaced panels surmounted and connected by a frieze. All save one of these panels have been extensively damaged, but even in this state the relations with the iconography of the Structure 4 Panel are clear (Fig. 4.12c). Note the turtle, bench, and serpent tail in the lower central portion of the composition. Instead of an empty space in the center of the standard, there seems to be a small seated figure, a motif known for Feathered Serpent standards not only at Tajín but also at Chichén Itzá (Ringle 2004:181–183). It is interesting to note that for the Late Postclassic, Sahagún (1950–1982, Book 2:61) notes a "mirror ballcourt" (Tezcatlachco) in addition to the main Teotlachco, or Ballcourt of the Gods. The mirror disk is a central element of the Feathered Serpent banner, and Sahagún even notes that two mirror banners were used in the Panquetzaliztli rites described above. Thus what may be identified as dual ballcourt organization and the use of banner rites in conjunction with ballcourt decapitation appear in major public rituals at both sites. Returning to the columns imagery, 13 Rabbit and a member of his court participate in the standard rites. For the Structure 4 Panel (Fig. 4.15a), we have discussed

the central standard at length and identified the associated burning rites, but we have yet to discuss the identities and actions of the figures on either side of this central motif. On the far left side of the image, a human figure, shown in profile, stands in a rectangular pool of water marked by a saurian head. Above the pool a large scroll form emanates from the outer edge of the composition. A zoomorphic head—which includes an eye, a supraorbital plate and feather emanations—floats behind the figure's head. Similar zoomorphic heads float behind the heads of each human figure in this composition. The subsidiary figure's costume includes a headband with three large beads, a small earplug, a mosaic collar, a loincloth, and ballgame kneepads. He holds a large pouch, which is seen on subsidiary figures throughout Tajín. A glyph depicted below the pouch represents the number 19, formed by three bars, each representing five, surmounted by four dots. This number seems to be associated with the left-central figure.

This central figure wears a more elaborate headdress of soft netted fabric surmounted by feathers. A severed hand or its effigy, also seen in association with the raising of the mirror standard (Fig. 4.13a), is tied to the back of the headband. The rest of the costume consists of a cloth collar, a plain loincloth, kneepads, and anklets. The figure holds a sacrificial knife in one hand and a cloth sash, similar to the cloth of rule, in the other. Lines mark his cheeks, indicating that this figure is old.

FIGURE 4.15. (*Opposite*) Feathered Serpent standards and seated figures: *a,* Structure 4 Panel, El Tajín (drawing by Daniela Koontz); *b,* detail of the Great Ballcourt, North Temple, Chichén Itzá (drawing by Linda Schele, © David Schele, courtesy Foundation for the Advancement of Mesoamerican Studies, Inc., www.famsi.org); *c,* detail of the northwest mural, Great Ballcourt, Upper Temple of the Jaguars (drawing by Linda Schele, © David Schele, courtesy Foundation for the Advancement of Mesoamerican Studies, Inc., www.famsi .org); *d,* summit panel of the Pyramid of the Niches, El Tajín (drawing by Daniela Koontz); *e,* detail of mural on the southwest panel of the northwest wall, Great Ballcourt, Upper Temple of the Jaguars, Chichén Itzá (drawing by Linda Schele, © David Schele, courtesy Foundation for the Advancement of Mesoamerican Studies, Inc., www.famsi.org).

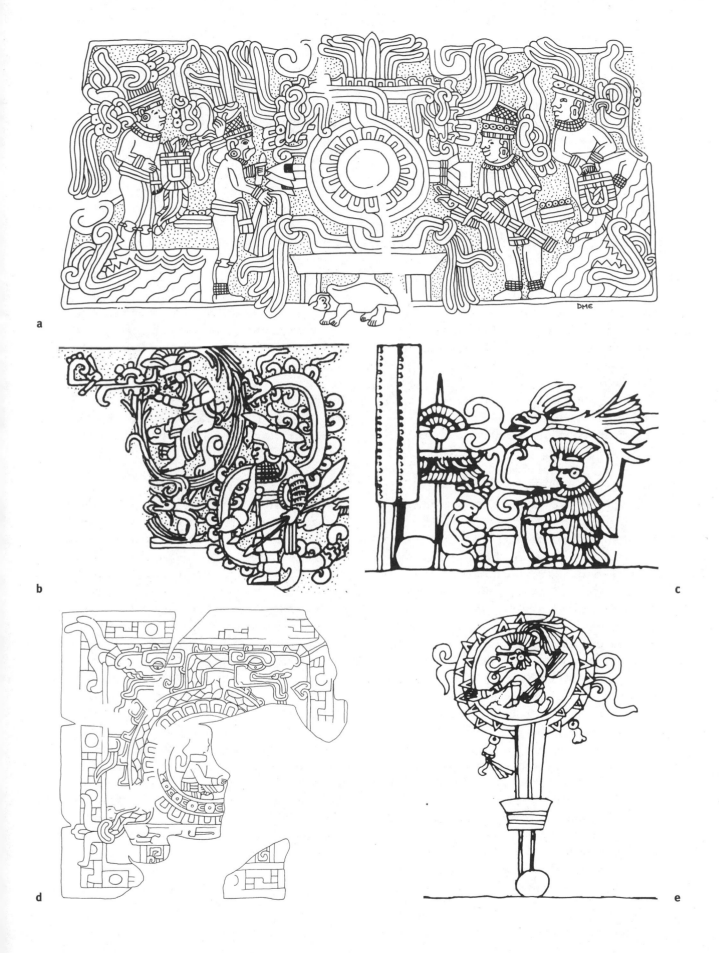

a

b

c

d

e

Across the standard on the opposite side of the composition, the central figure on the right is dressed in a more elaborate version of the same costume. He sports the same loincloth, anklets, and a variant of the same headdress. In addition he wears an elaborate cape not seen on the figure to the left, and his body is shown in frontal view, in opposition to the profile view of the left-central figure. He is depicted as young, without cheek lines, as opposed to the aged figure across the way. The figure holds a small piece of cloth, not seen elsewhere, in his right hand and a burning bundle, also seen in the standard rites of the columns imagery, in his left. Below the zoomorphic head associated with this figure is a glyph for the number 20, formed by three bars and five dots. This number glyph mirrors the glyph for 19 associated with the central figure on the left.

Ringle (2004:182) compared the Structure 4 Panel composition with a similar arrangement carved on the wall of the North Temple of the Great Ballcourt at Chichén Itzá (Fig. 4.15b). We have already seen how other programs at this same Great Ballcourt shared many Epiclassic ballgame cult elements with El Tajín (Chapter 3). Ringle rightly pointed out that both the Tajín and Chichén scenes focus on a throne or bench flanked by ritual celebrants, but most important is the presence of ascending Feathered Serpents surmounting both benches/thrones. In the Chichén Itzá example the Feathered Serpent is seen directly above, in the center of the next register, while in the Tajín example the two serpents follow the contour of the standard, as we have seen. Further, the same ascending Feathered Serpent at Chichén could also be associated with standards, as is clear from yet another Great Ballcourt image (Fig. 4.15c). Although here the Feathered Serpent does not encircle the standard as in the Tajín representations, there is a close relationship between the appearance of these two motifs throughout the Chichén program. Another important similarity in Feathered Serpent iconography at both sites involves a seated figure inside the intertwined Feathered Serpent (Fig 4.15b–d). Ringle (2004:183) demonstrated that this motif could be found throughout Tajín iconography, as well as in the same Chichén Itzá ballcourt program treated above. All four of the Tajín versions of this motif are badly damaged, but the example shown here

clearly exhibits the same intertwined Feathered Serpent and petaled disk, and supporting bench as seen in the Structure 4 Panel. Instead of a hole drilled through the center of the disk, however, there is a seated figure, facing right, and based on what remains of the image, this figure is comparable to the seated figure in the Chichén example.

The seated individual enveloped by the Feathered Serpent in the Chichén scene has been identified as an ancestral figure (Schele and Mathews 1998:252). A sun disk–framed variant of this figure, clearly associated with the ancestor cartouches of earlier Maya art, hovers over scenes of warfare and at times is even attached to a standard (Fig. 4.15e). Nevertheless, the structural similarities between Tajín and Chichén images of the Feathered Serpent enclosing a seated figure is striking, as is the correlation of these figures with standards at both sites (Ringle 2004). Most scholars now agree that these Chichén scenes are part of an extensive series of accession or investiture rites (Wren and Schmidt 1991; Schele and Mathews 1998; Ringle 2004). In these interpretations, the empty throne represented at the center of the composition (Fig. 4.16, bottom) will eventually be the seat of the acceding political figure, with the Feathered Serpent emerging immediately above (Fig. 4.16, top; 4.15b). As stressed earlier, Tajín imagery contains the same combination of an empty bench surmounted by the Feathered Serpent, suggesting that this rite too is part of an accession sequence (Figs. 4.15a 4.15d). This relationship of a royal bench and a Feathered Serpent standard makes sense given what has already been proposed for the columns sequence with similar standards—namely, that it forms an accession sequence together with scaffold sacrifice and other rites. Given the multiple threads linking these standard rites to accession, we return to the identification of the participants in the most elaborate Tajín version of this standard rite (Fig. 4.15a). In the comparable representation at Chichén (Fig. 4.16), these figures are read as secondary-tier nobles who are there to witness and legitimate the transfer of power (Wren and Schmidt 1991; Ringle 2004). This practice is known from numerous other contexts in Mesoamerica, where the court and other elite must be assembled for ultimate power to be legitimately exchanged. In comparable represen-

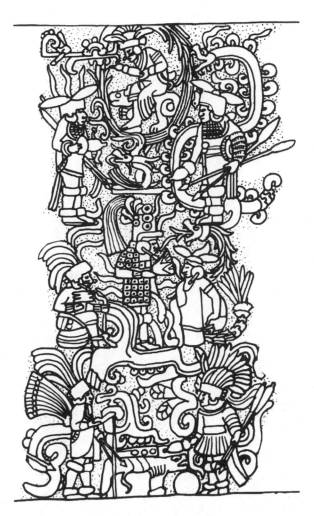

FIGURE 4.16. Accession and the Feathered Serpent standard. Detail of the central axis of the north wall relief, Great Ballcourt, North Temple, Chichén Itzá. Drawing by Linda Schele, © David Schele, courtesy Foundation for the Advancement of Mesoamerican Studies, Inc., www.famsi.org.

tations of this standard rite from the Structure of the Columns sequence at El Tajín (Figs. 4.12a, 4.13), 13 Rabbit and his court are the main protagonists. By analogy with these representations, the four figures of the Structure 4 Panel would be courtly officials participating in the accession rites. This is not an unusual strategy at El Tajín. Supporting figures are also shown in the South Ballcourt program, often holding regalia (Fig. 3.1), and just such a figure presents the baton of rule to 13 Rabbit in this program (Fig. 4.6b). The costumes of the Structure 4 Panel figures also indicate supporting or secondary roles. The headdresses of the two central figures are a particular netted design that is also seen in the South Ball-

court on the supporting figure who constrains the sacrificial victim (Fig. 3.8). The figure on the left of the bench and standard holds the lanceolate blade used in several sacrificial scenes at Tajín, including the decapitation sacrifice in the South Ballcourt.

The outer flanking figures do not wear the same headdress, but they do carry the bags often associated at the site with priestly celebrants. Returning to Ringle's initial comparison with Chichén accession rites (Fig. 4.15b), then, we can say that in addition to the similarities seen in the Feathered Serpent and empty throne combination, both compositions seem to feature several secondary figures overseeing the transfer of power. This analysis also reveals that standard rites could be integral to accession rites, although it is probable, given the ethnohistorical evidence, that these rites were performed in other situations as well. Ringle (2004) argued that at Chichén Itzá the central portion of this composition was left vacant for the acceding ruler, and this may be the meaning for the Structure 4 Panel as well, given that the standard rites are used in conjunction with accession rites in the columns imagery.[16]

Thirteen Rabbit at the World Tree

The next set of narratives occupies the base of the central column, leading up to the accession of 13 Rabbit at its apex (Fig. 4.3). The processional format seen in the scaffold-gladiatorial iconography described above is continued here, once again featuring 13 Rabbit in the more important ritual roles while at the same time describing the actions of numerous adjuncts. What is different here is the allusion to several clearly mythic scenes, with imagery derived from the south-central Gulf lowlands and one instance of what may be a specific reference from portable Epiclassic Maya art. Moreover, several of 13 Rabbit's adjuncts are dressed in costumes seen nowhere else at Tajín, and at least two of these figures are identified by name glyphs that do not follow Tajín conventions but may instead be identified with the Epiclassic writing system of the south-central Gulf lowlands. While there are again correspondences with Tajín ballcourt iconography

FIGURE 4.17. Blowgunner scene on the central column, Structure of the Columns, El Tajín. Drawing by Daniela Koontz.

in this sequence, 13 Rabbit and his designers seem intent on highlighting rites, costumes, and individuals with clear ties to areas south of El Tajín, along the Gulf lowlands.

The Blowgunner and the Tree

The lower register of the central column (Fig. 4.3h) contains at least two scenes divided by an architectural motif. The key scene in this composition contains a large figure holding a long tube or staff and striding toward a tree (Fig. 4.17). At the top of the tree is an elaborately plumed bird; the talons and tail feathers survive, but the upper half has been lost. A serpent head decorates the base of the tree, while another sits directly behind the head of the main figure in the column example. A small feline with an outstretched paw sits between the main character and the tree.[17] A Classic Maya vase contains a strikingly similar depiction of this scene (Fig. 4.18). On the left side of this image stands a tree with an analogous supernatural bird perched in it. A jaguar paw appears from behind the base of the tree, shown in the same gesture as the feline in the Tajín example. In the center of the Maya image, a spotted individual with a wide-brimmed hat aims a blowgun at the bird in the tree. The pellet can be seen leaving the end of the gun. This

figure is equivalent to the one striding toward the tree in the Tajín image (Fig. 4.17), and thus the long tube held by the Tajín figure may in fact be a blowgun.

Imagery depicting heroic youthful blowgunners hunting elaborately plumed birds is found not only in Maya art and literature, but throughout Mesoamerica. What is striking when comparing the Maya and Tajín examples is the similarity in composition of the two scenes: not only is a young, heroic blowgunner directly related to an elaborately plumed bird resting at the top of tree, but a feline with its paw outstretched toward the blowgunner is shown at the base of the tree. This feline is a very specific detail not seen in other traditions, strongly suggesting that the congruence between the Tajín and Maya blowgunner imagery is more than simply a shared Mesoamerican symbolic vocabulary.

It is important to note that this particular Maya vase is one of several from the Epiclassic that have very similar iconography, even though the styles in which the vases are painted vary considerably. This may indicate a Maya "stock scene" that included several diagnostic elements, including a lightly dressed young lord with a blowgun and an elaborately plumed bird in a tree with a jaguar at its base.[18] The numerous representations of this scene in Maya ceramics of this period and its absence in the Tajín region apart from this

example suggest that Tajín designers appropriated Maya imagery or acquired that imagery from an intervening Gulf lowland partner. Note that while the Tajín designers seem to be following this imagery rather closely, they do so in their own carving style, much like the several extant Maya examples of this stock scene on ceramics translate the specific iconography into clearly different stylistic idioms.

In Maya visual and literary culture, the scene with the blowgunner and bird is the Classic period analog of the "Defeat of 7 Macaw" episode found in the later *Popol Vuh,* where the hero twin Hunahpu shoots the pretender 7 Macaw for the latter's hubris in impersonating the sun (Robiscek and Hales 1982:56–57; Cortez 1986; Coe 1989). Tedlock (1996) and Freidel, Schele, and Parker (1993:70) have shown that throughout Maya history the bird's defeat is also a cosmogonic act: it removes the sun of the last creation in preparation for the creation of this era. The multiple close correspondences between the Classic Maya and Tajín iconography would argue for the same interpretation of the Tajín imagery. With this scene, 13 Rabbit has placed the imagery of this section of the Structure of the Columns into cosmogonic space and time, specifically by depicting the heroic action that prepares the way for the current cosmos. This is important when seen in comparison with the overall narrative shape of the other monumental accession program, that of the South Ballcourt. The South Ballcourt narrative also turns on a cosmogonic

theme, but portrays a different supernatural acting in a different event (Fig. 3.13). The South Ballcourt narrative depicts the creation of humans by the Principal Tajín Deity and raising of the sky over the Flowering Mountain. Thus the actions of the Principal Tajín Deity in the ballcourt cosmogenesis may be seen as structurally similar to the actions of the blowgunner in this scene. This substitution, if it is such, is certainly an interesting variation on the relations of cosmogony and power at El Tajín. As we will see, there is yet more evidence that the cosmogonic story involving the macaw is the subject of this section of the columns imagery.

A Macaw Dance

Beside the blowgunning scene with the elaborately plumed bird is a bird dance (Fig. 4.3h). We have already examined a bird dance in the South Ballcourt program (Fig. 3.9), which was associated with ballcourt sacrifice. Although that dance and the columns avian dance are sometimes linked, there are important differences in the natural model for the bird. The South Ballcourt example has a longer beak, suggesting it is a vulture (Kampen 1972:37, 1978), whereas the columns example has a shorter, more downcurving beak, almost certainly that of the macaw or one of the few other highly valued Mesoamerican birds with similarly resplendent feathers, such as the quetzal (Taube 2005:40).

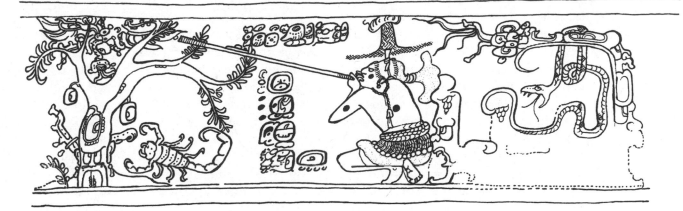

FIGURE 4.18. Epiclassic Maya ceramic painting of blowgunner scene. Drawing by Linda Schele, © David Schele, courtesy Foundation for the Advancement of Mesoamerican Studies, Inc., www.famsi.org.

The fact that the columns imagery depicts a dance with the short-beaked bird, and not the vulture dance seen in the ballcourt examples at Tajín, seems to relate directly to the story of the elaborately plumed bird told in the adjacent blowgunner scene. The Late Postclassic K'iche Maya danced the "Defeat of 7 Macaw" (the primordial elaborately plumed bird) during the founding ceremonies at Bearded Place (Carmack and Mondloch 1982:191), a rite associated with the defeat of 7 Macaw and the subsequent cosmogony told in the *Popol Vuh*. Given the proximity of the depiction of the blowgunning of this bird and the fact that the dancer is impersonating a macaw, I would argue that the imagery at Tajín represents an analogous dance. Thus the blowgunning of the macaw and the ritual dance that commemorated it are joined in two adjacent scenes at Tajín.

Although we can cite specific analogies from the Highland Maya area, dances involving this bird deity had deep historical roots for Gulf lowland elite. Guernsey (2006:106–108) has synthesized a large amount of iconography portraying a similar dance in the Late Preclassic Gulf lowlands and found it to be an integral part of elite ritual. It seems that almost a millennium before the Tajín images, elites would dress and perform as the bird as well as stage re-creations of the mythic narrative.

Taube (2005:41) noted that this Tajín bird costume includes "wings" surmounted by repeating avian heads, a specific image that is found also at Teotihuacan. In addition, he posited a distinct solar symbolism for all of these figures, seen largely through the close relationship of the bird deity and the macaw, especially the *Ara macao* (scarlet macaw) and the *Ara militaris* (military macaw). Macaw feathers were associated throughout Mesoamerica with heat (Miller and Taube 1993:132), and the scarlet macaw was particularly associated with solar heat (Pohl 2001:97). The mythic narrative also joins sun and macaw when the supernatural macaw of the *Popol Vuh* is addressed as a "false sun." That same text relates the blowgunning of the supernatural bird to preparing the way of the true sun (Tedlock 1996; Milbrath 2001:174). Thus the K'iche "Dance of 7 Macaw" may be interpreted as the story of the dawn of the true sun, linking solar origins to

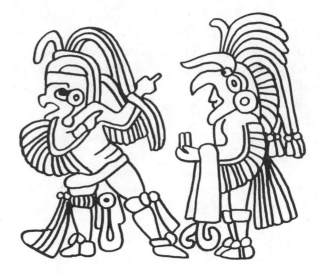

FIGURE 4.19. Possible macaw and vulture dancers depicted on the north wall of the North Temple, Great Ballcourt, Chichén Itzá. Drawing by Daniela Koontz.

elite claims to power, a role perhaps also played by the analogous macaw dance at Tajín.

Not surprisingly, another close Mesoamerican analog to the Structure of the Columns combination occurs at the North Temple of Chichén Itzá's Great Ballcourt, in the same program where earlier we identified investiture rites similar to those seen in Tajín's Structure 4 Panel (Fig. 4.15b). The Chichén Itzá program also associates the themes of blowgunning, tree raising, and a similar bird dance (Wren and Schmidt 1991; Freidel et al. 1993:379–383; Ringle 2004). The west wall of that temple depicts bird dancers with the same feathered arms, or "wings," seen at Tajín. One of the two dancers shown at the base of the north wall at Chichén Itzá (Fig. 4.19) is certainly the vulture dancer, and the other is perhaps the macaw dancer seen at Tajín. The figure on the right wears the long beak of the vulture, while the figure on the left wears a shorter beak, possibly that of a macaw. Just as in the Structure of the Columns example, the Chichén Itzá bird dancers approach a tree where a large bird perches, about to alight. On the adjoining north wall, in the second register, right side, the blowgunning scene occurs amid purification rites associated with the ballgame (see Freidel et al. 1993:382). Interestingly, the Chichén Itzá scene does not contain the same direct references to Maya conventions seen farther south, such as the jaguar at the base of the tree, that we see in

the Tajín imagery. In addition to the similarities with events represented at Chichén, the macaw dance at Tajín may be related to contemporary imagery in the Gulf lowland area between El Tajín and Chichén Itzá, where bird dances were depicted on many vessels in the Río Blanco style (Von Winning and Gutierrez Solana 1996:55–77; Koontz 2008). A series with several examples in this same style contains images of dancers shown with feathered arms, much like the Tajín example, but instead of the helmet mask of the macaw, they are given a buccal mask associated with the bird deity in earlier art across eastern Mesoamerica, including the south-central Veracruz region (Von Winning and Gutierrez Solano 1996:59). We have already seen how representations on vases in this style closely match Tajín images of tribute (Fig. 4.8). Thirteen Rabbit commissioned a local variant of this ceramic type, called Polished Black Relief, which is found mainly on the surface of the Mound of the Building Columns complex (Du Solier 1945:186). Both the vessel shape (flat-bottomed bowls with plain lip molding) and the type of relief suggest some relation with the modeled/carved ware of southern Veracruz, especially the Río Blanco style ware (Wyllie 2008; Koontz 2008). The local pedigree of the Tajín variant is undeniable, however, as Lira López (1995b:142) has shown that Polished Black Relief uses local pastes and is a variant of one of the most abundant and widespread Tajín ceramic types, Polished Black.

The imagery on Polished Black Relief ware consists mainly of the bird dances and the processions of captives seen in the columns imagery, with significant emphasis on the bird imagery (Du Solier 1945). Moreover, 13 Rabbit marked these vases with his name glyph, something seen elsewhere only in the columns imagery. All of this suggests that Polished Black Relief was employed around the Mound of the Building Columns complex as yet another medium for the presentation of 13 Rabbit's iconographic program, which we see in full in the imagery of the columns. Although we have observed iconographic connections to the more southern Gulf lowlands in this program, we have also noted clear relations to more widespread Tajín themes such as ballcourt ritual and consistent regal accouterments such as the cloth and baton. In like fashion, the Polished Black Relief ceramics combine substantive relations to Gulf lowlands elite wares with clearly local manufacture for a particular local context (the court of 13 Rabbit).

The data on iconography and the Polished Black Relief ceramics related to the Structure of the Columns program may now be synthesized. Like the scaffold and gladiatorial sacrifices noted above, as well as the ballcourt decapitation and standard rites in the previous chapters, the Río Blanco and Tajín macaw dances are yet other examples of shared elite rituals along the Gulf lowlands and beyond throughout the Epiclassic. More specifically, given the preponderance of bird imagery both in the Tajín and south-central Gulf lowland examples, the Polished Black Relief ceramics may be evidence of a distinct or specific network of elites who shared a particular vessel type and associated imagery that focused on the macaw dance and related rites as paths to power.

The presence of widespread ritual and mythic correspondences, as well as similar costumes and objects, suggests that these rites formed a cult practiced along much of the Gulf lowlands. Given that the macaw dance seems to have been important to several Epiclassic Gulf lowland elites, and especially so for the south-central Gulf lowlands and 13 Rabbit's court at El Tajín, it may be productive to ask some basic questions about the distribution of cult objects. The rite's elite context may be established from the beginning. Members of the elite were the main, if not sole, performers of such rites throughout the Epiclassic Maya area (Inomata 2006), and the elaborate headdresses, special costumes, and multitude of accouterments in the iconography of Tajín suggest the same was true there. The *Popol Vuh* makes clear that the mythic backdrop of the cult was also directly associated with elite status. As a bejeweled, resplendent being, 7 Macaw was originally a powerful lord. He was defeated by the Twins, who took his jewels and replaced them with maize dough, signaling the bird's defeat. Guernsey (2006:150) has noted that this is in many ways a striking exchange, for maize dough is often sacralized in Mesoamerican myth and ritual, whereas here it is a sign of defeat, directly opposed to the acquisition of (elite) finery. Shortly after this episode the Twins were told not to plant maize.

This power exchange between the Twins and 7 Macaw occurs as the avian deity is shot, possibly alluding to the capture and harvest of macaw feathers. Guernsey (2006:151–152) goes on to posit a precious feather exchange system during the Late Preclassic among members of a bird deity cult in the Soconusco, highland Guatemala, and the south-central Gulf lowlands. We have already seen numerous indications that feathers were traded and rendered in tribute throughout the Gulf Coast lowlands during the later Epiclassic. In this reading of the 7 Macaw story, one function of the tale may have been to provide a mythic charter for the trade of these precious feathers among the elite, for whom the feathers were a chief marker of identity.

The defeat of 7 Macaw cleared the path for the true sun, and this connection with the sun and solar heat brings us to another aspect of the relationship between the macaw and elite power. Solar cults allowed for the public display of the solar "heat" of the ruler or high-ranking personage. Related Classic Maya texts and images insist on the fiery nature of the ruler (Houston and Stuart 1996:295). There is some evidence that Classic Veracruz peoples also understood this relationship, as indicated by a figure shown with a solar disk covering his torso at Las Higueras (Sánchez Bonilla 1992:138; Morante López 2005:98–105; Wyllie 2008). Display, as well as trade, was controlled by elite specialists who transformed this material into the headdresses and other featherwork so crucial to elite display. The nexus between feather acquisition, crafting, and display was so fundamental that in the Late Postclassic, throughout Central Mexico and Oaxaca, a macaw was considered the personification of 7 Flower, the patron deity of royal houses and craftspeople (Pohl 2001:97).

The circulation of highly valued feathers throughout eastern Mesoamerica and into the Gulf lowlands was a major component of elite long-distance exchange (Foias 2002). Recall the presentation of feather bundles in the Tajín scaffold scene, as well as in similar scenes throughout south-central Gulf lowlands ceramic imagery (Figs. 4.7, 4.8). Similar presentations of feather trade or tribute are also found in contemporary Maya imagery and constituted a key courtly rite judging from the numerous representations

(Stuart 1998:411; Houston 2000:173; Reents-Budet 2001:214). It is highly likely that the Classic Veracruz macaw cult was directly associated with that known for the western Maya, given the use of scaffold sacrifices during investiture ceremonies that also feature the bird deity in that area (Taube 1988).

Given these strong associations with the more southern and eastern lowlands, the cult of the bird deity may be said to have furthered elite connections with those areas, and especially with the south-central Gulf lowlands, a region with which Tajín shared other specific elite traits. It seems that Tajín was here accessing age-old Gulf lowlands traditions relating political power to the acquisition of resplendent feathers and the performances these feathers made possible. This had been the case for a millennium in the more southern Gulf lowlands by the time of Tajín's apogee. Guernsey (2006) posited that this earlier network allowed for the transfer of ideas about political legitimation and elite alliance, wrapped in the trade of feathers necessary for the performance of the rite and undergirded by the primordial legitimacy communicated in its mythic background. This reading of the Tajín columns imagery and the macaw narrative suggests that the court of 13 Rabbit shared many of these same ideas of political legitimacy, where the acquisition and display of feathers, sanctioned by a mythic charter of heroic victory over a primordial macaw, was a central rite of 13 Rabbit's accession ceremonies.

The remainder of the central column contains images of several poorly understood rites leading to the accession of 13 Rabbit at the summit. Despite our inability to interpret adequately several of the specific ritual actions, these rites nevertheless give us our clearest picture of the participation of figures claiming south-central Gulf lowland elite affiliation.

Raising a World Tree

Directly above the bird deity imagery, another scene is based around the same elaborate, scroll-branched tree (Fig. 4.3f). Here, however, there is no bird perched on top. The tree grows from the torso of a skeletal figure reclining on the

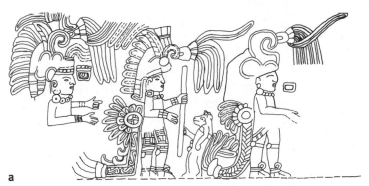
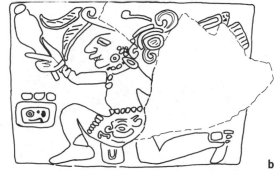

a

b

FIGURE 4.20. Figures associated with south-central Veracruz: *a,* detail on the north column of figures with rectangular cartouche name glyphs and serpent tails with mirrors on their backs, Structure of the Columns, El Tajín (drawing by the author); *b,* modeled/carved ceramic, Río Blanco style, showing kneeling figure with a square cartouche glyph (drawing by the author after Von Winning and Gutiérrez Solano 1996:52).

ground line. Figures with elaborate headdresses and *tezcacuitlapilli* back mirrors with serpent tails process towards the tree. Two of these are named with glyphs in square cartouches seen nowhere else at Tajín (Fig. 4.20a). The back mirror/serpent tail combination, a distinctive costume at Tajín, is also worn by the blowgunner figure just below this scene (Fig. 4.17). Two of the processing figures (the second and fourth from the left) also hold long staffs.[19] Freidel, Schele, and Parker (1993:71) have shown that in the Classic Maya creation epic, the next step after the defeat of 7 Macaw was the raising of the World Tree that held up the sky. This Maya tree emerges from a skeletal head surmounted by a sacrificial bowl. At Tajín, the complete skeletal figure substitutes for the skull bowl (Fig. 4.3f), but otherwise the Tajín imagery continues the cosmogonic narrative by raising the World Tree after the defeat of the bird deity, much as in the Maya epic *Popol Vuh* and earlier Classic period imagery. Arguing from more general iconographic patterns, Tuggle (1968) had already determined that the trees in both of these scenes are Tajín versions of the Mesoamerican World Tree. "World Tree" may here be defined broadly as the *axis mundi,* especially as seen within the Mesoamerican system of the four world directions and the spiritually potent center. The theme of vegetation growing from a sacrificial victim is found throughout the Structure of the Columns program. For example, in the scaffold sacrifice seen on Sculpture 1 (Fig. 4.7), the victim has vegetation growing from his body. Ropes also emerge from his torso, recalling the rope of sustenance in Central Mexico. More

broadly, the theme of fecundity from death, and specifically from skeletal figures, is not only a Classic Veracruz trait but reflects widespread western Mesoamerican ideas about fecundity in general and its relation to death and the earth (Tuggle 1968:63). An especially clear example of this is found in the *Codex Borgia,* page 53 (Fig. 4.21), which depicts the setting of the World Tree of the Center (Byland 1993; Schele 1995). The tree stands in the center of the composition, decorated with red and yellow maize at its base and in each of its branches, emphasizing its fecundity. As at Tajín, the *Borgia* tree grows out of a reclining skeletal figure, here shown as a female reclining on the crocodile mouth that symbolizes the earth. Behind her the waters of the primordial sea are set into a disk. Two flanking figures activate the tree by perforating their penises and spilling the blood onto the skeletal figure. The generation of life from skeletal material echoes a central theme of the South Ballcourt panels, where the Principal Tajín Deity is shown performing autosacrifice to create humans.

The register immediately below (Fig. 4.3g) depicts a ritual closely related to the raising of the World Tree. In both of these scenes the ritual costumes are identical: the participants wear back mirrors from which trail serpent effigies (compare Fig. 4.20a). This procession does not end in a World Tree, however, but in two structures. The first is a temple with the flying cornice typical of Tajín architecture, while the structure on the far right appears to be a simple, thatched palapa. Inside the temple structure an eroded individual sits in front of a figure consisting of a head and

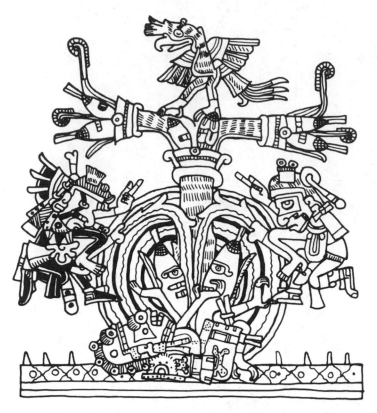

FIGURE 4.21. World Tree growing from a skeletal figure, *Codex Borgia* 53. Drawing by Linda Schele, © David Schele, courtesy Foundation for the Advancement of Mesoamerican Studies, Inc., www.famsi.org.

a significantly truncated body. I have argued elsewhere (Headrick and Koontz 2006) that this figure is a bundle, similar to those found in other Classic Veracruz images. The contents of the palapa are also eroded and difficult to read, but it is clear that the seated figure is holding a miniature human figure, perhaps a statue.

The leftmost figure in the procession may be identified as 13 Rabbit by the feathered staff in his headdress. He also holds a staff of some sort and carries a burden figure on his back. The burden figure is too abraded to ascertain any detail, but other instances at Tajín of burden figures like this one show them as skeletal. Since the costuming indicates that this register and the one above (World Tree procession, Fig. 4.3f) are part of the same procession, it is likely that the skeletal bundle that 13 Rabbit is carrying in this register will eventually be placed on the ground as shown in the register above (Fig. 4.3f), where it will produce the World Tree. This is important because as we have seen, the World Tree procession is part of the larger narrative involv-

ing the tree, a primordial bird, and its defeat at the hands of heroes. We may now reconstruct the entire sequence on the three lower registers (Fig. 4.3h–f). The lowest register depicts the blowgunning of the Principal Bird Deity and the dance associated with that bird (Fig. 4.3h). On the two registers immediately above, a procession ends with the tree on which the Principal Bird Deity perched, now growing out of human sacrifice as the World Tree (Fig. 4.3f). The setting of the World Tree is performed by 13 Rabbit and a number of associates, but the former controls the skeletal figure that will serve as a foundation for the tree. These dances and processions must have been directly associated with 13 Rabbit's accession, which is shown at the apex of this column (Fig. 4.3e).

Just as depictions of World Trees and birds are found in several areas of Mesoamerica, performances that include them are not limited to the Maya. The Mexica ritual *Xócotl huetzi,* which took place during the eighteenth month of the solar year, contains many of the same elements seen in this series, especially tree raising and the defeat (by capture) of the bird in the top of the tree (Sahagún 1950–1982, Book 2:111–117; Durán 1971:445). The capture of the bird was treated as a contest between the young men of the group. There is, however, no mention of blowgunning or skeletal bases for the tree. Taube (2000:305) likened the pole in these rites to a World Tree, but added that it could also represent a monumental fire drill, and the whole rite could be seen as a captive warrior sacrifice by fire. This insight is especially pertinent to the Tajín program, where we have already seen young male sacrificial victims treated as captive warriors and burned.

In summary, the iconography of these three scenes involving serpent-tailed processional figures, skeletal figures, and trees describes a ritual in which a skeletal figure is carried by the Tajín ruler to the spot of the World Tree's birth. This tree sprouts from the body of the skeletal figure, exemplifying the idea that life springs from death, and particularly from skeletal figures, found throughout western Mesoamerica. Apart from the presence of the skeletal figure, however, the narrative of creation is couched in terms that have several specific resemblances to roughly

contemporary Maya imagery, especially that seen on portable vases, even when cognate imagery existed elsewhere at Tajín or in the region. A further southerly connection is revealed by the name glyphs and other features of some of these figures, some of whom seem to have close ties to the elite of the south-central Gulf lowlands.

Name Glyphs and Southern Veracruz

In the register that contains the World Tree raised from the skeletal figure (Fig. 4.3f), several figures exhibit what to many seem aberrant or unusual qualities (Fig. 4.20a). Most important is a unique glyphic style in the names of two of the three central figures. Instead of the usual glyphic element surmounted by the bar and dot numerals, as seen throughout the columns imagery (Fig. 4.5), these figures exhibit a cartouche inside of which is a heavily schematized or geometric glyph. This same naming system appears in the south-central Veracruz Río Blanco wares (Fig. 4.20b). The large feather bonnet headdress worn by the column figures is also rare at Tajín, but common in more southerly portions of Veracruz, including Las Higueras (Sánchez Bonilla 1993:144) and the Río Blanco area itself (Hangert 1958). Kampen (1972: Fig. 33a) first noticed that the central figures in this scene exhibit different body proportions than the columns imagery norm, and that the glyph scale is unusual. Now we can say that the image's unique qualities stem from the fact that some members of 13 Rabbit's court are depicted as coming from or otherwise identified with the south-central Gulf lowlands (Koontz 2008).

Conclusions

We began this investigation of the Structure of the Columns imagery by noting that it is a particularly detailed presentation of the Tajín court at the moment of 13 Rabbit's accession. A close examination of the iconography reveals a cosmopolitan set of court participants, with clear examples of south-central Gulf lowlands figures among those with Tajín associations. The rites depicted—especially the scaffold and gladiatorial sacrifices—suggest an elite inter-action sphere that reached throughout the Gulf lowlands and perhaps beyond. Most, if not all, of the rites depicted may be directly related to accession and the legitimation of political power. There seems to be a two-pronged strategy to the rites of legitimation surrounding 13 Rabbit's accession: some, particularly the ballgame and standard rites, are shown throughout the site in similar contexts, but sacrifices involving the scaffold and gladiatorial rites are unique to this program. The latter rites seem to be associated with rites of power farther south, in the south-central Gulf lowlands and the Maya area. That 13 Rabbit may have appropriated certain legiti-mating rites from this area is borne out by the inclusion of figures related to the south-central Gulf lowlands through glyphic conventions and figural proportions, something seen at Tajín only in the Structure of the Columns imagery. Ceram-ics found on the surface of the Structure of the Columns, specifically the Polished Black Relief wares, also point to south-central Gulf lowland ceramic form and decoration, although the pieces were clearly crafted in the Tajín area. Extending this Gulf lowlands interaction sphere even farther south and east, there is an image of a blow-gunner and a tree at Tajín that closely resembles Maya painting on portable vases, suggesting that a whole series of rites either filtered through southern Veracruz or came from the western Maya area directly in a way that we have yet to understand.

Of the several fundamental questions raised by these elite networks, perhaps the most tangible is the method of travel. How did such iconography move throughout the Gulf lowlands, as it so obviously did? One method may have been in the form of elaborately decorated modeled/carved wares, the Tajín version of which was Polished Black Relief. Not only did El Tajín have its own version of this ware, but the iconography of that ware closely follows the columns imagery, and the name glyphs on this pottery also point to 13 Rabbit. Scenes with directly comparable ico-nography of accession, tribute, and related rites may be found in related versions of modeled/carved wares in the south-central Gulf lowlands (Fig. 4.8), and we have already seen that figures dressed and named as if from this area are shown on the columns (Fig. 4.20). A chief subject matter

on these vases throughout the Gulf lowlands is the avian dance, and thus a likely mechanism for this exchange would have been participation in the bird deity cult, with its exchange of feathers and accompanying rites that provided charter for political power and elite status.

Finally, there is the matter of the format of the columns imagery: the wrap-around or re-entrant format is found nowhere else at the site, even on other carved columns (see Kampen 1972: Figs. 17c, d). The modeled/carved ceramic tradition along the Gulf lowlands favored just such a compositional scheme, often wrapping processions around the entire vase, forming a continuous re-entrant composition. Perhaps the columns were in one sense these elite objects monumentalized, and thus 13 Rabbit was alluding to his participation in this Gulf lowlands elite interaction sphere with what was clearly an innovative format.

AUDIENCES AND DEITIES AT EL TAJÍN

On one level, complex narrative imagery like that found at El Tajín is meant to be read. The studies presented in the previous three chapters attempted to read the imagery by exploring connections between motifs, texts, and archaeological data. We identified motifs and their contexts, and then attempted to find explanatory analogs or other comparative data in the absence of any direct links to texts. These iconographical methods are widely accepted in the field and are used to produce meaning from a wide variety of objects and representations in all sorts of historical contexts.[1] We were especially interested in placing the imagery of El Tajín more firmly into its Mesoamerican context through the iconographic analysis of related sets of motifs at Tajín and similarly related motifs in other regions of the Gulf lowlands and elsewhere.

Iconography remains a valid method for reconstructing the narratives told through art and the worldviews that sustained those narratives, and it is especially vital in mapping out such cultural connections as those referenced above. That said, it has long been recognized that iconographic studies often omit certain important components of the experience of public art. Principal among these is the experience of a particular audience situated in a particular space. For example, in the case of the Tajín ballcourt sculptures, the analyses above have little to say about the position of the audience or how that position could have affected their experience of the sculpture. The narrative told and the worldviews enunciated were those of the elite designers and patrons of these monuments, which simply could not have been identical to those of other audiences for the sculptures.

Perhaps it is more accurate to say that the views enunciated on these monuments were

those that the elite designers and patrons wanted to communicate to various audiences. Because much of the public art was designed by the elite for popular consumption, we are constantly pulled toward an exegesis of elite aggrandizement as the chief message of the imagery (Nagao 1989). While this may be the case on an iconographical level, it may appear simplistic on a more phenomenological level, where one must also consider the actual ritual performance in the urban center. In looking at the event itself, and not just the trace or the representation, the audience's reception becomes an important element in any analysis, and that reception may not be reducible to elite aggrandizement. As Inomata (2006:809) has noted for Classic Maya studies, scholars "should direct [their] attention not only to the maneuvering of a small number of 'aggrandizers' but to the motivation and roles of an audience or the masses." This chapter is very much interested in audience, and especially in what the audience saw and how they saw it.

On the face of it, any attempt to get at something of the audience experience that occurred more than a thousand years ago and left no direct textual trace might seem futile. One simply cannot call forth the ancient sensory experience itself. Nevertheless, the way in which the experience was encoded or framed may be available. For example, in a foundational study, Houston and Taube (2000) investigated how Mesoamerican sense experience is encoded in image and script. In this work the authors identify certain textually documented visual fields, especially those conceived as dominant. These experiences actively constituted social relations as one group publicly took up a privileged visual position, especially during moments of heightened experience such as public ritual. In another attempt to articulate the various experiences of ritual audiences, Sanchez (2005) reminds us that monumental art and architecture did not have a single, homogenous audience, and the placement of sculpture and architecture was crucial in defining how different audiences were constituted, especially when access to certain spaces and monuments was not universal. In other words, what you saw depended on who you were. In general, social fissures and factions inevitably accompany the construction of various audiences with differen-

tial access to spaces and messages, especially when we are dealing with large-scale social phenomena such as the rites investigated in this chapter.

To facilitate the analysis of audience experience, we focus on two analytical fields that help locate and define that experience. The first, focusing on what the audience saw, may be explored through the analysis of vista. *Vista* here means the visual field of a particular audience, which acknowledges the audience as an active constituent in the experience of the art. It is finally this experience that we are interested in here, as opposed to a more static, iconographic reading that presupposes an ideal viewer outside the pomp and bustle of an actual event.

To further delineate audience and experience, the following analysis is focused on the relations between vista and the social construction of the audience. In this context it is helpful to imagine the experience not only in terms of what the viewer would see, but also from where it is seen. To the analytical category of vista, then, we add that of locus, the place from which one acquires a vista. In the context of an ancient Mesoamerican city, every vista has a locus: a place that serves to orient vision and to situate the viewer socially through relationships to other loci. Analyzing the relationships among loci can be a powerful method for teasing out social differentiation: those who experienced the rite from the top of a temple were not in the same social space as those who witnessed it on the plaza floor below.

Constructing Audiences for a Central Plaza Rite

It is only appropriate that we return to the very heart of the site, the Central Plaza, to examine the intersection of vista and locus (Figs. 2.2, 5.1). The Central Plaza is an ideal space in which to investigate vista and locus, for it contains a large space specifically designed for the congregation of an audience. As presented in Chapter 2, we know something of the rites they would have witnessed there, especially the standard rites held at the base of the Pyramid of the Niches and on the summit of Structure 4. Having identified these rites, we may now ask how the audiences experienced them.

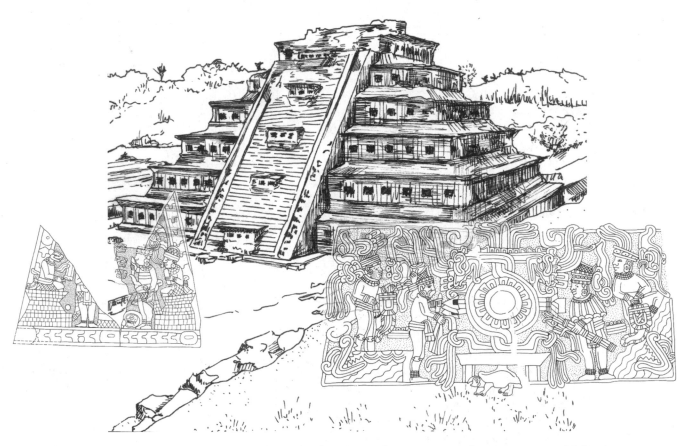

FIGURE 5.1. View of the Central Plaza and the Pyramid of the Niches from the top of Structure 4. Insets show Structure 2 Panel (*left*) and Structure 4 Panel (*right*). Main drawing and right inset by Daniela Koontz; left inset by Michael Kampen, courtesy of the University Press of Florida.

Recall that in Chapter 2 the Pyramid of the Niches was identified as a central element in the urban core and a major marker of Tajín identity. In that discussion, Tajín identity was treated as largely whole and uncontested, as recounted in the associated myths and performed in the rites. Identities become more interesting and varied, however, when one examines how the audiences for these pronouncements would have experienced them. By reconstructing the audiences that witnessed these rites and relating the rites to other social signs, we can see how the experience of Tajín identity was politically marked during public spectacles. This marking would have been determined by the vista from which one experienced the rites and by the different artworks associated with each vista. To explore what these vistas and their associated artworks may tell us about the social positions of different Tajín viewers in and around the Central Plaza, we will first recall the associated artworks and their iconography, preparing the way for an examination of the vistas and loci created for the audiences assembled in that space.

Returning to the iconography of the Central Plaza (Fig. 5.1), we identified the theme of the Structure 2 Panel (left) as ballcourt decapitation sacrifice. Recall that it was placed on the northernmost rim of the great platform that also served as one wall of the ballcourt where just such decapitation rites were again represented and certainly enacted. In this way the panel connects the major rites in the South Ballcourt with the Central Plaza. More generally, the panel illustrates the fundamental relationship between Tajín architectural sculpture and the rites that took place in the immediate vicinity. Much of Tajín sculpture—not only in the Central Plaza, but throughout the site—may be shown to represent or otherwise allude to rites that took place in immediately adjacent spaces. This is true of the Central Plaza and South Ballcourt, and also the Mound of the Building Columns. We will invoke this relationship of sculpture, rites, and

space later when we define certain Central Plaza experiences.

The Structure 4 Panel (Figs. 5.1 [right], 2.6), situated directly across the plaza, was the pendant to the ballcourt decapitation scene. The panel's iconography centers on a standard that rises through a bench to end with a disk encircled by feathered serpents (Fig. 5.2a). The most important aspect of the previous iconographical analysis is the identification of rites associated with this standard. We saw that these standards—specifically one centered on a disk and another with intertwined serpents—were manipulated by human ritualists in the Mound of the Building Columns (Fig. 5.2b). We discussed other iconographic clues suggesting that the Structure 4 Panel is presenting a ritual scene, especially the identity of the four figures on either side of the central standard. Figures with similar costumes and accouterments are shown elsewhere as ritual assistants in accession and related rites. Recall that in addition to presenting a standard-raising ceremony, the Structure 4 Panel was originally the base for such a ceremony, with the hole carved through its center serving as the receptacle for the standard. This ceremony must have taken place, according to the archaeologist's reckoning of the original placement, inside the temple at the summit of Structure 4 (García Payón 1973a).[2] In the terms of this argument, the locus of the rite in the temple superstructure was small and restricted, especially compared with what I will argue below were the teeming masses below on the plaza. Further, not only would the ritual participants at the summit have been separated from these masses, but their position would have yielded a vista that literally surveyed the crowd.

The summit of Structure 4 was not the only place that standard rites were held in the area. Directly in front of the Pyramid of the Niches is a series of prismatic blocks (Fig. 5.1, at the foot of the pyramid). Each block contains a single hole drilled into the center of its upper face. These holes are directly comparable in size to the one found in the center of the Structure 4 Panel, and as I have argued in Chapter 2, they probably served the same purpose, as standard bases. Further, it is likely that the standard rites at the foot of the Niches and the summit of Structure 4 were part of an integrated ritual spectacle, just as the

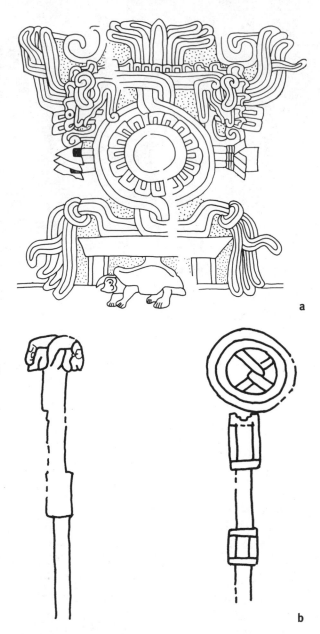

FIGURE 5.2. Feathered Serpent standard and related devices: *a,* central motif, Structure 4 Panel (drawing by Daniela Koontz); *b,* standards shown in Mound of the Building Columns imagery (drawing by the author).

later Mexica used standards on the plaza and at the summit of their central temple in the Panquetzaliztli rites documented in greatest detail by Sahagún (1950–1982, Book 2:146–147; Koontz 2006).

The establishment of a single ritual spectacle on Structure 4 and in the Central Plaza is important for our purposes because it establishes loci and vistas that were part of the same experience

and thus directly comparable. In the Structure 4 example, as we have already seen, the rite would have been surveyed from the summit and centered on the elaborately decorated Structure 4 Panel, but the other locus, that of the plaza floor, and its vista we have yet to discuss in any detail. I would like to turn now to the experience of the people in the plaza, and how their experience of the standard rites would have differed from that of the participants on the summit of Structure 4.

We know from ethnohistorical reports, as well as several pre-Columbian inscriptions and images that only priests, other elites, and a handful of other individuals were allowed onto the summits of the raised architecture during public performances. The popular audience for the rites is often assumed to have gathered at the base of the pyramid, although this is not always reported ethnohistorically and is rarely if ever mentioned or illustrated in source material. Several lines of evidence support the proposition that large crowds assembled in Tajín's Central Plaza for these rites, including the elaborate stone and stucco plaza floor and the careful delimitation of the space, which would have focused any gathering on the activities on and in front of the main pyramid. Perhaps most convincing, however, are the later accounts of Mesoamerican standard rites analogous to those illustrated at Tajín. The Spanish friars and their informants specifically describe the standard rites as popular in nature, and Durán (1971:88) describes the gathering of a large crowd at the foot of the main pyramid during the Mexica standard rites. This later ethnohistorical evidence, coupled with the logic of the physical layout at Tajín, strongly suggests that there was a large Central Plaza crowd in attendance during the standard rites.

Although both the Structure 4 participants and the audience in the Central Plaza may have witnessed the same events, in almost every respect the experience of the standard rites for those in the Central Plaza would have been significantly different from that of the participants high on the summit of Structure 4 (Fig. 5.1). The standard bases at the foot of the pyramid would have served to orient the viewers much as the Structure 4 Panel would have served as the base for the standard and thus the focal point of the rite at the summit. Instead of a small crowd and

one elaborately carved, jewel-like base, in the Central Plaza there are over a dozen monumental, plain prismatic bases, and room for several thousand spectators. Further, the backdrop of the more popular presentation of standard rites would have been the Pyramid of the Niches itself. This structure embodies more than any other the elements that designate Tajín architectural identity: the combination of flying cornice and niche is here worked out more consciously and elaborately than anywhere else at the site, and in this sense the structure is the embodiment of Tajín polity identity, as first proposed by Kubler (1973) and discussed here in Chapter 2.

The imageless standard bases and extended spectator space of the Central Plaza, the locus of one experience of the standard rite, must be seen in relation to the experience of those on the summit of Structure 4, with the elaborately carved single standard base in the closed, restricted, and raised space of the Structure 4 superstructure. A simple yet telling difference is in the treatment of the bases themselves: the base of the Structure 4 Panel is carved in the finest Classic Veracruz scroll style (Fig. 2.6), whereas the standard bases in the plaza received no carved decorative treatment (Reese-Taylor and Koontz 2001:20).[3] Access to Classic Veracruz style was a mark of the elite throughout the region, seen in a closely related set of scroll styles employed in elite burials with carved yokes and other ballgame paraphernalia, as well as in finely wrought ceramics and decoration on palace structures. This elite Classic Veracruz scroll style would have been foregrounded in the restricted standard rite at the summit of Structure 4, but would not have been a significant presence in the plaza locus.[4] The dominant presence of the elaborate carving style on the summit is, I believe, a sign that the summit standard rite was designed specifically for the elite. Although the Feathered Serpent standard is associated with the summit, there is some evidence that another standard type marked the plaza rites at Tajín. This simpler, more traditional rectangular banner (Fig. 5.3a) closely resembles those worn into battle by later Central Mexican warriors (Fig. 5.3b), which certainly performed the same military insignia function as those in the Gulf lowlands. Numerous large versions of these standards form the central motifs of a

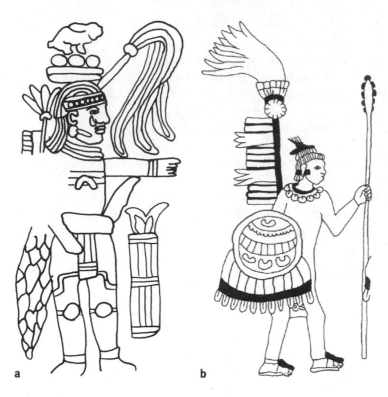

FIGURE 5.3. Battle standards worn by warriors: *a*, detail of north column, Structure of the Columns, El Tajín (drawing by the author); *b*, detail of *Codex Mendoza*, fol. 67r (drawing by Daniela Koontz).

rite depicted in the nearby Las Higueras murals (Morante López 2005:116–117). The close links between the ritualism depicted at both sites (Sánchez Bonilla 1992) suggest that the standards were important ritual objects as well as more pragmatic military devices at Tajín as well as Las Higueras.[5] Thus the fifteen bases lining the Pyramid of the Niches would have provided another important place for the deployment of standards. Perhaps the rectangular banner standards were massed at the foot of the pyramid, while the Feathered Serpent banner was raised on the summit of the adjacent Structure 4.

This scenario of a two-tiered system of standards at El Tajín is hypothetical, but it does have some interesting support in the documentation surrounding standard symbolism and use in Late Postclassic Central Mexico. There the battle standard (*cuachpamitl* or *pamitl*), often a rectangular banner attached to a pole support comparable to the Tajín example (Fig. 5.3a, b), was the chief insignia of a warrior unit.[6] It was carried into battle as a visual cue for the unit's movements and

the location of the unit leader (Hassig 1988:56–57).[7] There were many of these standards, and they seem to have been ordered in a hierarchical relationship based on the size and scope of the unit, with the ultimate organization consisting of four great standards, one for each ward of the city (Hassig 1988:57). In addition to these standards deployed throughout the military as organizational devices, there were two special standards, called by Sahagún (1950–1982, Book 2:146) "devices for seeing, made of feathers, with a hole in their midst." This description may be compared with the Structure 4 Panel's central motif, the Feathered Serpent standard (Fig. 5.2a), which contains an allusion to mirrors in the central disk (an important device for "seeing"), one ruff of feathers surrounding the disk and another surmounting it, and a hole in the center. Over the course of the Mexica Raising of the Standards rite these special devices were taken to the summit of the temple. There they were used to "capture" the patron deity associated with the summit, and in one version the ruler himself was present for this event (Sahagún 1950–1982, Book 2:146, n. 22). It has been stressed here that the Tajín Feathered Serpent standard was used in rites at the summit of Structure 4, suggesting that not only were the Tajín Feathered Serpent and Mexica "device for seeing" standard types similar in form, but that they were also highly charged, probably chiefly ceremonial, and closely associated with the highest echelons of the elite.

This elite "device for seeing" standard type may be juxtaposed with *cuachpantli* standard types that served as the major Mexica military insignia in battle but were also deployed in the Panquetzaliztli rite by military leaders (Kubler and Gibson 1951:32).[8] The *cuachpantli* standards were likely deployed at the foot of the Templo Mayor, where a line of standard-bearers was found archaeologically (Matos Moctezuma 1988:73). The placement of the Templo Mayor standards recalls that of the standard bases at the foot of Tajín's Pyramid of the Niches. During the Panquetzaliztli rites, the Templo Mayor functioned as Coatépec, and Tajín's Pyramid of the Niches likely embodied a similar central sacred mountain for that polity, an identification partially based on the ritual role of standards at the base of both

pyramids (see Chapter 2). In this reconstruction of Mexica military rites and the similar patterns seen at Tajín, the *cuachpantli* banners, embodying the polity's various major military divisions, were raised at the foot of the central pyramid, while at the summit of that pyramid (or in the case of Tajín, the adjacent Structure 4), a special class of standard was used among the highest echelons of the elite.

Other elite markers found at the summit of Structure 4 are the small, restricted nature of the space and the raised position of the participants in relation to those on the plaza floor (Fig. 5.1). This latter point deserves further comment regarding the vista of this group. Although the standard rite in the closed temple atop Structure 4 would not have been visible to those on the plaza floor below, the plaza rite would have been in clear view of the elites gathered on the summit. Although the analysis of vista above could be construed as a general phenomenological assertion, I believe that conscious, emic spatial perceptions in the summit vista were in operation here. As Sarro (2006:173–174) points out, Tajín Chico is marked by a significant difference in elevation and also separation from the more easily accessible, and therefore more public, spaces of the lower ceremonial center. Both the form and function of Tajín Chico buildings, which Sarro considers a single, large palace complex, appear designed to proclaim the elite nature of the space. Thus separation and elevation may be chief signifiers of elite space at Tajín, with the differentiated standard rites as yet another example of this spatial practice. Although we lack supporting textual documentation of spatial perception from the Tajín region during this period, we do have contemporary Maya texts that define specific uses of spatial perceptions by their elite.

As Houston and Taube (2000:287–289) assert in their study of sense experience among the Classic Maya, sight was agentive in ways that the other senses were not. When Late Classic Maya rulers looked down on ritual acts, they were participating and even legitimating those acts in a real, active sense (see also Herring 2005:54–56). Maya writing records the active gaze of these rulers with the specific *yichnal* expression, and the accompanying imagery positions the ruler's field of vision as emanating from above. It is important to note that the texts denote not simply a dominant gaze, but also active participation in another's actions (Houston et al. 2006:174). If we may use this Classic Maya analogy at Tajín, then the contemporary Tajín elite stationed on the small platform at the summit of Structure 4 would not only have been privy to the restricted rites in the sanctuary, but also in just such a position to "see" the Central Plaza rites below in the same active, legitimating sense. In terms of this argument, the locus was elevated and thus privileged according to Mesoamerican spatial discourse, but further, the elevation created a specific vista that embraced—as only the active agent of sight could—the entire Central Plaza, in this way legitimating the more popular proceedings below. Recall that this dominant position was also marked by an emphasis on the elite Classic Veracruz scroll style.

The iconography of the standard itself may also speak directly to eliteness in its references to the Feathered Serpent. We have already seen a two-part division in regional standard symbolism, with the Feathered Serpent standard a more restricted device. In addition to its tie to Tajín elite identity, the Feathered Serpent is, in both major models of Epiclassic political symbolism (Ringle 2004; López Austin and López Luján 2000), the central symbol of pan-Mesoamerican political legitimacy. Ringle (2004:181–183) has associated this particular Tajín standard with several images of standards at Chichén Itzá (Freidel et al. 1993). He noted that intertwined Feathered Serpents at the latter site are often shown as standards associated with thrones, and hence directly related to rule. López Austin and López Luján (2000) also linked the Feathered Serpent with the right to rule, and specified that it is this power symbol that linked political elites across Mesoamerica by the Epiclassic period. As Ringle (2004) pointed out, the major representations of the Feathered Serpent at Tajín occur on the Structure 4 Panel and in the sanctuary at the summit of the Pyramid of the Niches. As noted above, both environments were places of significantly restricted access and traditionally identified with the elite. Thus not only do the formal and spatial trappings of the Structure 4 Panel and its stan-

dard communicate eliteness, but perhaps so does the Feathered Serpent symbolism of the standard itself.

In contrast, the vista of the plaza participants would have been dominated by the fifteen standards raised at the foot of the pyramid. These were likely the *cuachpantli* type banners used to exhibit the military organization of the polity as a whole. Moreover, the backdrop would have been the niche and flying cornice architecture of the Pyramid of the Niches. Interestingly, this distinctive architectural style is not contiguous with the Classic Veracruz scroll style. The niche and flying cornice combination is restricted to Tajín and its hinterland, whereas the Classic Veracruz scroll style circulated throughout the central Gulf lowlands, encompassing a much wider elite interaction sphere (Fig. 1.1). Although framed in a different way, once again it appears that the Pyramid of the Niches functioned as a sort of polity emblem, while the Classic Veracruz scroll style, employed in important decoration throughout the site, references a related but distinct interaction sphere that marked elites throughout a larger region. We can say, then, that the vista available to those on the Central Plaza foregrounded the Tajín polity in the form of the Pyramid of the Niches, the city's architectural signature. Moreover, we have seen how the iconography of the Central Plaza identified the building as the city's primordial mountain. Thus the plaza participants were visually awash with signs of the polity or group. At the same time, the vista of the participants on the summit locus was one of elite dominance as evidenced by the style decorating the ritual elements, and the restricted and raised nature of the space.

The analysis of standard rites as experienced in the center of Tajín has allowed us to construct elite (Structure 4) and popular (Central Plaza) audiences for the event. *Elite* and *popular* are rough social categories in Mesoamerica, and recent scholarship has shown that each of these is full of divisions and gradations (see Chase and Chase 1992; Inomata and Houston 2001). That said, at Tajín these categories help us conceive of the single most significant cleavage in the experience of these events—from the summit of the pyramid or in the plaza—as seen from the per-

spective of vista and locus. Further, the categories of elite and popular may help us understand other aspects of Tajín public art—specifically, characteristics of the deity system it employs.

Two Major Tajín Deities and Their Relationship

Before we consider the nature of the Tajín deity system and how it may have articulated with the ritual performances discussed above, let us consider several pertinent issues in studies of the Mesoamerican supernatural. The organization of deities was systematically related to the structure of political power throughout Mesoamerica. The relation of supernatural power and the body of the ruler has been an especially important topic (Houston and Stuart 1996; López Austin 1973). In addition, the relation of deity and polity served to organize political groups and their relations (Nicholson 1971:409; López Austin 1994:38–39; Pohl 2003). This system did not remain static over time or across geography, however, and some of the most fruitful recent thinking has exposed the contingent, historical nature of any particular Mesoamerican deity system. In the context of this study, it is the relation of various Epiclassic deity systems that formed an important part of the larger context for the system seen at Tajín.

In their initial delineation of the Epiclassic Zuyuan system, López Austin and López Luján (2000:30–33) noted the presence of two overlapping deity systems during this period: one based on the group patron, and the other on an overarching, pan-ethnic Feathered Serpent. The patron deity had an indissoluble link with the entire community and often was the group's creator (López Austin and López Luján 2000:40–41). Leadership of any particular group was often based on a relationship between the leader and the group patron. The Feathered Serpent, on the other hand, was a universalizing patron of the group leaders as a set apart; as Andrea Stone (1989) points out, the Classic Maya elite used the militaristic aspects of a related cult to differentiate themselves from the masses, and Ringle's work (Ringle et al. 1998; Ringle 2004) stresses this aspect of Epiclassic Feathered Serpent imagery

in northern Yucatan. In these schemes, the Feathered Serpent was the patron of the elite as a separate group or class, not the localized deity of any single ethnic group. Thus while on one level the leaders derived their power from a relation with an age-old group patron, on another level the leaders were elite because of their relation with the Feathered Serpent, from whom elite legitimacy flowed.

Fundamental aspects of the Tajín deity system seem to mesh well with the Zuyuan division of major Epiclassic deities into patron and Feathered Serpent. As we have already seen in the discussion of the Pyramid of the Niches panels (Chapter 2), two supernaturals take precedence over all others: the Principal Tajín Deity and the Feathered Serpent (see Fig. 2.17). Both deities appear often and are central to especially important scenes throughout the corpus, as we have seen throughout this volume. Patronage of the major rites documented at the site seems to be split more or less evenly among the two: the Principal Tajín Deity reigns over ballcourt decapitation and accession (Chapter 3), while the Feathered Serpent is associated above all with war standards (Chapters 2 and 4).

Noting the widespread pairing of deities similar to the Principal Tajín Deity and the Feathered Serpent at several places in Mesoamerica during this period, Ringle (Ringle et al. 1998:224) framed this complementarity as a juxtaposition of a nature god (Tlaloc) and a culture god (Quetzalcoatl). In other Epiclassic contexts this characterization seems apt, and the Principal Tajín Deity does show characteristics of the Central Mexican Tlaloc with its curved fangs and association with lightning. Nevertheless, the Principal Tajín Deity has several other characteristics that cannot be associated with Tlaloc and do not seem to be the exclusive purview of nature gods.

Perhaps more pertinent to the Tajín case is the difference between localized patron deities and the elite Feathered Serpent seen in the Zuyuan model (López Austin and López Luján 2000:40–41). Several aspects of the Principal Tajín Deity work well as a polity patron in the terms set out by that model: most importantly, this deity presents the baton and cloth to the ruler in accession scenes, and thus is the source of political

power specific to the Tajín realm (Fig. 4.6). Such scenes make the intimate connection between group leader and patron deity manifest.

Using the Zuyuan model to identify the Principal Tajín Deity as a patron deity is complicated, however, by the god's role as creator of humans (Fig. 3.13). Normally this function falls to the supreme creator deity, the Feathered Serpent, and not to the group patron (López Austin and López Luján 2000:35). It is largely because of this scene that the Principal Tajín Deity has been identified as an early version of Quetzalcoatl, although as we have seen, another Feathered Serpent deity is featured prominently in the iconography of the site, and the Principal Tajín Deity exhibits several iconographic characteristics not associated with Quetzalcoatl.[9] We are left with a Tajín deity long associated with a Central Mexican fanged god of lightning, but with several characteristics usually given to other deities in the Late Postclassic Central Mexican system. In another Epiclassic Mesoamerican area of sustained ballcourt activity, the fanged deity of lightning could be associated with ballcourt rites and depicted in the same "birthing" posture associated with human creation in the Tajín imagery (Fox 1993). Here, however, the emphasis is not on human creation but on more general fecundity. These wider Epiclassic patterns suggest that the fanged deity associated with ballcourt rites could be seen as generally fecund and specifically as a creator god acting in ballcourts during the period.

Instead of attempting to make the Tajín deity fit a Late Postclassic deity category, it is perhaps more productive to note its iconographic traits and the narrative roles it plays, and how these relate to other Tajín deities. The Principal Tajín Deity creates humans in the sacred landscape that was identified above with the Tajín realm (Fig. 3.13), and it is this deity that controls the polity's regalia. In the context of the history of the site and region, it is not surprising that the Principal Tajín Deity would be considered the site's ancient patron. The deity's goggled ancestor, complete with the buccal mask with fangs that marked him, appears as a major image on early (Cacahuatal phase, ca. AD 350–600) tripod supports in the region (Pascual Soto 2000:38), as well as in an early public sculpture in a ballcourt (Pascual Soto

2004:447). This ballcourt context echoes the later Tajín placement of this god's actions, suggesting a particularly close tie between god and court in the north-central Gulf lowlands. Like the deity so intimately associated with them, ballcourts appear early in the history of monumental architecture in the region (Wilkerson 1999; Pascual Soto 2000). These early courts were signs of elite growth and control, just as they were in other areas of the central Gulf lowlands area throughout the Classic and into the Epiclassic (Daneels 1997:63–64, 2008).[10] Thus the combination of ballcourt and Principal Tajín Deity had been an expression of elite power long before Tajín's rulers used it as a major path to political legitimacy. This god's localized associations are what one would expect of a patron deity, especially compared with the larger regional elite associations described here for the Feathered Serpent.

The Tajín Feathered Serpent is closely associated with elaborate battle standards that may be directly related to elite activity throughout the region. We saw in the columns program (Chapter 4) that these standards formed the central focus for rites conducted among a host of elite participants dressed in elaborate costumes. The Structure 4 Panel (Chapter 2) depicts another version of the Feathered Serpent banner rite, with a reduced number of elite participants and the rich scroll style that marks elite contexts throughout the site and the region. In addition to having elite iconography, we noted above that this panel was placed in the sanctuary at the summit of the pyramid. There it served as the base for a rite in a restricted, elite space, especially in comparison to the more popular banner rite held at the foot of the Pyramid of the Niches. Finally, the Feathered Serpent banner appears as the central motif in several panels from the sanctuary atop the Pyramid of the Niches, again emphasizing its restricted, elite nature. Instead of being responsible for human creation and the control of regalia, the Feathered Serpent deity appears to have patronized particular elite groups who controlled certain war standards. These latter were very likely the physical signs of elite warrior groups, as they were later in Mesoamerican history. As predicted in the Zuyuan model, these military groups associated with the Feathered Serpent seem to have crosscut other political

boundaries to tie regional elites together, as witnessed in the columns imagery at Tajín where named elites from throughout the Gulf Coast are shown participating in standard rites and others.

The Feathered Serpent also appears early in the history of the region (Pascual Soto 2000:37, 2004:445), but not in the context of the Feathered Serpent standards that were to become so important to apogee-period Tajín and other Epiclassic elites. As we have seen, early representations of standards in the Tajín region do not contain the intertwined Feathered Serpent motif diagnostic of this complex in Epiclassic times (Fig. 3.2). Instead, the Feathered Serpent banners at Epiclassic Tajín are an innovative combination of earlier forms, several of which seem to have grown out of Teotihuacan's Feathered Serpent Pyramid and its attendant cult. Although the Epiclassic Tajín version is clearly a regional variation, the Feathered Serpent standard cult was not limited to Tajín during the period. Ringle (2004:180–182) has identified the Feathered Serpent/standard combination at Chichén Itzá and has suggested that it also functioned as a battle standard. Further, he has shown how specific aspects of the Feathered Serpent standard iconography, such as the seated figure placed inside the central standard motif, are shared by both sites, suggesting similar symbolic meanings and ritual practices attached to these standards, and thus probably a shared cult.

This shared Feathered Serpent standard cult should be seen in conjunction with the ballcourt decapitation sacrifice cult shared by both sites: recall that we noted significant parallels in the public imagery of both sites associated with ballcourt decapitation, as well as the presence on the Chichén ballcourt ritualists of yokes and *palmas*, a combination diagnostic of the ritualists performing the Tajín ballcourt decapitation rite (see Fig. 2.5; Tozzer 1957; Wilkerson 1991). Other examples of similar ballcourt decapitation imagery are found in Gulf lowland areas between Tajín and Chichén, suggesting that the cult extended throughout the Gulf lowlands during the Epiclassic.

At Epiclassic Tajín, ballcourt decapitation was the necessary prelude to political accession to paramount political power (Chapter 3), and it seems that ballcourt rites were not only depicted

similarly, but were also central to accession at Chichén Itzá. Ringle (2004) has argued convincingly that Chichén accession ceremonies are depicted in the Great Ballcourt and contain numerous allusions to ballcourt rites (among others). There are certainly important iconographic and stylistic differences between the two programs, but the fundamental similarities in the relation of the Feathered Serpent banner, ballcourt sacrifice with yoke and *palma,* and accession to political power are not fortuitous. Instead, the relations signal what was certainly a widespread Epiclassic Gulf lowlands cult or, perhaps more accurately, a related set of cults, crucial to elite power in the region.

It is now clear that fundamental aspects of the cult were not developed by Epiclassic Tajín or Chichén. From a Gulf lowland perspective, the practice of ballcourt decapitation sacrifice was an ancient one by the time of the Epiclassic cult, with clear examples of ballcourt paraphernalia together with severed human heads found as early as AD 100 at Cerro de las Mesas in the south-central Gulf lowlands (Coe 1965:697). The Gulf lowlands ballcourt had long been an important architectural sign of elite power in the region, again significantly predating the rise of Tajín and Chichén (Daneels 2008). There is

also good iconographic evidence to suggest that rites with standards were crucial to Gulf lowland political power by the phase preceding the rise of Tajín (Cacahuatal, ca. AD 350–600), specifically in the imagery of the first public stela, where an officiant/ruler displays a standard in several examples (Chapter 2). When viewing the Feathered Serpent banner cult and the rites surrounding ballcourt decapitation from a Gulf lowlands perspective, instead of proposing a revolution in elite symbol systems to accompany what was clearly a fundamental realignment of political power during this period, we must admit significant continuity with earlier Gulf lowland symbol systems. The indigenous development of what would become central elite symbols and practices suggest significant Gulf Coast contributions to the emerging elite networks of the Mesoamerican Epiclassic. That said, the innovations seen in the Tajín use of Feathered Serpent banners, scaffold sacrifices, and ballcourt rites cannot be explained as simple developments out of the regional culture. Instead, they suggest intensive interaction with elite from several areas of Mesoamerica in exchange networks that were fundamental to the formation of El Tajín in particular and Epiclassic Mesoamerica in general.

NOTES

Chapter One

1. The complete list of scholars who discuss some aspect of ballcourt iconography at El Tajín would be very long; classic treatments of substantial parts of the iconography may be found in Spinden 1933; Ekholm 1946, 1949; Proskouriakoff 1954; and Wilkerson 1984.

2. These Epiclassic centers include not only Cacaxtla and Xochicalco, as pointed out by numerous scholars (e.g., Diehl and Berlo 1989), but also a host of sites throughout Mesoamerica (Beekman and Christensen 2003:149).

3. For a discussion of the different Mesoamerican periodizations and their histories, see Mendoza 2001. The Epiclassic period as defined here derives largely from the work of Diehl and Berlo (1989), by far the most comprehensive treatment to date of the period as a subject. It should be pointed out that in some literature on El Tajín (e.g., Wilkerson 2001a), the Epiclassic designation is used for the period AD 900–1100, while the period 600–900 is called the Late Classic.

4. For a synthesis of shifting images of war and peace in Maya scholarship, see Webster 2000. For a remarkable reconceptualization of conflict and militarism at Teotihuacan, see Sugiyama 2005.

5. For descriptions of sites near Tajín, see Jiménez Lara 1991; Wilkerson 1999:122; and Pascual Soto 1998, 2000. For the distant site of Yohualichan and other regional centers with Tajin architectural elements, see Palacios 1926 and Wilkerson 1999:121–122. García Payón (1971:532), Wilkerson (1987a:15), and Daneels (2004:421) describe the similarities in ceramics across this region during Tajín's apogee.

6. Other Classic and Epiclassic Gulf lowland architectural styles contained some combination of talud and niche, with the Maltrata monument from south-central Veracruz showing a Tajín-like niche and flying cornice architectural motif.

7. There is some indication that this zone of Tajín architecture may also continue south along the foothills of the Sierra Madre for some distance, encompassing the Epiclassic sites of Xiuhtetelco in the Sierra de Puebla and extending to Banderilla and Napatecuhtlan near present-day Xalapa, Veracruz (Wilkerson 2001a:327). While there are strong indications in this region of Tajín elite culture in the form of hachas (Scott 1997) and palmas (Arellanos and Beauregard 1981), there has been little exploration of the architecture in this latter area (Vásquez Zarate 1997).

8. Lira López (1990:50) gives no other information on the ¹⁴C date, citing an unpublished report by J. Brüggemann in the Archivo Técnico of the Instituto Nacional de Antropología e Historia (El Problema Cronológico de El Tajín, Informe Técnico Tajín 89, Instituto Nacional de Antropología e Historia, Mexico City, 1989).

9. Earlier proponents of the Feathered Serpent as a symbol that crosscuts lineage ties to unite elites include Kubler (1982) and Fox (1987). See also Coggins 2002.

Chapter Two

1. The substructure of the Pyramid of the Niches has led to much speculation on the shape and nature of Classic period El Tajín (Cacahuatal phase, ca. AD 350–600). García Payón (1971:527) cites the substructure as the chief building of that early period, but as we have seen, there is little evidence to back such a claim. Pascual Soto (1998, 2000) has explored this early period in the Tajín hinterlands and found important early sources of Tajín art and material culture, but little evidence for this early period has been found at the site itself. Wilkerson (2001a:327), like García Payón (1971:527), believes that the great earth-moving projects of the Tajín Epiclassic may have buried much of Cacahuatal phase Tajín below what is now Tajín Chico. This hypothesis has yet to be extensively tested.

2. Defining just what pieces were actually found in the plaza, however, is not without problems due to the irregular recording practices of the early archaeologists. The reconstruction that follows is based on recent detective work by Arturo Pascual Soto (1990) in the archives of the Instituto Nacional de Antropología e Historia and on my own observations in these archives.

3. Pascual Soto (1990:173; see also Brüggemann 1992a:21) has shown that Structure 2 contained the trapezoidal panel formerly designated Pyramid of the Niches Sculpture 7.

4. Related images of decapitation may be found on vases from the Tiquisate region on the Pacific coast of Guatemala (Hellmuth 1978:80; Cohodas 1991).

5. Ringle (2004:181) rightly points out that throne backs contain similar imagery. While this piece certainly plays on the idea of a throne back, actually placing the object in such an orientation would hide one of the side carvings and expose both uncarved surfaces.

6. See Braswell 2003 for the dating of Esperanza phase Kaminaljuyú.

7. A substantial number of individual pieces from what were once objects of this type have also been identified. See Aveleyra 1963 and Uriarte 2006.

8. Rings do appear in the ballcourts at the Maya sites of Chichén Itzá, Uxmal, and Naranjo during this period (Cohodas 1991:283).

9. A standard remarkably similar to the one on this Maya vase and in the Bonampak murals is found in the Gulf lowland murals of Las Higueras (Morante López 2005:76).

10. See the discussion of the region's Cacahuatal phase monuments in Pascual Soto 2000 and the discussion of sculptural chronology in this volume, Chapter 3.

11. See Kampen 1972: Fig. 18 for another example of early iconography that includes the standard.

12. Taube (2000:328, n. 3) notes that possible Veracruz examples of this headdress may predate the Teotihuacan version.

13. Nicholson (2001:399) points out the lack of evidence for proselytizing, universalizing religious movements in Mesoamerica, and use of the term *cult* here is not meant to take on this connotation. In this context Ringle (2004:167) notes that the Feathered Serpent cult may best be seen as "a set of imagery, beliefs, and practices associated with an ideology of leadership," not a universalizing cult. See Trigger 2003:490–494 for a comparative perspective on cults and leadership in ancient civilizations.

14. Taube (1992a, 2000), after Caso and Bernal (1952), argues that the headdress associated with the cult is ancestral to the Aztec Xiuhcoatl, or Fire Serpent, and thus is naturally related to fire rites.

15. Aveleyra (1963) describes the numerous pieces of these stone effigies found in greater Teotihuacan, but the La Ventilla effigy standard is the only complete example.

16. Pasztory (1983:280) identified this object as a fan. At approximately 1.2 m, however, the banner matches the scale of the banners portrayed in the Mound of the Building Columns at Tajín (see Kampen 1972) and at Tikal (Fialko 1988).

17. Kampen (1978) noted a Classic Veracruz sacrificial scene in one of the few well-preserved reliefs from this court.

18. "The Aztecs were so contented here [at Coatépec], although it was no more than a model, no more than a pattern, of the promised land . . ." (Durán 1994:26).

19. ". . . y agujero enmedio, del grandor de mas de una bola, con que juegan ahora a la bola, que llaman Itzompan, y luego la atajan por medio, quedando un triángulo enmedio del agujero, que llaman el pozo de agua, que en cayendo allí la pelota de batel [batey]. . . ." (Tezozómoc 1980:227–229).

20. ". . . allá en Teotlachco [Huitzilopochtli] cómese . . . á la llamada Coyolxauh[qui] . . . la mató en Teotlachco, y la degolló y se le comió el corazón" (Tezozómoc 1992:35).

21. Feathered saurians with similar forelimbs are found throughout Epiclassic and Early Postclassic Mesoamerica in contexts that suggest a close relation to the Feathered Serpent complex described here.

22. The only complete treatment of Tajín supernaturals to date (Bertels 1991) differs significantly from the analysis in this volume, largely because that author does not focus on the narrative position of the deities.

23. Spinden (1933:247) tentatively connected these images with Coatépec, although she did not consider the *itzompan* to be a place in the center of the court.

Chapter Three

1. Scattered examples of formal architectural courts exist earlier, in the Early and Middle Preclassic Pacific Coast

of Chiapas (Hill and Clarke 2001; Agrinier 1991) and possibly in southern Veracruz (Coe and Diehl 1980) and Guerrero (Angulo 1994).

2. These results were in line with Brüggemann's assertions (1985, 1993) that there was little development in the Tajín ceramic assemblage throughout the history of the site.

3. No ballcourt substructures have been firmly identified to date at Tajín. Raesfeld (1990:92) excavated only at the corners of the ballcourt structures, however, leaving open the possibility of a significantly smaller structure buried inside the visible court buildings. García Payón (1959:445) alludes to a substructure or earlier building phase of the South Ballcourt, but the evidence for this substructure was never published. A ballcourt-related panel found cached in the fill of this same court (García Payón 1950) surely could have come from an earlier version, but that is not evident from the published context.

4. Reports by L. Pescador Canton in the Archivo Técnico of INAH attempt a seriation of the courts based on a larger sample of courts and more subtle ceramic distinctions than used by Raesfeld (1990). Pescador asserts that the large, vertical-walled courts (the South Ballcourt and Ballcourt 30/31) were later. These results are important but must be considered preliminary until we develop a firmer ceramic seriation at Tajín.

5. Taladoire and Colsenet (1991:165) define the terms used here for court morphology.

6. Wilkerson (1991:48) includes the much smaller North Ballcourt in the vertical-walled variety.

7. Ringle (2004:170) proposes the same function for the Great Ballcourt at Chichén Itzá, a point we will return to when comparing the imagery of that court with the El Tajín programs.

8. The definition of the South Ballcourt program as simple narrative ultimately derives from Weitzmann's (1970) definition of the term. See Reents-Budet 1989 for a concise description of narrative modes in Mesoamerican, and particularly Classic Maya, art. Quilter (1997:116–117) discusses narrative art across pre-Columbian societies, literate and nonliterate.

9. Wilkerson (1984:119, 1991: 50) states that the South Ballcourt blocks are sandstone from the region's Meson Formation outcrops; Esquitin Lastiri (1991:128) gives the material as "a compact, clayey limestone."

10. Tozzer (1957:141) first identified these motifs as ballcourt structures.

11. *Codex Bodley* 10:IV shows this same ballcourt meeting and subsequent conquests. Here 8 Deer's partner is 1 Death, who like 1 Motion has celestial associations (Caso 1960). In the *Colombino-Becker* example, the two participants, 1 Motion and 8 Deer, are represented in the act of playing ball and then immediately conquering the place shown immediately before them (Caso 1996:65).

12. Transcription from the original 1703 manuscript, now in the Newberry Library, as found in Edmonson 1971:59.

13. Tedlock's superb translation of the *Popol Vuh* (1996:91) renders this passage as "When they gathered in the ballcourt for entertainment."

14. John W. Fox (1991), working from different evidence, has also proposed an alliance function for the K'iche ballgame.

15. The Aztec called this weapon a *tepoztopilli* (Hassig 1988:81–83), and there is ample evidence of its existence in the Mesoamerican arsenal from Preclassic times onward.

16. The literature on Mesoamerican warfare and the supernatural has recently grown exponentially: some key statements include Klein 1994; Carrasco 1995; Webster 2000:80; Schele and Miller 1986:208–240; Freidel et al. 1993:293–336.

17. See also Schele and Mathews 1998:283–284.

18. Cohodas (1975:117) identified the zoomorph as a "crocodile-tree," a distinct possibility and what would be an important variation on the general serpentine zoomorphs identified above.

19. Mary Miller (1998:192–193) makes the important point that even when it appears a Classic Maya battle is being depicted, the outcome has already been decided and the losers are already stripped of their finery and ready for sacrifice, as if the depiction is a reconception or perhaps even a restaging of the battle. This is also true of imagery from Cacaxtla, in the highlands.

20. See Brüggemann 2001b:38 for a comparison of Tajín court profiles.

21. At Tajín, only Ballcourt 30/31 has a similar profile.

22. Wilkerson (1984, 1991) also finds that the central panels must be read after the corner panels, although he argues from different evidence. Because the final two panels focus on the actions of deities, while the first four panels foreground the ritual actions of humans, Wilkerson characterizes the central panels as "the response of the gods."

23. Delhalle and Luykx (1998) identified the deity specifically as Quetzalcoatl, but this identification runs into the same problems as that of Tlaloc, namely that the deity does not behave as any single Late Postclassic Aztec deity.

24. Earlier, Cohodas (1975:117) associated this scene with the rebirth of the Hero Twins in the *Popol Vuh.*

25. Delhalle and Luykx (1998:247) cite an *hacha* depicting a human head with a fish headdress.

26. Fox (1993) found an analogous male deity, also related to the Central Mexican Tlaloc, in the same posture depicted in an Epiclassic ballcourt in Chiapas. Although this deity was not associated specifically with childbirth or the creation of humans, there were clear associations with fertility.

27. The number 400 may be used as a metaphor for "innumerable" in Nahua narrative. These same 400 Rabbits may also be likened to the 400 warriors of the Nahua creation myth (Taube 2000:280).

Chapter Four

1. Earlier researchers posited five (Wilkerson 1991:52) or six (García Payón 1954:40; Tuggle 1968:40; Kampen 1972:12) columns.

2. Akkeren (1999:286) proposes that the Bonampak bead is amber and thus the nose-bead of rulers. Whether this

is true or not, the point remains that a precious stone intimately associated with power is being offered in both the Tajín and Bonampak cases.

3. The murals of Las Higueras contain a similar scene with the donation of a string of beads. See Sánchez Bonilla 1992:144.

4. Berdan, Masson, Gasco, and Smith (2003:104–106) discuss the differences between tribute and elite gift exchange, noting that much of the latter was symmetrical. The Classic Veracruz images, on the other hand, show clearly hierarchical relationships and goods always flowing towards the more powerful.

5. "Acabado de acuchillar y matar al los cautivos, luego todos los que estaban presentes, sacerdotes y principales y los señores de los esclavos, comenzaban a danzar en su areito, en rededor de la piedra donde habían muerto a los cautivos; . . . Y el padrino de los cautivos, llamado Cuitlachueue, cogía las sogas con que fueron atados los cautivos en la piedra y levantábalas hacia las cuatro partes del mundo, como haciendo reverencia o acatamiento, y haciendo esto andaba llorando y gimiendo como quien llora a los muertos."

6. Durán (1971:178) calls this same rope the *centzonmecatl,* the rope of four hundred strands.

7. Kampen (1972:42) goes so far as to argue against the historicity of the columns because he views the dress of the character associated with the 13 Rabbit glyph as inconsistent and therefore not a single personage. As I argue in the text, however, there are consistent signs associated with 13 Rabbit, and the change in costume is necessary to document the various rites the figure is undergoing.

8. Machado (2001) has identified another context for this feathered staff headdress in depictions of a supernatural related to maize. See also Sarro 2001:247–248 and Ladrón de Guevara 1992:111.

9. Ringle (2004:183–185) rightly points out the similarities between the Principal Tajín Deity here and the "effigy" or impersonator figure shown in an investiture scene at Chichén Itzá. Although the deities that these figures impersonate are not identical, they both wear ballgame gear and present politically charged objects.

10. The *Historia Tolteca-Chichimeca* was painted sometime between 1544 and 1563 (Leibsohn 1993) but recounted Postclassic events in and around Cholula (Kirchoff et al. 1989). It is our most valuable source for Early Postclassic Chichimec political history (Pohl 1994:147).

11. ". . . luego tomaron prisioneros a los que eran enemigos de los tolteca, cuyos tlatoque se llamaban Quauhtzitzimitli y Tlazotli, Tzompantli, Yauhtlicuiliuhqui. Y cuando los chichimeca los tomaron prisioneros los llevaron allá a Cholollan, allí los tlatoque con ellos celebraron fiesta (sacrificio)."

12. The two figures were the dual priest/rulers of Cholula, chosen from among the devotees of Quetzalcoatl (the Feathered Serpent) (Carrasco 1971:372).

13. For a discussion of this rank in the Pre-Columbian hierarchies of Western Mesoamerica, see Carrasco (1971:351–352). The giving of this status and the related *tecuhtli* rank seems to have been carefully controlled by ritual throughout Mesoamerica (see also Pohl 1994:89–93; Ringle 2004).

14. ". . . luego Icxicouatl y Quetzalteueyac le perforaron el septum a los tepilhuan chichimeca con el hueso del águila y el hueso de jaguar. He aquí el signo en el que aparece la manera en que se establecieron como tlatoque los moquiuixca, los quauhtinchantlaca; cómo fueron enflorados, fueron saludados; cómo las flechas de los tepilhuan chichimeca brotaron."

The Nahuatl word that I translate as "the arrows . . . appeared for the first time" is *tlacochcueponque,* which Kirchoff translates literally into Spanish as "brotaron las flechas." He notes that *cueponi* signifies "brotar un flor," and in that sense can be understood as "salir por primera vez," or "to appear for the first time" (see Kirchoff et al. 1989:171, n. 1).

15. "¡Han hecho merced a sus parientes los tolteca y los calpolleque! ¡Oh chichimeca, vé, camina, da el encuentro a la llanura, a la tierra divina, merece tu pueblo! contestaron: 'Nos han hecho merced, lo ha permitido su corazón, oh tolteca; hemos cumplido con nuestro deber, hemos ayudado al pueblo de ustedes.' luego ya les dan mujeres a los chichimeca."

16. As an alternate hypothesis, Wilkerson (1991:55) suggested that the scene depicts the meeting of two lineages, with the one on the left submitting to the one on the right.

17. Kampen (1972: Fig. 32b) identifies the animal as canine, but I would argue that both the ear and the nose mark the animal as feline.

18. The main natural reference of this bird is the macaw, but it should be noted that this supernatural avian was more generally associated with rich, valuable plumage, which also came from the quetzal and related species (Taube 2003:279). In other contexts where its raptorial aspects are emphasized, the bird can be identified as a species of falcon (Guernsey 2006:98).

19. There may be one other appearance of the serpent-tail costume at Tajín. Kampen (1972: Fig. 35g) illustrates a fragment from the Mound of the Building Columns that shows a serpent-tailed individual playing ball with a skeletal figure. Although the figure is eroded, and the sculpture is cut off at the point that would have revealed a back mirror, the presence of the serpent tail, a rare costume element at Tajín, strongly suggests that this figure is equivalent to the processants depicted on the central column. Beside the ballgame scene are two figures in the Tajín dance posture who flank a zoomorph belching the central standard mirror as it appears in this program. García Payón (1973a) was the first to point out that this stone is one of the rare depictions at Tajín of what appears to be an actual ballgame.

Chapter Five

1. Here the term *iconography* is used in its broadest sense, as any study that foregrounds the meanings inherent in the object, especially when those meanings are eventually related to source texts. These studies would include Panofsky's (1955) original definition of iconology, as well as iconography and other idealist methodologies. Idealist method-

ologies may be opposed to those that focus more on social aspects of the work's reception, thus leading to questions of audience experience, as in this chapter.

2. García Payón found the piece on the north side of the structure but argued that the original placement was in the summit temple. Supporting this is the superb condition of the piece, suggesting that it was kept out of the elements for its entire history.

3. As with much Tajín architecture, these bases were probably painted.

4. Early photographs by Fewkes (1907) suggest that the small altar in the Central Plaza was marked with Classic Veracruz scrolls.

5. This is not surprising, given that Mesoamerican military insignia were often considered to be infused with supernatural power (Freidel et al. 1993:327–334).

6. See Berdan and Anawalt 1997:214–215 for a discussion of the nomenclature of Mexica standards.

7. The small paper banners that were used in sacrificial ceremonies throughout Late Postclassic Mesoamerica did not serve as military insignia and thus are not treated here.

8. Sahagún (1950–1982, Book 2:146) noted that at the culmination of the Panquetzaliztli rites, "First arrived the standards and two devices for seeing, made of feathers, with a hole in their midst," suggesting that both types of standards were deployed during the festivities.

9. For the Principal Tajín Deity as Quetzalcoatl, see Delhalle and Luykx 1986, 1998. Despite the fact that several scholars have read the human creation scene as directly analogous to Quetzalcoatl's creation of humans in later Nahua narrative, this too may be a reference to the duties of the patron deity, who was generally conceived as the creator of the sponsored human group in the Zuyuan deity system (López Austin and López Luján 2000:41). In this same Zuyuan system, the creator of humans in a more universal sense was the Feathered Serpent, who is not shown in any context yet identified as the human creator deity at Tajín. It is possible, then, that the creation of humans story found in the South Ballcourt at Tajín is a reference to the creation of this group, whereas later Mesoamerican narratives use common elements to construct an episode in which the Feathered Serpent created all humans. While the argument for a local creation of humans is tentative, it is not unusual for Mesoamerican creation stories to refer to particular groups. Further, the idea of creation by a local patron deity would mesh well with the other attributes of the Principal Tajín Deity that mark him as a patron, especially the control of local regalia.

10. Daneels (1997, 2004:401) makes the important point that in some regions only the capital contained a ballcourt, whereas in other regions, control was much more diffuse, with ballcourts at second- and third-order centers in addition to the capital. The point remains that the rise of courts signals the growth of an elite; however, that elite may have organized itself.

BIBLIOGRAPHY

Acosta, José R. 1940. Exploraciones en Tula, Hgo., 1940. *Revista Mexicana de Estudios Antropológicos* 4(3):172–194.

Agrinier, Pierre. 1991. The Ballcourts of Southern Chiapas, Mexico. In *The Mesoamerican Ballgame,* ed. Vernon L. Scarborough and David R. Wilcox, pp. 175–194. Tucson: University of Arizona Press.

Aguilera, Carmen, and Rubén Cabrera Castro. 1999. Figura pintada sobre piso en La Ventilla, Teotihuacan. *Arqueología* 22:3–16.

Alcorn, Janice. 1984. *Huastec Ethnobotany.* Austin: University of Texas Press.

Anawalt, Patricia. 1982. Analysis of the Aztec Quechquemitl: An Exercise in Inference. In *The Art and Iconography of Late Post-Classic Central Mexico,* ed. Elizabeth H. Boone, pp. 37–72. Washington, DC: Dumbarton Oaks, Trustees for Harvard University.

Angulo, Jorge. 1994. Observaciones sobre su pensamiento cosmogónico y la organización sociopolítica. In *Los olmecas en Mesoamerica,* ed. John E. Clark, pp. 223–237. Mexico City: El Equilibrista.

Arellanos, Ramón, and Lourdes Beauregard. 1981. Dos palmas Totonacas de reciente hallazgo en Banderilla, Ver. *La Palabra y el Hombre* 38–39:145–160.

Aveleyra de Anda, Luis. 1963. *La estela teotihuacana de La Ventilla.* Mexico City: Instituto Nacional de Antropología e Historia.

Barnes, William. 1999. Aztec "Zapotecizing": The Imperial Significance of Mexica Acculturation. Paper presented at the Annual Meeting of the College Art Association, Los Angeles.

Berdan, Frances F., and Patricia Rieff Anawalt. 1997. *The Essential Codex Mendoza.* Berkeley and Los Angeles: University of California Press.

Berdan, Frances F., Marilyn A. Masson, Janine Gasco, and Michael E. Smith. 2003. An International Economy. In *The Postclassic Mesoamerican World,* ed. Michael E. Smith and Frances F. Berdan, pp. 96–108. Salt Lake City: University of Utah Press.

Bertels, Ursula. 1991. *Die götterwelt von El Tajín, Mexiko.* Münster: Lit.

Beyer, Hermann. 1934. Shell Ornament Sets from Huasteca, Mexico. In *Studies in Middle America,* Publication 5, pp. 153–215. New Orleans: Tulane University, Middle American Research Institute.

Bierhorst, John (editor and translator). 1992. *History and*

Mythology of the Aztecs: The Codex Chimalpopoca. Tucson: University of Arizona Press.

Boone, Elizabeth H. 1991. Migration Histories as Ritual Performance. In *To Change Place: Aztec Ceremonial Landscapes,* ed. Davíd Carrasco, pp. 121–151. Boulder: University of Colorado Press.

———. 2003. A Web of Understanding: Pictorial Codices and the Shared Intellectual Culture of Late Postclassic Mesoamerica. In *The Postclassic Mesoamerican World,* ed. Michael E. Smith and Frances F. Berdan, pp. 207–221. Salt Lake City: University of Utah Press.

Braswell, Geoffrey. 2003. Dating Early Classic Interaction Between Kaminaljuyú and Central Mexico. In *The Maya and Teotihuacan: Reinterpreting Early Classic Interaction,* ed. Geoffrey Braswell, pp. 81–104. Austin: University of Texas Press.

Bricker, Victoria. 1981. *The Indian Christ, the Indian King: The Historical Substrate of Maya Myth and Ritual.* Austin: University of Texas Press.

Broda, Johanna. 1970. Tlacaxipehualiztli: A Reconstruction of an Aztec Calendar Festival from 16th Century Sources. *Revista Española de Antropología Americana* 5:197–273.

Brüggemann, Jürgen K. 1985. Seriación de la cerámica procedente de pozos estratigráficos. In *Informe de la Temporada 84/85 del Proyecto Tajín.* Mexico City: Archivo de Dirección de Monumentos Prehispánicos, Instituto Nacional de Antropología e Historia.

———. 1991. Análisis urbano del sitio arqueológico del Tajín. In *Proyecto Tajín,* ed. Jürgen K. Brüggemann, vol. 2, pp. 81–127. Mexico City: Instituto Nacional de Antropología e Historia.

———. 1992a. *Tajín: Guía oficial.* Mexico City: Instituto Nacional de Antropología e Historia.

———. 1992b. Arquitectura y urbanismo. In *Tajín,* essays by Jürgen Brüggemann, Sara Ladrón de Guevara, and Juan Sánchez Bonilla, pp. 55–84. Mexico City: El Equilibrista.

———. 1993. El problema cronológico del Tajín. *Arqueología* 9–10:61–72.

———. 1995. La zona del Golfo en el Clásico. In *Historia Antigua de México,* ed. Linda Manzanilla and Leonardo López Luján, vol. 2, pp. 11–40. Mexico City: Miguel Angel Porrúa.

———. 2001a. El Tajín. In *The Oxford Encyclopedia of Mesoamerican Cultures,* ed. David Carrasco, vol. 1, pp. 377–380. Oxford: Oxford University Press.

———. 2001b. La zona del Golfo en el Clásico. In *Historia antigua de México,* 2nd edition, ed. Linda Manzanilla and Leonardo López Luján, vol. 2, pp. 13–46. Mexico City: Instituto Nacional de Antropología e Historia.

———. 2004. ¿Dónde está la presencia de Teotihuacan en El Tajín? In *La costa del Golfo en tiempos Teotihuacanos: Propuestas y perspectivas,* ed. M. E. Ruiz Gallut and A. Pascual Soto, pp. 349–368. Mexico City: Instituto Nacional de Antropología e Historia.

Brüggemann, Jürgen K., Alvaro Brizuela Absalón, Sara Ladrón de Guevara, Patricia Castillo, Mario Navarrete Hernández, and René Ortega Guevara. 1992. *Tajín.* Xalapa: Gobierno del Estado de Veracruz.

Bye, Robert, and Edelmira Linares. 2001. Pulque. In *Oxford Encyclopedia of Mesoamerican Cultures,* ed. Davíd Carrasco, vol. 3, pp. 38–40.

Byland, Bruce E. 1993. Introduction and Commentary. In *The Codex Borgia: A Full-Color Restoration of the Ancient Mexican Manuscript,,* ed. G. Diaz and A. Rodgers, pp. xiii–xxxii. New York: Dover Publications.

Byland, Bruce E., and John M. D. Pohl. 1994a. *In the Realm of 8 Deer: The Archaeology of the Mixtec Codices.* Norman: University of Oklahoma Press.

———. 1994b. Political Factions in the Transition from Classic to Postclassic in the Mixteca Alta. In *Factional Competition and Political Development in the New World,* ed. Elizabeth Brumfiel, pp. 117–126. Cambridge: Cambridge University Press.

Cabrera Castro, Rubén. 1996. Las excavaciones en La Ventilla: Un Barrio Teotihuacano. *Revista Mexicana de Estudios Antropológicos* 42:5–30.

Cabrera Castro, Rubén, Saburo Sugiyama, and George Cowgill. 1991. Templo de Quetzalcóatl at Teotihuacán: A Preliminary Report. *Ancient Mesoamerica* 18(1):53–67.

Carballo, David. 2007. Effigy Vessels, Religious Integration, and the Origins of the Central Mexican Pantheon. *Ancient Mesoamerica* 18(1):53–67.

Carlson, John B. 1981. Olmec Concave Iron-Ore Mirrors: The Aesthetics of a Lithic Technology and the Lord of the Mirror. In *The Olmec and Their Neighbors: Essays in Memory of Matthew W. Stirling,* ed. Elizabeth P. Benson, pp. 117–147. Washington, DC: Dumbarton Oaks.

Carmack, Robert. 1981. *The Quiche Mayas of Utatlan: The Evolution of a Highland Guatemala Kingdom.* Norman: University of Oklahoma Press.

Carmack, Robert, and James Mondloch. 1982. *El Título de Totonicapan.* Mexico City: Universidad Autónoma de México.

Carrasco, Davíd. 1995. Give Me Some Skin: The Charisma of the Aztec Warrior. *History of Religions* 35(1):1–26.

Carrasco, Pedro. 1971. Social Organization of Ancient Mexico. In *Handbook of Middle American Indians,* vol. 10, ed. Gordon F. Ekholm and Ignacio Bernal, pp. 349–375. Austin: University of Texas Press.

Caso, Alfonso. 1953. Calendarios de los totonacos y huastecos. *Revista Mexicana de Estudios Antropológicos* XIII (2–3):337–350.

———. 1960. *Codex Bodley 2858.* Mexico City: Sociedad Mexicana de Antropología.

———. 1966. *Interpretación del Códice Colombino/Interpretation of the Codex Colombino.* Mexico City: Sociedad Mexicana de Antropología.

———. 1996 *Códice Alfonso Caso.* Mexico City: Fondo de Cultura Económica.

Caso, Alfonso, and Ignacio Bernal. 1952. *Urnas de Oaxaca.* Mexico City: Instituto Nacional de Antropología e Historia.

Castillo Peña, Patricia. 1995. *La expresión simbólica del Tajín.* Mexico City: Instituto Nacional de Antropología e Historia.

Castro-Leal, Marcia. 2001. Fluidos humanos y vegetales en

el juego de pelota sur de El Tajín, Veracruz. In *Antropología e historia mexicanas: Homenaje al Maestro Fernando Cámara Barbachano,* ed. Beatriz Barba de Piña Chan et al., pp. 203–212. Mexico City: Instituto Nacional de Antropología e Historia.

Chase, Arlen F., and Diane Z. Chase. 1992. Mesoamerican Elites: Assumptions, Definitions, and Models. In *Mesoamerican Elites: An Archaeological Assessment,* ed. D. Z. Chase and A. F. Chase, pp. 3–17. Norman: University of Oklahoma Press.

Clancy, Flora Simmons. 1985. Maya Sculpture. In *Maya: Treasures of an Ancient Civilization,* ed. Charles Gallenkamp and Regina Elise Johnson, pp. 58–70. Albuquerque: Albuquerque Museum.

——. 1999. *Sculpture in the Ancient Maya Plaza: The Early Classic Period.* Albuquerque: University of New Mexico Press.

Coe, Michael D. 1965. Archaeological Synthesis of Southern Veracruz and Tabasco. In *Handbook of Middle American Indians,* ed. G. R. Willey, vol. 3, pp. 679–715. Austin: University of Texas Press.

——. 1982. *Old Gods and Young Heroes: The Pearlman Collection of Maya Ceramics.* Jerusalem: Israel Museum, Maremont Pavilion of Ethnic Arts.

——. 1989. Hero Twins: Myth and Image. In *The Maya Vase Book,* ed. J. Kerr, vol. 1, pp. 161–184. New York: Kerr Associates.

Coe, Michael D., and Richard Diehl. 1980. *In the Land of the Olmec.* Austin: University of Texas Press.

Coggins, Clemency. 2002. Toltec. *Res: Anthropology and Aesthetics* 42:34–85.

Cohodas, Marvin. 1975. The Symbolism and Ritual Function of the Middle Classic Ball Game in Mesoamerica. *American Indian Quarterly* 2(2):99–130.

——. 1978. Diverse Architectural Styles and the Ball Game Cult: The Late Middle Classic Period in Yucatan. In *Middle Classic Mesoamerica: A.D. 400–700,* ed. Esther Pasztory, pp. 86–107. New York: Columbia University Press

——. 1991. Ballgame Imagery of the Maya Lowlands: History and Iconography. In *The Mesoamerican Ballgame,* ed. Vernon L. Scarborough and David Wilcox, pp. 251–288. Tucson: University of Arizona Press.

Cortez, Constance. 1986. The Principal Bird Deity in Preclassic and Early Classic Maya Art. Unpublished M.A. thesis, Department of Art History, University of Texas at Austin.

Cortéz Hernandez, Jaime. 1989. Elementos para un intento de interpretación del desarrollo hidraulico del Tajín. *Arqueología* 5:175–190.

Cowgill, George. 1997. State and Society at Teotihuacan, Mexico. *Annual Review of Anthropology* 26(1):129–161.

Daneels, Annick. 1997. El proyecto Exploraciones en El Centro de Veracruz, 1981–1995. In *Coloquio arqueología del centro y sur de Veracruz,* ed. Sara Ladrón de Guevara and Sergio Vásquez, pp. 59–74. Xalapa, Veracruz: Universidad Veracruzana.

——. 2002. Presencia de Teotihuacan en el centro y sur de Veracruz. In *Ideología y política a través de materiales, imágenes y símbolos: Memoria de la Primera Mesa Redonda de Teotihuacan,* ed. M. E. Ruiz Gallut, pp. 655–683. Mexico City: Universidad Nacional Autónoma de México, Instituto Nacional de Antropología e Historia.

——. 2004. Máscaras de piedra de estilo Teotihuacano en la costa del Golfo. In *La costa del Golfo en tiempos Teotihuacanos: Propuestas y perspectivas,* ed. María Elena Ruiz Gallut and Arturo Pascual Soto, pp. 393–426. Mexico City: Instituto Nacional de Antropología e Historia.

——. 2008. Ballcourts and Politics in the Lower Cotaxtla Valley: A Model to Understand Classic Central Veracruz? In *Classic-Period Cultural Currents in Southern and Central Veracruz,* ed. Philip J. Arnold III and Christopher Pool. Washington, DC: Dumbarton Oaks.

Day, Jane Stevenson. 2001. Performing on the Court. In *The Sport of Life and Death: The Mesoamerican Ballgame,* ed. E. Michael Whittington, pp. 64–77. London: Thames and Hudson.

Delhalle, Jean-Claude, and Albert Lukyx. 1986. The Nahuatl Myth of the Creation of Humankind: A Coastal Connection? *American Antiquity* 51(1):117–121.

——. 1998. Mourir a El Tajín. *Revue de l'Histoire des Religions* 215(2):217–247.

Diehl, Richard. 1983. *Tula: The Toltec Capital of Ancient Mexico.* London: Thames and Hudson.

——. 2000. The Precolumbian Cultures of the Gulf Coast. In *The Cambridge History of the Native Peoples of the Americas, Mesoamerica,* ed. Richard E. W. Adams and Murdo J. Macleod, vol. 2, pt. 1, pp. 156–196. Cambridge: Cambridge University Press.

Diehl, Richard A., and Janet Catherine Berlo (editors). 1989. *Mesoamerica After the Decline of Teotihuacan: A.D. 700–900.* Washington, DC: Dumbarton Oaks.

Durán, Diego. 1971. *Book of the Gods and Rites and the Ancient Calendar.* Norman: University of Oklahoma Press.

——. 1994. *The History of the Indies of New Spain.* Translated, annotated, and with an introduction by Doris Heyden. Norman: University of Oklahoma Press.

Du Solier, Wilfredo. 1939. Principales conclusiones obtenidas del estudio de la cerámica arqueológica del Tajín. In *Actas del XXVII Congreso Internacional del Americanistas,* vol. II, pp. 25–38. Mexico City: Instituto Nacional del Antropología e Historia.

——. 1945. La cerámica arqueológica de El Tajín. *Anales del Museo Nacional de Arqueología, Historia y Etnografía,* quinta época, tomo III, pp. 147–192.

Edmonson, Munro. 1965. *Quiche-English Dictionary.* Middle American Research Institute Publication 30. New Orleans: Tulane University Press.

——. 1971. *The Book of Counsel: The Popol Vuh of the Quiché Maya of Guatemala.* Middle American Research Institute Publication 35. New Orleans: Tulane University Press.

Ekholm, Gordon. 1946. The Probable Use of Mexican Stone Yokes. *American Anthropologist* 48(4):593–606.

——. 1949. Palmate Stones and Thin Stone Heads: Suggestions on Their Possible Use. *American Antiquity* 15(1):1–9.

Fialko, Vilma. 1988. El marcador de juego de pelota de Tikal: Nuevas referencias epigráficas para el Clásico Temprano. In *Primer simposio mundial sobre epigrafía Maya,* pp. 61–80. Guatemala City: Asociación Tikal.

Foias, Antonia. 2002. At the Crossroads: The Economic Basis of Political Power in the Petexbatun Region. In *Ancient Maya Political Economies,* ed. Marilyn Masson and David Freidel, pp. 223–248. Walnut Creek, CA: Alta Mira Press.

Fox, John Gerard. 1993. The Ballcourt Markers of Tenam Rosario, Chiapas, Mexico. *Ancient Mesoamerica* 4(1):55–64.

———. 1996. Playing with Power: Ballcourts and Political Ritual in Southern Mesoamerica. *Current Anthropology* 37(3):483–496.

Fox, John W. 1987. Maya Postclassic State Formation: Segmentary Lineage Migration in Advancing Frontiers. Cambridge: Cambridge University Press.

———. 1991. Lords of Light versus the Lords of Dark: The Postclassic Highland Maya Ballgame. In *The Mesoamerican Ballgame,* ed. V. L. Scarborough and D. R. Wilcox, pp. 213–238. Tucson: University of Arizona Press.

Freidel, David, Linda Schele, and Joy Parker. 1993. *Maya Cosmos: Three Thousand Years on the Shaman's Path.* New York: William Morrow and Company.

Freidel, David, and Charles Suhler. 1999. The Path of Life: Toward a Functional Analysis of Ancient Maya Architecture. In *Mesoamerican Architecture as a Cultural Symbol,* ed. Jeff Karl Kowalski, pp. 250–274. Oxford: Oxford University Press.

Furst, Jill Leslie. 1978. *Codex Vindobonensis Mexicanus 1: A Commentary.* Institute of Mesoamerican Studies Publication 14. Albany: State University of New York.

García Payón, José. 1949. Notable relieve con sorprendentes revelaciones. *Uni-Ver* 1:351–359.

———. 1950. Palmas y hachas votivas. *Uni-Ver* 2:63–66.

———. 1951. La pirámide de El Tajín: Estudio analítico. *Cuadernos Americanos* 10(6):153–177.

———. 1952. Totonacas y Olmecas: Un ensayo de correlación histórico-arqueológico. *Uni-Ver* 3:27–52.

———. 1954. El Tajín: Descripción y comentarios. *Universidad Veracruzana* 3(4):18–63.

———. 1959. Ensayo de interpretación de los tableros del juego de pelota sur de El Tajín. *El México Antiguo* 9:445–460.

———. 1963. Quienes constuyeron El Tajín y resultados de las últimas exploraciones de la temporada 1961–1962. *La palabra y el hombre* 7:243–252.

———. 1965. *Descripción del pueblo de Gueytlalpan (Zacatlan, Juxupango, Matlaltan, y Chila, Papantla) 20 de mayo de 1581.* Xalapa: Universidad Veracruzana.

———. 1971. Archaeology of Central Veracruz. In *Handbook of Middle American Indians,* ed. Gordon F. Ekholm and Ignacio Bernal, vol. 11, pp. 505–542. Austin: University of Texas Press.

———. 1973a. El tablero de Montículo Cuatro. *Boletín del Instituto Nacional de Antropología e Historia* (ser. 2) 7:31–34.

———. 1973b. *Los enigmas de El Tajín.* Colección Científica 3. Mexico City: Instituto Nacional de Antropología e Historia.

Garibay, Angel María. 1965. *Teogonía e historia de los Mexicanos.* Mexico City: Porrúa.

Gillespie, Susan D. 1989. *The Aztec Kings: The Construction of Rulership in Mexica History.* Tucson: University of Arizona Press.

———. 1991. Ballgames and Boundaries. In *The Mesoamerican Ballgame,* ed. Vernon L. Scarborough and David Wilcox, pp. 317–346. Tucson: University of Arizona Press.

Graulich, Michel. 1988. Double Immolations in Ancient Mexican Sacrificial Ritual. *History of Religions* 27(4):393–404.

Grübe, Nikolai. 1992. Classic Maya Dance: Evidence from Hieroglyphs and Iconography. *Ancient Mesoamerica* 3(2):201–218.

Guernsey, Julia. 2006. *Ritual and Power in Stone: The Performance of Rulership in Mesoamerican Izapan Style Art.* Austin: University of Texas Press.

Hangert, Waltraut. 1958. Informe Sobre el Edificio Número 1, El Faisán. *La palabra y el hombre* 7:267–274.

Hansen, Richard. 1998. Continuity and Disjunction: The Pre-Classic Antecedents of Classic Maya Architecture. In *Function and Meaning in Classic Maya Architecture,* ed. Stephen D. Houston, pp. 49–122. Washington, DC: Dumbarton Oaks.

Harrison, Peter D. 2001. Thrones and Throne Structures in the Central Acropolis of Tikal as an Expression of the Royal Court. In *Royal Courts of the Ancient Maya,* ed. Takeshi Inomata and Stephen D. Houston, pp. 76–101. Boulder: Westview Press.

Hassig, Ross. 1988. *Aztec Warfare: Imperial Expansion and Political Control.* Norman: University of Oklahoma Press.

———. 1992. *War and Society in Ancient Mesoamerica.* Berkeley and Los Angeles: University of California Press.

Headrick, Annabeth. 1991. The Chicomoztoc of Chichén Itzá. Unpublished M.A. thesis, Department of Art and Art History, University of Texas, Austin.

Headrick, Annabeth, and Rex Koontz. 2006. Ancestral Burdens in Gulf Coast Cultures. *Ancient America,* Special Publication no. 1:184–207.

Hellmuth, Nicholas. 1978. Teotihuacan Art in the Escuintla, Guatemala Region. In *Middle Classic Mesoamerica,* ed. Esther Pasztory, pp. 71–85. New York: Columbia University Press.

Herring, Adam. 2005. *Art and Writing in the Maya Cities, A.D. 600–800: A Poetics of Line.* Cambridge: Cambridge University Press.

Heyden, Doris. 1981. Caves, Gods and Myths: World-View and Planning in Teotihuacan. In *Mesoamerican Sites and World-View,* ed. Elizabeth Benson, pp. 1–37. Washington, DC: Dumbarton Oaks.

Hill, Warren, and John E. Clark. 2001. Sports, Gambling and Government: America's First Social Compact? *American Anthropologist* 103(2):331–345.

Houston, Stephen D. 1983. Reading for the Flint-shield Glyph. *Contributions to Maya Hieroglyphic Decipherment* 1:13–25.

———. 2000. Into the Minds of Ancients: Advances in Maya Glyphs Studies. *Journal of World Prehistory* 14(2):121–201.

Houston, Stephen D., and David Stuart. 1996. Of Gods, Glyphs and Kings: Divinity and Rulership Among the Classic Maya. *Antiquity* 70:289–312.

Houston, Stephen D., David Stuart, and Karl A. Taube. 2006. *The Memory of Bones: Body, Being, and Experience among the Classic Maya.* Austin: University of Texas Press.

Houston, Stephen D., and Karl Taube. 2000. An Archaeology of the Senses: Perception and Cultural Expression in Ancient Mesoamerica. *Cambridge Archaeological Journal* 10(2):261–294.

Inomata, Takeshi. 2006. Plazas, Performers, and Spectators: Political Theaters of the Classic Maya. *Current Anthropology* 47(5):805–842.

Inomata, Takeshi, and Stephen D. Houston (editors). 2001. *Royal Courts of the Ancient Maya.* 2 vols. Boulder: Westview Press.

Jackson, Sarah, and David Stuart. 2001. The Aj K'uhun Title: Deciphering a Classic Maya Term of Rank. *Ancient Mesoamerica* 12:217–228.

Jiménez Lara, Pedro. 1991. Reconocimiento de superficie dentro y fuera de la zona arqueológica del Tajín. In *Proyecto Tajín,* ed. Jürgen K. Brüggemann, tomo 2, pp. 5–64.

Jiménez Moreno, Wigberto. 1959. Síntesis de la historia pretolteca de Mesoamerica. In *El esplendor del México Antiguo,* vol. 2, pp. 1019–1108.

Joyce, Arthur A., Andrew G. Workinger, Byron Hamann, Peter Kroefges, Maxine Oland, and Stacie M. King. 2004. Lord 8 Deer "Jaguar Claw" and the Land of the Sky: The Archaeology and History of Tututepec. *Latin American Antiquity* 15(3):273–297.

Kampen, Michael. 1972. *The Sculptures of El Tajín, Veracruz, Mexico.* Gainesville: University of Florida Press.

———. 1978. Classic Veracruz Grotesques and Sacrificial Iconography. *Man* (n.s.) 13:116–126.

Kellogg, Susan. 2001. Ethnohistorical Sources and Methods. In *Archaeology of Ancient Mexico and Central America: An Encyclopedia,* ed. Susan Toby Evans and David Webster, pp. 240–248. New York: Garland Publishing.

Kelly, Isabel, and Angel Palerm. 1952. *The Tajín Totonac,* Part 1: *History, Subsistence, Shelter and Technology.* Smithsonian Institution Institute of Social Anthropology Publication no. 13. Washington, DC: United States Government Printing Office.

King, Mark B. 1990. Poetics and Metaphor in Mixtec Writing. *Ancient Mesoamerica* 1:141–151.

Kirchoff, Paul, Lina Odena Güemes, and Luis Reyes García. 1989. *Historia Tolteca-Chichimeca.* Mexico City: Instituto Nacional de Antropología e Historia.

Klein, Cecilia. 1976. The Identity of the Central Deity on the Aztec Calendar Stone. *Art Bulletin* 58(1):1–12.

———. 1994. Fighting with Femininity: Gender and War in Aztec Mexico. *Estudios de Cultura Náhuatl* 24:219–253.

Knauth, Lothar. 1961. El juego de pelota y el rito de la decapitación. *Estudios de Cultura Maya* 1:183–198.

Koontz, Rex. 2006. Performing Coatépec: The Raising of the Banners Festival Among the Mexica. In *Space and Spatial Analysis in Archaeology,* ed. E. C. Robertson, J. Seibert, D. Fernandez, and M. Zender, pp. 371–380. Calgary and Albuquerque: University of Calgary Press and University of New Mexico Press.

———. 2008. Iconographic Interaction Between El Tajín and South-Central Veracruz. In *Cultural Currents in Classic Veracruz,* ed. Philip Arnold III and Christopher Pool. Washington, DC: Dumbarton Oaks.

———. n.d. Social Identity and Cosmology at El Tajín. In *The Art of Urbanism,* ed. William Fash and Leonardo López Luján. Washington, DC: Dumbarton Oaks. Forthcoming.

Kowalski, Jeff K. 1987. *The House of the Governors: A Maya Palace at Uxmal, Yucatan, Mexico.* Norman: University of Oklahoma Press.

———. 1992. Las deidades astrales y la fertilidad agrícola: Temas fundamentales en el simbolismo del juego de pelota mesoamericano en Copán, Chichén Itzá y Tenochtitlan. In *El juego de pelota en Mesoamérica: Raíces y supervivencia,* ed. Maria T. Uriarte, pp. 305–333. Mexico City: Siglo Veintiuno Editores.

———. 1999. An Introduction. In *Mesoamerican Architecture as a Cultural Symbol,* ed. J. K. Kowalski, pp. 2–13. Oxford: Oxford University Press.

Krotser, Ramón, and Paula Krotser. 1973. Topografía y cerámica de El Tajín, Ver. *Anales del Instituto Nacional de Antropología e Historia,* época 7a, 3:177–221.

Kubler, George. 1967. *The Iconography of the Art of Teotihuacán.* Washington, DC: Dumbarton Oaks.

———. 1973. Iconographic Aspects of Architectural Profiles at Teotihuacan and in Mesoamerica. In *The Iconography of Middle American Sculpture,* pp. 24–39. New York: The Metropolitan Museum of Art.

———. 1980. Eclecticism at Cacaxtla. In *Third Palenque Round Table, 1978,* pp. 163–172: Austin: University of Texas Press, 1980.

———. 1982. Serpent and Atlantean Columns: Symbols of Maya-Toltec Polity. *Journal of the Society of Architectural Historians* 41(2):93–115.

Kubler, George, and Charles Gibson. 1951. *The Tovar Calendar: An Illustrated Mexican Manuscript ca. 1585.* New Haven: The Academy.

Ladrón de Guevara, Sara. 1992. Pintura y escultura. In *Tajín,* essays by Jürgen Brüggemann, Sara Ladrón de Guevara, and Juan Sánchez Bonilla, pp. 99–131. Mexico City: El Equilibrista.

———. 1999. *Imagen y pensamiento en El Tajín.* Xalapa: Universidad Veracruzana.

———. 2005. Lenguaje corporal en Tajín. *Arqueología Mexicana* 71:44–47.

Leach, Edmund. 1976. *Culture and Communication.* Cambridge: Cambridge University Press.

Leibsohn, Dana. 1993. *The Historia Tolteca-Chichimeca: Recollecting Identity in a Nahua Manuscript.* Ph.D. dissertation, Department of Art History, University of California at Los Angeles. Ann Arbor: University Microfilms.

León-Portilla, Miguel. 1987. *Mexico-Tenochtitlan, su espacio y tiempo sagrados*. Mexico City: Plaza y Valdes.

Leyenaar, Ted J. J. 1988. Ulama: The Survival of the Mesoamerican Ballgame Ullamaliztli. In *Ulama: Het balspel bij de Maya's en Azteken, 2000 v. Chr.-2000 n. Chr.: van mensenoffer tot sport* [Ulama: The Ballgame of the Mayas and Aztecs, 2000 BC–AD 2000: From Human Sacrifice to Sport], ed. Ted J. J. Leyenaar and Lee A. Parsons, pp. 94–147. Leiden: Spruyt, Van Mantgem and De Does BV.

Lira López, Yamile. 1990. *La cerámica de El Tajín, norte de Veracruz, México*. Beiträge zur Archäologie Bd. 3, Berlin.

———. 1995a. El Palacio del Edificio de las Columnas en El Tajín. In *El Tajín: Estudios monográficos*, texts by Hector Cuevas Fernández et al., pp. 85–124. Xalapa: Universidad Veracruzana.

———. 1995b. Una revisión de la tipología cerámica de El Tajín. *Anales de Antropología* 32:121–159.

———. 1997. El Tajín: Una ciudad del centro-norte de Veracruz. In *XI Simposio de Investigaciones Arqueológicas en Guatemala*, pp. 819–828. Guatemala City: Museo Nacional de Guatemala.

———. 1998. La cerámica de "relieve" de Tajín. Paper presented at the XXV Mesa Redonda de la Sociedad Mexicana de Antropología, San Luis Potosí, México.

Looper, Matthew, and Julia Guernsey Kappelmann. 2001. Cosmic Umbilicus in Mesoamerica: A Floral Metaphor for the Source of Life. *Journal of Latin American Lore* 21(1):3–54.

López Austin, Alfredo. 1973. *Hombre-dios: Religión y política en el mundo náhuatl*. Mexico City: Universidad Nacional Autónoma de México, Instituto de Investigaciones Históricas.

———. 1993. *The Myths of the Opossum*. Translated by Bernard R. Ortiz de Montellano and Thelma Ortiz de Montellano. Albuquerque: University of New Mexico Press.

———. 1994. *Tamoanchan y Tlalocan*. Mexico City: Fondo de Cultura Económica.

———. 1996. *The Rabbit on the Face of the Moon: Mythology in the Mesoamerican Tradition*. Salt Lake City: University of Utah Press.

López Austin, Alfredo, and Leonardo López Luján. 1999. *Mito y realidad de Zuyuá: Serpiente emplumada y las transformaciones mesoamericanas del clásico al posclásico*. Mexico City: Colegio de México Fondo de Cultura Económica.

———. 2000. The Myth and Reality of Zuyuá: The Feathered Serpent and Mesoamerican Transformations from the Classic to the Postclassic. In *Mesoamerica's Classic Heritage*, ed. Davíd Carrasco, Lindsay Jones, and Scott Sessions, pp. 21–86. Boulder: University Press of Colorado.

———. 2004. Tollan y su gobernante Quetzalcoatl. *Arqueología Mexicana* XII(67):38–43.

López Austin, Alfredo, Leonardo López Luján, and Saburo Sugiyama. 1991. The Temple of Quetzalcoatl at Teotihuacan: Its Possible Ideological Significance. *Ancient Mesoamerica* 2(1):93–105.

López Luján, Leonardo, Laura Filloy Nadal, Barbara Fash, William Fash, and Pilar Hernandez. 2006. The Destruction of Images in Teotihuacan: Anthropomorphic Sculpture, Elite Cults, and the End of a Civilization. *Res: Anthropology and Aesthetics* 49/50:13–39.

Machado, John. 2001. The Structure "I" Murals of El Tajín: Standing at the Edge of the Underworld. Master's thesis, Department of Art and Art History, University of Texas at Austin.

McVicker, Donald. 1985. The "Mayanized" Mexicans. *American Antiquity* 50(1):82–101.

Martinez Marín, Carlos. 2001. Migrations. *The Oxford Encyclopedia of Mesoamerican Cultures*, ed. David Carrasco, vol 2: 305–309.

Matos Moctezuma, Eduardo. 1987. Symbolism of the Templo Mayor. In *The Aztec Templo Mayor*, ed. Elizabeth Hill Boone, pp. 185–210. Washington, DC: Dumbarton Oaks.

———. 1988. *The Great Temple of the Aztecs: Treasures of Tenochtitlan*. London: Thames and Hudson.

Medellín Zenil, Alfonso. 1957. La diedad Ehecatl-Quetzalcoatl, en el centro de Veracruz. *La palabra y el hombre* 2:45–49.

Mendoza, Ruben G. 2001. Mesoamerican Chronology: Periodization. In *Oxford Encyclopedia of Mesoamerican Cultures*, ed. Davíd Carrasco, vol. 2, pp. 222–225. Oxford: Oxford University Press.

Milbrath, Susan. 2001. Sun. *The Oxford Encyclopedia of Mesoamerican Cultures*, ed. Davíd Carrasco, vol. 3:172–174.

Miller, Mary Ellen. 1986. *The Murals of Bonampak*. Princeton: Princeton University Press.

———. 1991. Rethinking the Classic Sculptures of Cerro de las Mesas, Veracruz. In *Settlement Archaeology of Cerro de las Mesas, Veracruz, Mexico*, ed. Barbara Stark and Lynette Hellner, pp. 26–38. Los Angeles: Institute of Archaeology, University of California at Los Angeles.

———. 1998. A Design for Meaning in Maya Architecture. In *Function and Meaning in Classic Maya Architecture*, ed. Stephen D. Houston, pp. 187–222. Washington, DC: Dumbarton Oaks.

———. 2001. Life at Court: The View from Bonampak. *Royal Courts of the Ancient Maya*, ed. Takeshi Inomata and Stephen D. Houston, vol. 2, pp. 201–222. Boulder: Westview Press.

Miller, Mary Ellen, and Stephen D. Houston. 1987. The Classic Maya Ballgame and Its Architectural Setting: A Study of Relations Between Text and Image. *Res: Anthropology and Aesthetics* 14:46–65.

Miller, Mary Ellen, and Marco Antonio Samoya. 1998. Where Maize May Grow: Jade, Chakmools and the Maize God. *Res: Anthropology and Aesthetics* 33: 54–72.

Miller, Mary Ellen, and Karl Taube. 1993. *The Gods and Symbols of Ancient Mexico and the Maya: An Illustrated Dictionary of Mesoamerican Religion*. London: Thames and Hudson.

Miller, Virginia E. 1983. A Re-examination of Maya Gestures of Submission. *Journal of Latin American Lore* 9(1):17–38.

Millon, René. 1988. The Last Years of Teotihuacan Dominance. In *The Collapse of Ancient States and Civilizations*,

ed. Norman Yoffee and George Cowgill, pp. 102–164. Tucson: University of Arizona Press.

Monaghan, John. 1990. Sacrifice, Death, and the Origins of Agriculture in the Codex Vienna. *American Antiquity* 55(3):559–569.

Morante López, Rubén. 2005. *La Pintura Mural de Las Higueras, Veracruz.* Xalapa: Universidad Veracruzana.

Nagao, Debra. 1989. Public Proclamation in the Art of Cacaxtla and Xochicalco. In *Mesoamerica After the Decline of Teotihuacan, A.D. 700–900,* pp. 83–104: Washington DC: Dumbarton Oaks.

Nebel, Carl. 1836. *Voyage pittoresque et archeologique, dans la partie la plus interessante du Mexique.* Paris: M. Moench.

Newsome, Elizabeth. 2003. The "Bundle" Altars of Copán: A New Perspective on Their Meaning and Archaeological Contexts. *Ancient America* 4:1–72.

Nicholson, Henry B. 1971. Religion in Pre-Hispanic Central Mexico. In *Handbook of Middle American Indians,* vol. 10, ed. Gordon F. Ekholm and Ignacio Bernal, pp. 395–446. ·Austin: University of Texas Press.

———. 1988. Introduction: Research Concerning the Mesoamerican Ritual Ballgame. In *Ulama: Het balspel bij de Maya's en Azteken, 2000 v. Chr.-2000 n. Chr.: van mensenoffer tot sport* [Ulama: The Ballgame of the Mayas and Aztecs, 2000 BC–AD 2000: From Human Sacrifice to Sport], ed. Ted J. J. Leyenaar and Lee A. Parsons, pp. 11–21. Leiden: Spruyt, Van Mantgem and De Does BV.

———. 1991. The Octli Cult in Late Pre-Hispanic Central Mexico. In *To Change Place: Aztec Ceremonial Landscapes,* ed. Davíd Carrasco, pp. 158–187. Boulder: University Press of Colorado.

———. 2001. Feathered Serpent. In *The Oxford Encyclopedia of Mesoamerican Cultures,* ed. Davíd Carrasco, vol. 1, pp. 397–400. Oxford: Oxford University Press.

Noguez, Xavier. 2001. La zona del Altiplano Central en el Posclásico: La etapa tolteca. In *Historia Antigua de Mexico,* 2nd edition, ed. Linda Manzanilla and Leonardo López Luján, vol. 3, pp. 199–236.

Ochoa, Lorenzo. 2001. La zona del Golfo en el Posclásico. *Historia Antigua de México,* 2nd edition, ed. Linda Manzanilla and Leonardo López Luján, vol. 3, pp. 13–56.

O'Mack, Scott. 1991. Yacateuctli and Ehecatl-Quetzalcoatl: Earth-divers in Aztec Central Mexico. *Ethnohistory* 38(1):1–33.

Orr, Heather. 1997. *Power Games in the Late Formative Valley of Oaxaca: The Ballplayer Carvings at Dainzú.* Ph.D. dissertation, Department of Art History, University of Texas at Austin. Ann Arbor: University Microfilms.

———. 2001. Ballgame. In *The Oxford Encyclopedia of Mesoamerican Cultures,* ed. Davíd Carrasco, vol. 1, pp. 75–78. Oxford: Oxford University Press.

Ortega, Rene. 1988. *Report on the Pyramid of the Niches.* Archivo Técnico, Instituto Nacional de Antropología, México, D.F.

Ortíz Ceballos, Ponciano. 1990. Los Teotihuacanos en Matacapan. In *La época clásica: Nuevos hallazgos, nuevas ideas,* ed. Antonio Cardoz de Mendez, pp. 307–328. Mexico City:

Museo Nacional de Antropología and Instituto Nacional de Antropología.

Ortíz Ceballos, Ponciano, and María del Carmen Rodríguez. 1999. The Gulf Coast Cultures and Recent Archaeological Discoveries at El Manatí, Veracruz. In *The Archaeology of Mesoamerica: Mexican and European Perspectives,* ed. Warwick Bray and Linda Manzanilla, pp. 97–115. London: British Museum Press.

Ortiz Ceballos, Ponciano, María del Carmen Rodríguez, and Alfredo Delgado. 1997. *Las investigaciones arqueológicas en el Cerro Sagrado Manatí.* Xalapa: Universidad Veracruzana.

Palacios, Enrique Juan. 1926. *El Tajín y Yohualichan.* Mexico City: Dirección de Monumentos Prehispánicos.

Panofsky, Erwin. 1955. *Meaning in the Visual Arts: Papers In and On Art History.* New York: Doubleday.

Parsons, Jeffrey R. 2001. Agave. In *Archaeology of Ancient Mexico and Central America: An Encyclopedia,* ed. Susan Toby Evans and David L. Webster, pp. 4–7. New York: Garland Publishing.

Parsons, Lee A. 1969. *Bilbao, Guatemala: An Archaeological Study of the Pacific Coast Cotzumalhuapa Region.* Milwaukee Public Museum, Publications in Anthropology 12. Milwaukee: Milwaukee Public Museum.

Pascual Soto, Arturo. 1990. *Iconografía arqueológica de El Tajín.* Mexico City: Universidad Autónoma de México.

———. 1994. Pueblos y signos de El Tajín en el Clásico Terminal. In *Encuentros y desencuentros en las artes,* ed. Pablo Escalante Gonzalbo, pp. 81–108. Mexico City: Universidad Autónoma de México, México, D.F.

———. 1998. *El arte en tierras de El Tajín.* Mexico City: Círculo de Arte.

———. 2000. El Tajín en vísperas del Clásico Tardío: Arte y cultura. *Universidad de México* 590:30–39.

———. 2004. La cultura de El Tajín en el Clásico Temprano. In *La costa del Golfo en tiempos Teotihuacanos: Propuestas y perspectivas,* ed. M. E. Ruiz Gallut and A. Pascual Soto, pp. 441–449. Mexico City: Instituto Nacional de Antropología e Historia.

Pasztory, Esther. 1972. The Historical and Religious Significance of the Middle Classic Ball Game. In *Sociedad Mexicana de Antropología XII Mesa Redonda,* pp. 441–455. Mexico City: Sociedad Mexicana de Antropología.

———. 1978. Historical Synthesis of the Middle Classic Period. In *Middle Classic Mesoamerica: A.D. 400–700,* ed. Esther Pasztory, pp. 3–22. New York: Columbia.

———. 1983. *Aztec Art.* New York: Harry N. Abrams.

Pohl, John M. D. 1994. *The Politics of Symbolism in the Mixtec Codices.* Vanderbilt University Publications in Anthropology no. 46. Nashville: Vanderbilt University.

———. 2001. Chichimecatlalli: Strategies for Cultural and Commercial Exchange Between Mexico and the American Southwest, 1100–1521. In *Aztlan: Art from a Mythic Homeland,* ed. Virginia Fields and Victor Zamudio Taylor, pp. 86–101. Los Angeles: Los Angeles County Museum of Art.

———. 2003. Creation Stories, Hero Cults, and Alliance Building. In *The Postclassic Mesoamerican World,* ed.

Michael E. Smith and Frances F. Berdan, pp. 61–66. Salt Lake City: University of Utah Press.

Pohl, John M. D., John Monaghan, and Laura Stiver. 1997. Religion, Economy, and Factionalism in Mixtec Boundary Zones. In *Códices y documentos sobre México,* ed. S. Rueda Smithers, C. Vega Sosa, and R. Martínez Baracs, pp. 205–232. Mexico City: Instituto Nacional de Antropología e Historia.

Proskouriakoff, Tatiana. 1954. *Varieties of Classic Central Veracruz Sculpture.* Contributions to American Anthropology and History no. 58. Washington, DC: Carnegie Institution of Washington.

———. 1971. Classic Art of Central Veracruz. In *Handbook of Middle American Indians,* ed. Gordon F. Ekholm and Ignacio Bernal, vol. 11, pp. 558–572. Austin: University of Texas Press.

Quilter, Jeffrey. 1996. Continuity and Disjunction in Pre-Columbian Art and Culture. *Res: Anthropology and Aesthetics* 29/30:82–101.

Quiñones Keber, Eloise (editor). 2002. *Representing Aztec Ritual: Performance, Text and Image in the Work of Sahagún.* Boulder: University of Colorado Press.

Raesfeld, Lydia. 1990. New Discoveries at El Tajín, Veracruz. *Mexicon* 12(5):92–95.

———. 1992. *Die Ballspielplätze in El Tajín, Mexiko.* Ethnologische Studien Bd. 8. Münster: Lit.

Ramírez Castilla, Gustavo. 1995. La Cultura Tajín en el contexto de las culturas de la Costa del Golfo Veracruzano. *Antropológicas* 13:51–61.

Reents-Budet, Dorie. 1989. Narrative in Classic Maya Art. In *Word and Image in Maya Culture,* ed. William F. Hanks and Don S. Rice, pp. 189–197. Salt Lake City: University of Utah Press.

———. 2001. Classic Maya Concepts of the Royal Court: An Analysis of Renderings on Pictorial Ceramics. In *Royal Courts of the Ancient Maya,* ed. T. Inomata and S. Houston, vol. 1, pp. 195–236. Boulder: Westview Press.

Reese-Taylor, Kathryn, and Rex Koontz. 2001. The Cultural Poetics of Space and Power in Ancient Mesoamerica. In *Landscape and Power in Ancient Mesoamerica,* ed. Rex Koontz, Kathryn Reese-Taylor, and Annabeth Headrick, pp. 1–27. Boulder: Westview Press.

Ringle, William. 2004. On the Political Organization of Chichén Itzá. *Ancient Mesoamerica* 15:167–218.

Ringle, William, Tomás Gallareta Negrón, and George J. Bey III. 1998. The Return of Quetzalcoatl: Evidence for the Spread of a World Religion during the Epiclassic Period. *Ancient Mesoamerica* 9: 183–232.

Rivas Castro, Francisco. 2001. El Maguey y el pulque en Teotihuacan: Representación y simbolismo. *Arqueología* 25:47–62.

Robiscek, Francis, and Donald Hales. 1982. *Maya Ceramic Vases from the Classic Period: The November Collection of Maya Ceramics.* Charlottesville: University Museum of Virginia.

Ruíz, Diego. 1785. Papantla. *Gaceta de México,* 12 July.

Sahagún, Bernardino. 1950–1982. *General History of the Things of New Spain: Florentine Codex.* 13 vols. Trans. and ed. Arthur J. O. Anderson and Charles E. Dibble. Salt Lake City: School of American Research and the University of Utah.

———. 1992. *Historia general de las cosas de Nueva España.* 4th ed. Mexico City: Editorial Porrúa.

Sanchez, Julia L. J. 2005. Ancient Maya Royal Strategies: Creating Power and Identity Through Art. *Ancient Mesoamerica* 16:271–275.

Sánchez Bonilla, Juan. 1992. Similitudes entre las pinturas de Las Higueras y las obras plásticas del Tajín. In *Tajín,* essays by Jürgen Brüggemann, Sara Ladrón de Guevara, and Juan Sánchez Bonilla, pp. 133–160. Mexico City: Citibank.

Sanders, William, and Barbara Price. 1968. *Mesoamerica: The Evolution of a Civilization.* New York: Random House.

Santley, Robert, Michael Berman, and Rani Alexander. 1991. Politicization of the Mesoamerican Ballgame and Its Implications for the Interpretation of the Distribution of Ballcourts in Central Mexico. In *The Mesoamerican Ballgame,* ed. Vernon L. Scarborough and David R. Wilcox, pp. 3–24. Tucson: University of Arizona Press.

Sarro, Patricia. 1991. Role of Architectural Sculpture in Ritual Space at Teotihuacán, Mexico. *Ancient Mesoamerica* 2(2):249–262.

———. 1995. *The Architectural Meaning of Tajín Chico, the Acropolis at El Tajín, Mexico.* Ph.D. dissertation, Department of Art History, Columbia University. Ann Arbor: University Microfilms.

———. 2001. The Form of Power: The Architectural Meaning of Building A of El Tajín. In *Landscape and Power in Ancient Mesoamerica,* ed. Rex Koontz, Kathryn Reese-Taylor, and Annabeth Headrick, pp. 231–256. Boulder: Westview Press.

———. 2004. Investigating the Legacy of Teotihuacan in the Architecture of El Tajín. In *La Costa del Golfo en Tiempos Teotihuacanos: Propuestas y Perspectivas,* ed. M. E. Ruiz Gallut and A. Pascual Soto, pp. 329–348. Mexico City: Instituto Nacional de Antropología e Historia.

———. 2006. Rising Above: The Elite Acropolis of El Tajín. In *Palaces and Power in the Americas: From Peru to the Northwest Coast,* ed. Jessica Christie and Patricia Sarro, pp. 166–188. Austin: University of Texas Press.

Schele, Linda. 1986. Founders of Lineages at Copán and Other Maya Sites. *Copán Notes* 8. Austin, TX: Copan Mosaics Project, Instituto Hondureño de Antropología e Historia.

———. 1995. Olmec Mountain and Tree of Creation in Mesoamerican Cosmology. In *The Olmec World: Ritual and Rulership,* essays by Michael D. Coe et al., pp. 105–117. Princeton: Princeton University Press.

Schele, Linda, and David Freidel. 1991. Courts of Creation: Ballcourts, Ballgames and Portals to the Maya Otherworld. In *The Mesoamerican Ballgame,* ed. Vernon L. Scarborough and David Wilcox, pp. 289–315. Tucson: University of Arizona Press.

Schele, Linda, and Nikolai Grübe. 1994. *Notebook for the XVIIIth Maya Hieroglyphic Workshop.* Austin: Department of Art and Art History, University of Texas.

Schele, Linda, and Julia Guernsey Kappelmann. 2001. What the Heck's Coatepec? The Formative Roots of Enduring Mythology. In *Landscape and Power in Ancient Mesoamerica,* ed. Rex Koontz, Kathryn Reese-Taylor, and Annabeth Headrick, pp. 29–53. Boulder: Westview Press.

Schele, Linda, and Peter Mathews. 1998. *The Code of Kings: The Language of Seven Sacred Maya Temples and Tombs.* New York: Simon and Schuster.

Schele, Linda, and Mary Ellen Miller. 1986. *The Blood of Kings: Dynasty and Ritual in Maya Art.* Fort Worth: Kimbell Art Museum.

Scott, John. 1997. Die Entwicklung der Yugos und Hachas im Präkolombischen Veracruz. In *Mexiko: Präkolombische Kulturen am Golf von Mexiko,* ed. Judith Rickenbach, pp. 119–126. Zürich: Museum Rietberg.

———. 2001. Dressed to Kill: Stone Regalia of the Mesoamerican Ballgame. In *The Sport of Life and Death: The Mesoamerican Ballgame,* pp. 50–63. London: Thames and Hudson.

Seler, Eduard. 1963. *Comentarios al Códice Borgia.* Mexico City: Fondo de Cultura Económica.

———. 1990–1998. *Collected Works in Mesoamerican Linguistics and Archaeology.* 6 vols. Translated under the supervision of Charles P. Bowditch. Culver City, California: Labyrinthos Press.

Shook, Edwin, and Elayne Marquis. 1996. *Secrets in Stone: Yokes, Hachas and Palmas from Southern Mesoamerica.* Memoirs of the American Philosophical Society, vol. 217. Philadelphia: American Philosophical Society.

Smith, Michael E., and Francis Berdan (editors). 2003. *The Postclassic Mesoamerican World.* Salt Lake City: University of Utah Press.

Spinden, Ellen. 1933. The Place of Tajín in Totonac Archaeology. *American Anthropologist* 35:225–270.

Stark, Barbara. 1998. Estilo de volutas en el Periodo Clásico. In *Rutas de intercambio en Mesoamérica: III Coloquio Pedro Bosch-Gimpera,* ed. E. C. Rattray, pp. 215–238. Mexico City: Universidad Autónoma de México.

———. 1999. Finely Crafted Ceramics and Distant Lands: Classic Mixtequilla. In *Pottery and People,* ed. J. M. Skibo and G. M. Feinman, pp. 137–156. Salt Lake City: University of Utah Press.

———. 2001. Gulf Lowlands: South Central Region. In *Archaeology of Ancient Mexico and Central America: An Encyclopedia,* ed. Susan T. Evans and David L. Webster, pp. 334–340. New York: Garland.

Stern, Theodore. 1949. *The Rubber-Ball Games of the Americas.* Monographs of the American Ethnological Society no. 17. New York: J.J. Agustin.

Stone, Andrea. 1989. Disconnection, Foreign Insignia, and Political Expansion: Teotihuacan and the Warrior Stelae of Piedras Negras. In *Mesoamerica After the Decline of Teotihuacan, A.D. 700–900,* ed. Richard A. Diehl and Janet C. Berlo, pp. 153–172. Washington, DC: Dumbarton Oaks.

———. 2002. Spirals, Ropes and Feathers: The Iconography of Rubber Balls in Mesoamerican Art. *Ancient Mesoamerica* 13:21–39.

Stresser-Péan, Guy. 1971. Ancient Sources on the Huasteca.

In *Handbook of Middle American Indians,* ed. Gordon F. Ekholm and Ignacio Bernal, vol. 11, pp. 582–602. Austin: University of Texas Press.

Stuart, David. 1995. *A Study of Maya Inscriptions.* Ph.D. dissertation, Department of Anthropology, Vanderbilt University. Ann Arbor: University Microfilms.

———. 1996. Kings of Stone: A Consideration of Stelae in Ancient Maya Ritual and Representation. *Res: Anthropology and Aesthetics* 29:148–171.

———. 1998. "The Fire Enters His House": Architecture and Ritual in Classic Maya Texts. In *Function and Meaning in Classic Maya Architecture,* ed. Stephen D. Houston, pp. 373–426. Washington, DC: Dumbarton Oaks.

———. 2000. Arrival of Strangers: Teotihuacan and Tollan in Classic Maya History. In *Mesoamerica's Classic Heritage: Teotihuacán to the Aztecs,* ed. Davíd Carrasco, Lindsay Jones, and Scott Sessions, pp. 465–513. Boulder: University Press of Colorado.

———. 2001. Ruler Accession Rituals. In *Oxford Encyclopedia of Mesoamerican Culture,* ed. Davíd Carrasco, vol. 3, pp. 95. Oxford: Oxford University Press.

Sugiura Yamamoto, Yoko. 2001. La Zona del Altiplano Central en el Epiclásico. In *Historia Antigua de México,* 2nd edition, ed. Linda Manzanilla and Leonardo López Luján, vol. 2, pp. 347–390. Mexico City: Instituto Nacional de Antropología e Historia.

Sugiyama, Saburo. 1993. Worldview Materialized in Teotihuacan, Mexico. *Latin American Antiquity* 4(2):103–129.

———. 1998. Termination Programs and Prehispanic Looting at the Feathered Serpent Pyramid in Teotihuacan, Mexico. In *The Sowing and the Dawning: Termination, Dedication, and Transformation in the Archaeological and Ethnographic Record of Mesoamerica,* ed. Shirley Botelier Mock, pp. 145–164. Albuquerque: University of New Mexico Press.

———. 2000. Teotihuacan as an Origin for Postclassic Feathered Serpent Symbolism. In *Mesoamerica's Classic Heritage: From Teotihuacan to the Aztecs,* ed. Davíd Carrasco, Lindsay Jones, and Scott Sessions, pp. 117–144. Boulder: University Press of Colorado.

———. 2005. *Human Sacrifice, Militarism, and Rulership: Materialization of State Ideology at the Feathered Serpent Pyramid, Teotihuacan.* Cambridge: Cambridge University Press.

Taladoire, Eric. 1981. *Les terrains de jeu de balle: Mésoamérique et Sud-ouest des Etats-Unis.* Mexico City: Mission Archéologique et Ethnologique Francaise au Mexique.

———. 2001. Architectural Background of the Pre-Hispanic Ballgame: An Evolutionary Perspective. In *The Sport of Life and Death: The Mesoamerican Ballgame,* ed. E. Michael Whittington, pp. 96–115. London: Thames and Hudson.

———. 2003. Could We Speak of the Super Bowl at Flushing Meadows? La Pelota Mixteca, a Third Pre-Hispanic Ballgame, and Its Possible Architectural Context. *Ancient Mesoamerica* 14:319–342.

Taladoire, Eric, and Benoit Colsenet. 1991. "Bois Ton Sang, Beaumanoir": The Political and Conflictual Aspects of

the Ballgame in the Northern Chiapas Area. In *The Meso-
american Ballgame,* ed. Vernon L. Scarborough and David
Wilcox, pp. 161–174. Tucson: University of Arizona Press.

Taube, Karl. 1983. The Teotihuacan Spider Woman. *Journal of
Latin American Lore* 9(2):107–190.

———. 1986. The Teotihuacan Cave of Origin. *Res: Anthro-
pology and Aesthetics* 12:52–82.

———. 1988. A Study of Classic Maya Scaffold Sacrifice. In
Maya Iconography, ed. Elizabeth Benson and Gillette Grif-
fin, pp. 331–351. Princeton: Princeton University Press.

———. 1992a. The Temple of Quetzalcoatl and the Cult of
Sacred War at Teotihuacan. *Res: Anthropology and Aesthetics*
21:53–85.

———. 1992b. The Iconography of Mirrors at Teotihua-
can. In *Art, Ideology, and the City of Teotihuacan,* ed. Janet
Catherine Berlo, pp. 169–204. Washington, DC: Dum-
barton Oaks.

———. 1993. *Aztec and Maya Myths.* Austin: University of
Texas Press.

———. 1994. Iconography of Toltec Period Chichén Itzá.
In *Hidden Among the Hills: Maya Archaeology of the Northwest
Yucatan Peninsula,* ed. Hanns J. Prem, pp. 212–246. Acta
Mesoamericana 7. Möckmühl: Verlag von Flemming.

———. 2000. The Turquoise Hearth: Fire, Self-Sacrifice,
and the Central Mexican Cult of War. In *Mesoamerica's
Classic Heritage: From Teotihuacan to the Aztecs,* ed. David
Carrasco, Lindsay Jones, and Scott Sessions, pp. 269–340.
Boulder: University of Colorado Press.

———. 2001. Dance. *The Oxford Encyclopedia of Mesoamerican
Cultures,* ed. David Carrasco, vol. 1:305–308.

———. 2003. Tetitla and the Maya Presence at Teotihuacan.
In *The Maya and Teotihuacan: Reinterpreting Early Classic
Interaction,* ed. G. Braswell, pp. 273–314. Austin: Univer-
sity of Texas Press.

———. 2005. Iconografía y escritura teotihuacana en la
costa sur de Guatemala y Chiapas. *U Tz'ib Serie Reportes*
1(5):35–54.

Tedlock, Dennis. 1996. *Popol Vuh: The Mayan Book of the Dawn
of Life.* Revised edition. New York: Simon and Schuster.

Tezozómoc, Fernando Alvarado. 1878. *Crónica mexicana.*
Mexico City: Impr. y. Litog. de I. Paz.

———. 1980. *Crónica mexicana.* 3rd ed. Mexico City: Edito-
rial Porrúa.

———. 1991. *Crónica mexicáyotl.* Translated by Adrián
León. Mexico City: Universidad Autónoma Nacional de
México.

———. 1992. *Crónica mexicáyotl.* 2nd ed. Mexico City: Uni-
versidad Nacional Autónoma de México de Investigacio-
nes Históricas.

Thompson, John Eric Sidney. 1962. *A Catalog of Maya Hiero-
glyphs.* Norman: University of Oklahoma Press.

Tozzer, Alfred M. 1957. *Chichén Itzá and Its Cenote of Sacrifice:
A Comparative Study of Contemporaneous Maya and Toltec.*
Memoirs of the Peabody Museum of Archaeology and
Ethnology, vols. 11–12. Cambridge: Harvard Univer-
sity, Peabody Museum of American Archaeology and
Ethnology.

Trigger, Bruce G. 2003. *Understanding Early Civilizations:
A Comparative Study.* Cambridge: Cambridge University
Press.

Troike, Nancy. 1974. The Codex Colombino-Becker.
Unpublished Ph.D. dissertation, Department of Anthro-
pology, University of London.

Tuggle, H. David. 1968. The Columns of El Tajín, Veracruz,
Mexico. *Ethnos* 33(1–4):40–70.

———. 1970. El significado del sangrado en Mesoamérica:
El evidencia de el Tajín. *Boletín del Instituto Nacional de
Antropología e Historia* 42:33–38.

Umberger, Emily. 2007. The Metaphorical Underpinnings
of Aztec History. *Ancient Mesoamerica* 18(01):11–29.

Urcid, Javier. 1993. The Pacific Coast of Oaxaca and Guer-
rero: The Westernmost Extent of Zapotec Script. *Ancient
Mesoamerica* 4:141–165.

Uriarte, Maria Teresa. 2006. The Teotihuacan Ballgame and
the Beginning of Time. *Ancient Mesoamerica* 17:17–38.

Van Akkeren, Ruud. 1999. Sacrifice at the Maize Tree: Rabi-
nal Achi in Its Historical and Symbolic Context. *Ancient
Mesoamerica* 10:281–295.

Vásquez Zárate, Sergio. 1997. Asentamientos Serrano Prehis-
pánicos en la Región Tlacolulan. In *Memoria del Coloquio:
Arqueología del Centro y Sur de Veracruz,* ed. Sara Ladrón de
Guevara and Sergio Vásquez Zárate, pp. 45–58. Xalapa:
Universidad Veracruzana.

Von Winning, Hasso. 1987. *La iconografía de Teotihuacan:
Los dioses y los signos.* 2 vols. Mexico City: Universidad
Autónoma de México.

Von Winning, Hasso, and Nelly Gutiérrez Solano. 1996. *La
iconografía de la cerámica de Río Blanco, Veracruz.* Mexico
City: Universidad Autónoma de México.

Webb, Malcolm. 1978. The Significance of the "Epiclassic"
Period in Mesoamerican Prehistory. In *Cultural Continuity
in Mesoamerica,* ed. David L. Browman, pp. 155–178. The
Hague: Mouton Publishers.

Webster, David L. 2000. The Not So Peaceful Civiliza-
tion: A Review of Maya War. *Journal of World Prehistory*
14(1):65–119.

Wilkerson, S. Jeffrey K. 1972. *Ethnogenesis of the Huastec
and Totonac: Early Cultures of North-Central Veracruz at
Santa Luisa, Mexico.* Ph.D. dissertation, Department of
Anthropology, Tulane University. Ann Arbor: University
Microfilms.

———. 1979. Huastec Presence and Cultural Chronology in
North-central Veracruz, Mexico. *Actes du XLIIe Congrès
International des Americanistes,* vol. 9B: 31–47.

———. 1980. Man's Eighty Centuries in Veracruz. *National
Geographic* 158(2):203–231.

———. 1984. In Search of the Mountain of Foam: Human
Sacrifice in Eastern Mesoamerica. In *Ritual Human Sacri-
fice in Mesoamerica,* ed. Elizabeth H. Boone, pp. 101–132.
Washington, DC: Dumbarton Oaks.

———. 1987a. Cultural Time and Space in Ancient Vera-
cruz. In *Ceremonial Sculpture of Ancient Veracruz,* ed. Mari-
lyn Goldstein, pp. 7–17. Brookville, New York: Long
Island University, Hillwood Art Gallery.

———. 1987b. *El Tajín: A Guide for Visitors.* Xalapa: Univer-
sidad Veracruzana.

———. 1990. El Tajín: Great Center of the Northeast. In *Mexico: Splendors of Thirty Centuries,* pp. 155–185. New York: Metropolitan Museum of Art.

———. 1991. And Then They Were Sacrificed: The Ritual Ballgame of Northeastern Mesoamerica Through Time and Space. In *The Mesoamerican Ballgame,* ed. Vernon L. Scarborough and David Wilcox, pp. 45–72. Tucson: University of Arizona Press.

———. 1994. The Garden City of El Pital. *National Geographic Research and Exploration* 10(1):56–71.

———. 1999. Classic Veracruz Architecture: Cultural Symbolism in Time and Space. In *Mesoamerican Architecture as a Cultural Symbol,* ed. Jeff Karl Kowalski, pp. 110–139. Oxford: Oxford University Press.

———. 2001a. Gulf Lowlands: North Central Region. In *Archaeology of Ancient Mexico and Central America: An Encyclopedia,* ed. Susan T. Evans and David L. Webster, pp. 324–329. New York: Garland.

———. 2001b. Santa Luisa (Veracruz, Mexico). In *Archaeology of Ancient Mexico and Central America: An Encyclopedia,* ed. Susan Toby Evans and David L. Webster, pp. 651–653. New York: Garland Publishing.

Willey, Gordon. 1981. Recent Researches and Perspectives in Mesoamerican Archaeology: An Introductory Commentary. In *Archaeology,* ed. Jeremy Sabloff, pp. 3–30. Handbook of Middle American Indians, Supplement 1. Austin: University of Texas Press.

Williams, Robert, Rex Koontz, and Timothy Albright. 1993. Eight Deer Plays Ball Again: Notes on a New Codiacal Cognate. *Texas Note* 50. Austin: Center for the History of Ancient American Art.

Winter, Irene. 1981. Royal Rhetoric and the Development of Historical Narrative in Neo-Assyrian Reliefs. *Studies in Visual Communication* 7(2):2–38.

Wren, L. H., and Peter Schmidt. 1991. Elite Interaction during the Terminal Classic Period: New Evidence from Chichén Itzá. In *Classic Maya Political History: Hieroglyphic and Archaeological Evidence,* pp. 199–225. Cambridge: Cambridge University Press.

Wyllie, Cherra. 2008. Children of the Cultura Madre. In *Cultural Currents in Classic Veracruz,* ed. Philip Arnold III and Christopher Pool. Washington, DC: Dumbarton Oaks.

Ximénez, Francisco. 1985. *Primera parte del Tesoro de las lenguas cakchiquel, quiché y Zutuhil, en que las dichas lenguas se traducen a la nuestra, española.* Guatemala City: Academia de Geografía e Historia de Guatemala.

Yarborough, Clare. n.d. [1992] Teotihuacan and the Gulf Coast: Ceramic Evidence for Contact and Interactional Relationships. Unpublished Ph.D. dissertation, Department of Anthropology, University of Arizona.

Zeitlin, Judith. 1993. The Politics of Classic-Period Ritual Interaction: Iconography of the Ballgame Cult in Coastal Oaxaca. *Ancient Mesoamerica* 4:121–140.

Zender, Marc, and Joel Skidmore. 2004. New Ballcourt Marker from Cancuen. *Mesoweb* http://www.mesoweb.com/reports/cancuen_altar.html (revised April 23, 2004; accessed Friday, January 21, 2005).

INDEX

Page numbers in italics refer to illustrations and photographs.

iconography of, general, 1, 2; location of, *6, 17*, 121n10; number of, in El Tajín, 2, 5, 37; and parallel structures, 37–38; rings in, 22, 118n8; as sites of ritual and pageantry generally, 40; Skull Place ballcourt of Mexica, 31, 34–35, 39; in Snake Mountain narratives, 31, 34–35; substructures of, 119n3; Tula Grande sunken ballcourt, 53–54, *54*. *See also* ballgames; North Ballcourt; South Ballcourt

ballgames: attire of, 45, 50, 89, 92, 94; from Structure of the Building Columns, 91, *92;* warfare compared with, 41. *See also* ballcourts; *palma;* South Ballcourt

Banderilla, 117n7

Basin of Veracruz, 47

baton, 61–62, 70, 76, *76*, 80, 84, 85, 90–91, 95, 113

battle standards. *See* standard-raising rites; warfare

Berdan, Frances F., 120n4

Berlo, Janet Catherine, 117n3

Bernal, Ignacio, 118n14

Bertels, Ursula, 118n22

Beyer, Hermann, 60

bird imagery: and bird deity cult, 99–100, 104; and blow-gunner, 96–97, *97*, 102; in Chichén Itzá, 98–99, *98;* at Coatépec, Veracruz, 52–53, *53;* and falcon, 120n18; King Vulture (*Sarcoramphus papa*), 52; macaw dance, 97–100, *98*, 120n18; and Mexica, 102; at Monte Albán, 53, *53;* in Mound of the Building Columns, 52, 97–100, *98;* and quetzal, 120n18; and sacrifice, 52–53, 61; South Ballcourt bird dance, 51–55, *51*, 97; in Teotihuacan, 98; at Tula Grande sunken ballcourt, 53–54, *54;* vulture figures, 52–53, *53*, 61, *98. See also* feathers

birth posture of male deities, 59, 65, 84, 113

black mirrors, 21, *21*, 23, 26, 89

blowgunning, 88, 96–97, *96*, 102, 103

Bonampak, 22, 30, 77–78, 119–120n2

Brüggemann, Jürgen K., 8, 10, 119n2

burning bundles, 78–79, 89, 91–92

Byland, Bruce E., 46

Cacahuatal phase, 23, *24*, 27, 41–44, *42*, 58, 115

Cacaxtla, 5, 119n19

Cantona, 37

cape on *palma* figure, 61–62

Carrasco, Davíd, 120n13

Caso, Alfonso, 72, 118n14

Castillo Peña, Patricia, 11, 79

Castro-Leal, Marcia, 65, 66

Central Plaza. *See* Pyramid of the Niches/Central Plaza

centzonmecatl (rope), 120n6

ceramics: in ballcourts, 10, 119n2; and dating and ethnicity of El Tajín, 8–10, 38, 119n2, 119n4; Fine Orange ware, 8; of Maya, 78, 96–97, *97*, 103; Polished Black Relief ware, 8–9, 99, 103; Río Blanco ware, 78, *78*, 99, *101*, 103; Teotihuacan II or III ware, 8–9

Cerro de la Morena stela, 43–44, *44*, 49

Cerro de las Mesas stela, *42*, *43*, 115

Cerro Grande stela, 41, 42, *42*, 44

Chaak, 58

Chalchiutlicue, 66

Chiapas ballcourt, 119n26

Chichén Itzá: accession rites at, 94, 95, 115; bird imagery in, 98–99, *98;* and black mirror, 21; compared with El Tajín, 12; decapitation imagery at, 114; Feathered Serpent standard at, 92, *93*, 94, *95*, 111; Great Ballcourt of, 11, 19, *19*, 37, 54–55, *93*, 94, *95*, 115, 119n7; impersonator figure at, 120n9; number of ballcourts in, 37; pyramids at, 30

Chichimec, 86, 88, 120n10

childbirth posture, 59, 65, 84, 113

Cholula, 86, 88, 120n10, 120n12

citlaltlachtli (constellation ballcourt), 11

Classic period: ballcourt rites during, 47; and El Tajín, 8; and Maya, 4; sculptures of, *42, 43*, 49; standard rites during, 28; and *tlachtemalacatl*, 22; and Totonacs, 9; warfare during, 28. *See also* Classic Veracruz centers; Late Classic period; Postclassic period; Preclassic period

Classic Veracruz centers: and ballcourts, 37, 41; and feather bundle and/or string of jade beads, 77–78; and Feathered Serpent cult, 27–28; and *hacha* imagery, 67; imagery of, 18–19, *42, 43*, 100; and macaw cult, 100; map of, *3;* sacrificial scene from, 118n17; and scroll style decoration, 21, 109, 112, 121n4; style of, 10

cloth and baton of rule, 61–62, 70, 76, *76*, 84, 85, 90–91, 95, 113

Coatépec (Snake Mountain), 30–35, 118n18, 118n23

Coatépec, Veracruz, 52–53, *53*, 61

Codex Bodley, 46, 119n11

Codex Borgia, 101, *102*

Codex Colombino-Becker, 46, 119n11

Codex Mendoza, 32, *32*, 63, 78, *78*, 110

Codex Nuttall, 45–46, *46*, 79–80, *80*

Codex of Azcatitlan, 32, *32*

Codex Vindobonensis, 60

Coe, Michael D., 22–23

Cohodas, Marvin, 119n18, 119n24

Colsenet, Benot, 119n5

copalxiquipilli (incense pouch), 41

Coyolxauhqui, 31

creation narratives, 58–62, 101, 113, 121n9

cuahpamitl standard, 110–112

cuauhtzatzaztli (scaffold), 86, 87

cueponi, 120n14

Daneels, Annick, 8, 46–47, 121n10

decapitation imagery: and accession ceremonies, 62, 114–115; and ancient rite of ballcourt decapitation, 115; and Chichén Itzá, 114; context of, 66–68; Pyramid of the Niches Structure 2 Panel, 17–19, *17*, 50–51, 107, *107;* in South Ballcourt, 49–51, *50*, 61–63, 66–68, 91; from Structure of the Building Columns, *67*, 91; and yoke/*palma* pair, 50–55, 114, 115. *See also* sacrifice

deities. *See* supernaturals

Delhalle, Jean-Claude, 56–60, 119n23, 119n25

Diehl, Richard A., 50, 117n3

Du Solier, Wilfredo, 8–9

Durán, Diego, 31, 109, 120n6

Edmonson, Munro, 119n12

effigy scaffold sacrifice (*cuauhtzatzaztli*), 87

Ehecatl, 56–57

by female figures, 84; and solar disk, 100; and standard-raising rites, 28, *28*, 89, 109–111, 118n9
Late Classic period, 4, 10, 117n3
Leach, Edmund, 63
Leyenda de los Soles, 58, 59
Lira López, Yamile, 10, 72, 99
Looper, Matthew, 85
López Austin, Alfredo, 12, 87–88, 112
López Luján, Leonardo, 12, 87–88, 112
Luykx, Albert, 56–60, 119n23, 119n25

macaw dance, 97–100, *98,* 120n18
Machado, John, 120n8
maguey, 63–66, *64,* 82–83, 90–91
Maize God, 85
Masson, Marilyn A., 120n4
Mathews, Peter, 77
Maya: and accession ceremonies, 62, 77; and ancestor cartouches, 94; and bird and tree imagery, 102–103; and blowgunner, 96–97, *97,* 103; Classic Maya battle, 119n19; and cross-arms gesture, 78; deities of, 58, 85; Epiclassic Maya art, 95; and feather trade or tribute, 100; and Feathered Serpent cult, 27; and Feathered Serpent Pyramid, 24–25; hieroglyphs of, 12; and *lakamtun* (standard stone), 30; and macaw dance, 98–99; Piedras Negras Stela 35 of, 23–24, *25;* and *Popol Vuh,* 46, 47, 97–101, 119n13, 119n24; pottery of, 78, 96–97, *97,* 103; and pulque drinking, 63; and ritual audiences, 106, 111; and ropes associated with evisceration sacrifice, 85; and scaffold sacrifice, 77, 78, 79, 82, 83; and stone stelae, 30; Teotihuacan interaction with, 24; Tupp K'ak' ceremonies of Yucatec Maya, 79; war standards of, 22–24, 30, *32;* and Yaxchilan Lintel 25, 47–49, *49. See also* Chichén Itzá; Tikal
Mayahuel, 66
Medelín Zenil, Alfonso, 57
Mexica: and battle standards, 35; and bird and tree imagery, 102; and black mirrors, 21; and *quechquemitl* for female deities, 84; Skull Place ballcourt of, 34–35, 39; and Snake Mountain narratives, 30–35; and standard rites, 17, 30, 31, 32, 35, 109, 110; and *Xócotl huetzi,* 102
military. *See* warfare
Miller, Mary Ellen, 49, 77, 85, 119n19
mirrors: black mirrors, 21, *21,* 23, 26, 89; and Feathered Serpent, 25, *26,* 92; from Pyramid of the Niches/Central Plaza Structure 4 Panel, 25, *26;* raising the mirror standard from Structure of the Building Columns, *22,* 90–95, *91–93;* from Structure of the Building Columns, 90–95, *91–93,* 101
Mixtec: ballcourt alliances of, 45–46, *46;* creation narrative of, 59–60; name glyphs and accession dates for, 62; and pulque, 65; and scaffold/gladiatorial sacrifice, 79–82, *80,* 85
Mixtequilla, 79, 84
Monte Albán, 53, *53*
Moquiuix, 86
Morgadal Grande, 42–43
Mound of the Building Columns: architectural context of, 70; ascent to, 70–72; audience of, 15; banners portrayed

in, 118n16; battle standards from, *110;* bird imagery from, 52, 97–100, *98,* 103–104; blowgunner and tree from, 96–97, *96,* 102; caped figure from, 61–62; characteristics of narrative system of, 72–76, *73–75;* cloth and baton imagery from, 61–62, 70, 76, *76,* 84, 90–91; conclusions on, 103–104; court participants and their activities from, 69–70, 72–76, *73–75,* 87, 95, 100, 103; decapitation imagery from, *67,* 91; descent of Principal Tajín Deity and accession of 13 Rabbit from, 83–85, *83,* 100, 103; entrance to Structure of the Building Columns, 71, *71;* imagery of generally, 11, 71–72, 104; location of, *6,* 69, 70; macaw dance from, 97–100, *98;* mirror standard raising from, 90–95, *91–93;* modification of upper portions of monumental center for, 5; name glyphs from, 72–73, *76,* 95, 101, *101,* 103; Polished Black Relief ware associated with, 8, 99, 103; raising World Tree from, 100–103; scaffold/gladiatorial sacrifice from, 81–83, *81,* 86–87, 90, 101, 103; scaffolds and sacrificial stones from, 12, *67,* 76–79; secondary-tier nobles from, 94–95; serpent standard raising from, 89–90, *90,* *93;* size of, 70; skeletal figures from, 91, 100–101, 102; and standards images, *22,* *108;* Structure of the Building Columns distinguished from, 70; 13 Rabbit from, 11, 12, 62, 76, 81–85, *81,* *83,* 87, 90, 92, 95–96, 100; throne imagery from, 70; war captives from, 45, 77–78, 83, 85–86. *See also* Structure of the Building Columns
Mountain of Foam (Pozonaltepetl), 64
Museo de Antropología de Xalapa, 41
Museum für Völkerkunde, 28

Nahua, 58–59, 63, 64, 119n27, 121n9
Nahuatl, 21, 32, 56, 60
name glyphs, 72–73, *76,* 95, 99, 101, *101,* 103
Napatecuhtlan, 117n7
Nautla Valley, 9
Newsome, Elizabeth, 79
niche/flying cornice architecture, 5, 7, 15–16, 32, 66, 112
Nicholson, Henry B., 118n13
North Ballcourt: canal connected with, 34; Feathered Serpent standard at, 29, 30, *33,* *90,* 92; location of, *17;* Piedras Negras Stela 35 in, 23–24, *25,* 34; standard-raising rites in, 34; as vertical walls of, 119n6
number glyphs, 94

Olmec, 21

Palerm, Angel, 63
palma: and Aparicio ballcourt, 18, *18;* cape on *palma* figure, 61–62; in Chichén Itzá's Great Ballcourt, 54–55; Coatépec *palma,* 52–53, *53,* 61; decapitation imagery of yoke/*palma* pair, 50–55, 114, 115; as elite sculptural form, 10, 117n7; and Las Higueras mural, 18–19; in Pyramid of the Niches/Central Plaza, 17–19; in South Ballcourt, 45, 50–51; from South Ballcourt, 89; and Tajín art, 7–8, 117n7
pamitl (battle standard), 110
Panofsky, Erwin, 120n1
Panquetzaliztli (Raising of the Standards festival), 30, 32, 35, 92, 110, 121n8

elite interaction sphere, 104; identity of, 82–83, 89, 120n7; in Mound of the Building Columns generally, 11, 12; and Polished Black Relief ware, 99; and rope imagery, 81–82, *81;* and rubber ball imagery, 78; and scaffold sacrifice, 90, 91; and serpent standard raising, 89; skeletal bundle, 102; in South Ballcourt, 95; and standard-raising rites, 92; and World Tree, 95–96, 102

Thompson, John Eric Sidney, 12

throne imagery, 70, 91, 94, 111

Tikal, 21, 22, 23, 28

Tlacaxipehualiztli festival, 80–81

tlachtemalacatl, 21–22

tlacochcueponque, 120n14

Tlaloc (Storm God), 56, 58, 113, 119n23, 119n26

Tlaltelolco, 31

tlatoque (rulers), 86

Tlazolteotl, 60

Tollan, 31

Toltecs, 86

tonacamecatl (rope of sustenance), 81–83, 101

Totonac, 9

Tozzer, Alfred M., 119n10

trade, 4, 66, 100

trees: and bird imagery, 102; blowgunner and, 96–97, *96, 102,* 103; and Mexica, 102; raising World Tree, 100–103, *102;* 13 Rabbit at World Tree, 95–96

Tuggle, H. David, 11, 12, 65, 76, 101

Tula, 30

Tula Grande, 53–54, *54*

Tupp K'ak' ceremonies, 79

Tuxtla Statuette, 57

Umberger, Emily, 31

Urban core of El Tajín, 5–8, *6, 7*

Urcid, Javier, 53, 84

Veracruz centers. *See* Classic Veracruz centers

vista: and audiences for Central Plaza rite, 106–112; definition of, 106

vulture figures, 52–53, *53,* 61, *98*

War Serpent, 23–24, 47–49, *49*

war standards. *See* standard-raising rites

warfare: and battle standards, 109–111, *110;* compared with ballgame, 41; Feathered Serpent associated with, 25–27, *26,* 113, 114–115; in South Ballcourt iconography, 47–49, *48;* standard-raising rites associated with, 20–30; and war captives, 45, 77–78, 83, 85–86; and War Serpent, 23–24, 47–49, *49;* and warrior initiation rites, 11, 12

water imagery: and blood from penis perforation sacrifice, 58, *59,* 60, 65, 67; and eye motif, 65; and fish and fish-beings, 58–59, 60, 65; and pulque at South Ballcourt, 64–66; semen associated with, 65; of skeletal figures in South Ballcourt, 34, *35,* 39, 52, 64, 67; of Skull Place (*itzompan*), 31, 34–35, 39, 64, 66, 67, 118n23; and Teotihuacan, 65–66; and Water Temple of South Ballcourt, 58, 60, 61, 62, 64

Water Temple, 58, 60, 61, 62, 64

Webb, Malcolm, 4

Weitzmann, Kurt, 119n8

Wilkerson, S. Jeffrey K., 9, 10, 12, 18, 52, 60, 63, 64, 79, 118n1, 119n6, 119n9, 119n22, 120n16

Wind God, 58

Winter, Irene, 40

World Tree, 95–96, 100–103, *102*

Xalapa, Veracruz, 8

Xiuhcoatl (Fire Serpent), 32, 118n14

Xiuhtetelco, 9, 117n7

Xochicalco, 5, 56

Xócotl huetzi, 102

Yaxchilan Lintel 25, 47–49, *49*

yichnal expression, 111

Yohualichan, 7, 66

yoke/*palma* imagery, 50–55, 114, 115. *See also* palma

Yucatan, 12. *See also* Chichén Itzá

Yucatec Maya, 79. *See also* Maya

Zapotecs, 77, 80

zoomorphs, 39, 47–49, 67, 91, 92, 119n18, 120n19

Zuyuá language, 12

Zuyuan system, 87–88, 112–114, 121n9